First published in Great Britain in 2016 by Coronet
An imprint of Hodder & Stoughton
An Hachette UK company

3

Copyright © Sidemen Clothing Limited 2016

The right of Ethan, JJ, Simon, Tobi, Vik, Harry and Josh
to be identified as the Authors of the Work has been
asserted by them in accordance with the Copyright,
Designs and Patents Act 1988.

A CIP catalogue record for this title is available
from the British Library

Hardback ISBN: 978 1 473 64816 6
Ebook ISBN: 978 1 473 64819 7

Edited by James Leighton
Designed by jamesedgardesign.com

Printed and bound in USA by Quad Graphics Inc

Hodder & Stoughton policy is to use papers that
are natural, renewable and recyclable products
and made from wood grown in sustainable forests.
The logging and manufacturing processes are
expected to conform to the environmental regulations
of the country of origin.

Hodder & Stoughton Ltd
Carmelite House
50 Victoria Embankment
London EC4Y 0DZ

www.hodder.co.uk

CORONET

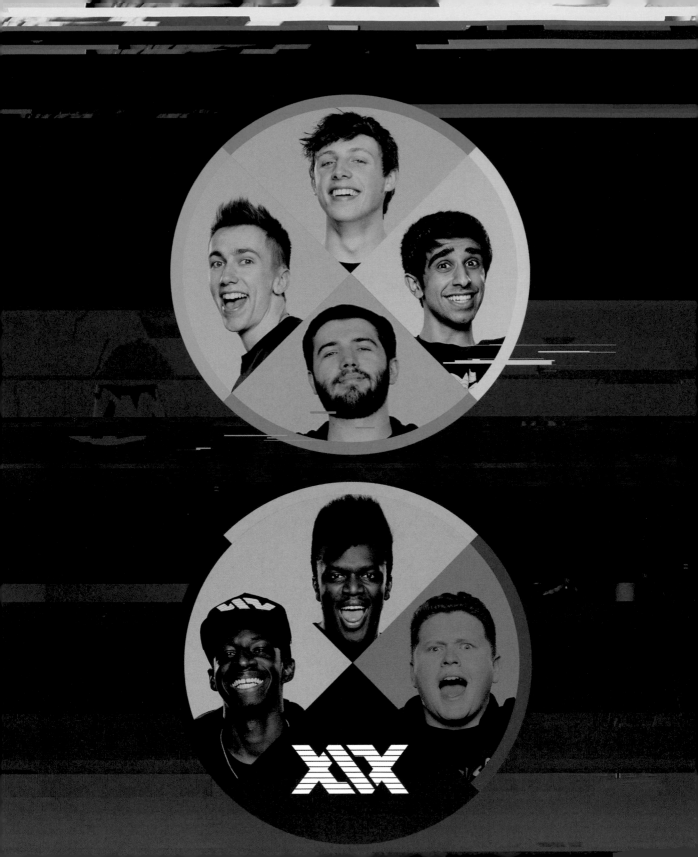

INTRODUCTION

You asked for it, so we decided to give it to you, so here it is, at long long last, a book all about us, YouTube's 'The Sidemen'! We've gone all out to give you…

Hold up, who's talking right now?
I thought it was you?
Nah man, I'm just chilling watching this madness unfold.
Well why don't we assign ourselves colours, like we do when we play GTA?
Good idea!

ᴊ So, I'll be orange, Vikk will be yellow…
ᴠ Wait a minute, are we going to spell my name with one K or two in this book?
ᴊ How do you want to spell it?
ᴠ Well really it's spelt with one K but for YouTube I spell it with two.
ᴊ Why did you do that?
ᴠ It's a long story. I'll explain why later.
ᴊ Ok, cool. Vikk it is! Anyway, like I was saying, I'll be orange, Vikk will be yellow, Simon will be white…
ᴠ But how can we see what Simon is saying if he is writing in white?
ᴊ Hmmmmmm good point. Simon, what colour do you want to be?

…………………………………

ᴊ Simon?
ᴠ He says he wants to be green.
ᴊ All right, so Simon is going to be green!
ꜱ Cool :) Hello everyone!
ᴊ So that leaves Harry with blue…
ʜ Ahoy!
ᴊ Ethan will be red…
ᴇ Oi oi!
ᴊ JJ will be pink…
ᴊᴊ Woah, hold up, why do I have to be pink? Why can't I be black?
ᴊ Because Tobi is black.
ᴛ ;)
ᴊᴊ But I'm way more black than Tobi! I've been to Nigeria and everything!

ᴊ You've never been to Nigeria.
ᴛ I've been twice!
ᴊ That settles it. Tobi is black. JJ is pink.
ᴊᴊ Fine!
ꜱ But what happens when we all want to speak together?
ᴊ You've always got to be difficult don't you?
ꜱ I'm just saying, sometimes we might want to speak as one voice?
ᴊ Well, then we will just speak in black without any initial at the start.
Like this?
ᴊ Exactly. So, just so we don't forget, this is how we are going to talk…

ᴛ = Tobi
ꜱ = Simon
ᴊᴊ = KSI
ᴠ = Vikk
ʜ = Harry
ᴇ = Ethan
ᴊ = Josh

ᴊ Everyone happy?
ᴊᴊ Yo, we should probably order a Nando's before we start?
ᴇ Yeah, this is hard work.
ᴠ You haven't even said anything yet!
ᴇ I've said more than Harry.
ʜ Sorry, I just went to have a shower while you sorted this all out.
ᴊ Listen, we can order Nando's later but we should really get started on this book, we've got a lot to get through.
ꜱ Are we going to tell them about…. Well y'know?
ᴊ Yeah, we probably should.
ᴇ What?
ᴊ Nothing.
ᴇ Is it about the time I…
ᴊ NO! We definitely can't put that in a book. Anyway, let's get started and give our fans what they really want.
ᴊᴊ Free Nando's?
ᴊ No! This book!
ᴊᴊ Oh yeah.

5

SIDEMEN BABY PICTURES

Look how cute and normal we looked before we discovered the internet! But can you guess who is who?

a)

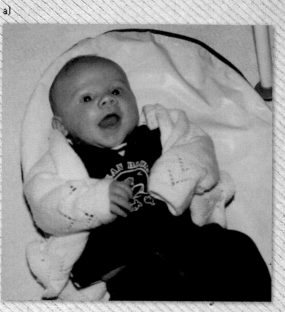

b)

c)

f)

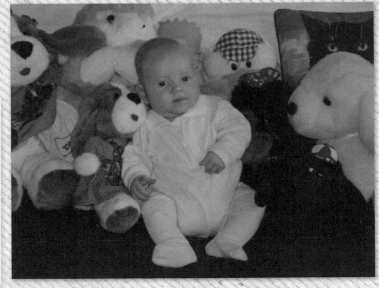

d)

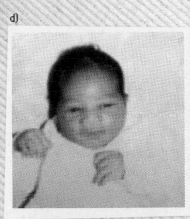

e)

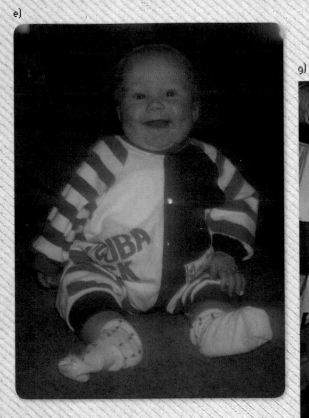

g)

Answers: a) Harry; b) JJ; c) Vikki; d) Tobi; e) Simon; f) Ethan; g) Josh

7

THE SIDEMEN ORIGINS

J As we always get asked how we all got together we should probably start our book right at the very beginning.

H Well to begin with there were dinosaurs…

JJ Oh yeah, there was big T-Rexes and some really hot scientist.

E Really? I don't remember that.

T That was Jurassic World!

H But right at the start of the universe there were dinosaurs, right?

S No, there was a meteor.

V No! The meteor killed all the dinosaurs!

JJ Sick, so what came before dinosaurs? Zombies?

E No there was that couple, Adam and Steve, and they ate an apple or something.

V Wasn't there, like, a big bang or something before that though?

J Guys, hold up!!! I didn't mean right at the beginning of time, I meant right at the beginning, for us, before we met!

H Oh yeah, that actually makes sense.

J So who wants to go first?

S Well you're the oldest so you should.

J I'm only three days older than you!

S Still the oldest…

J All right, fine, I'll go first.

JJ Woah! Before you start telling your life story, and making it really boring, let's try and do something different.

T Like what?

JJ I don't know, like maybe tell our story in a different way.

H Like in a comic strip?

E Or postcards?

JJ Yeah, or a Nigerian scam email chain!

J Uhhhhhh OK, that's not actually a bad idea, in fact I've got one of my CVs lying around here somewhere.

H Why have you got a CV?

J In case you all start to really annoy me and I want to get another job.

H But what would you do if you weren't a YouTuber?

J Read my CV and find out!

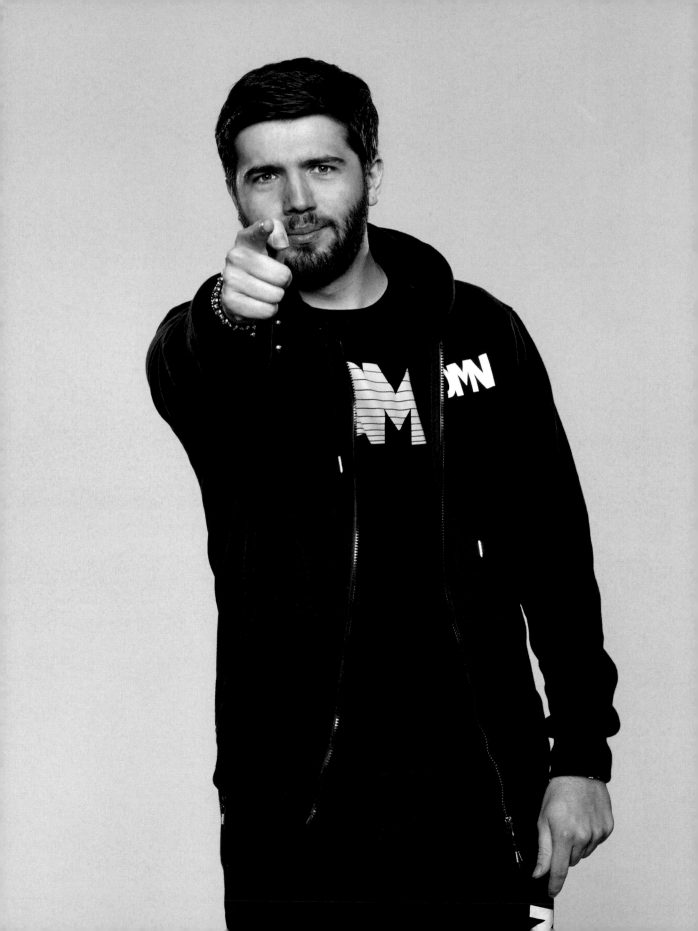

JOSH
(A.K.A. ZERKAA)

D.O.B: 4 September 1992
Birthplace: Bermondsey, London

YouTube Main Channel: ZerkaaHD
YouTube Second Channel: ZerkaaPlays

Instagram: ZerkaaHD
Snapchat: ZerkaaHD
Twitter: @ZerkaaHD

j. I am a full time YouTuber with over 3 million subscribers across my two channels. As a child I always loved football (I've had a season ticket at Millwall since I was six and my hero growing up was Neil Harris), as well as playing computer games. My first console was the N64 and I used to love playing Mario Kart. While I loved computer games I never thought I could play them as a job. My dad was a banker so I think people thought I would follow in his footsteps but to be honest I never really knew what I wanted to be, I went through several phases and at one point I wanted to be an architect and spent hours designing houses.

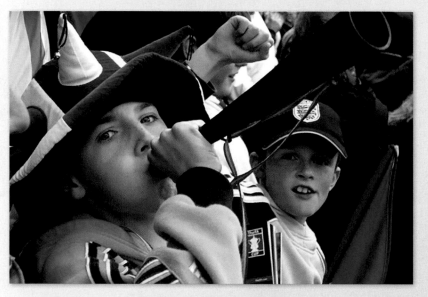

I attended Bexley Grammar School and while the school was really nice I would advise most people to avoid the local area as you're likely to get robbed/ chased if you don't have your wits about you! I suppose I did quite well in school. I probably could have done better, but laziness and playing video games probably affected my grades. My best subject was business studies and my worst chemistry and Latin. I always seemed to have lots of friends, as I was easy-going, and would float between groups. In fact this is how I met Tobi, as even though he wasn't in my class I was friends with some of his friends.

However, in 2006, while I was still in school, I discovered YouTube and then everything changed. I quickly set up an account but only started posting videos in 2008 after I started recording myself playing Call of Duty and FIFA to prove my score in tournaments I was playing in, on a website called Gamebattles. Soon after I realised it would be cool for people to see the videos on YouTube. Not many people were really doing this at the time, so my channel quickly became popular with gamers. By July 2010 I had over 61,000 subscribers after I uploaded my most popular video at that time, 'MW2 Final Killcam! Episode 100 (HD)'.

While I went to Ravensbourne University to study digital film production (I wanted to be a music video director by this stage) my YouTube channel really began to take off. I used the money I had already earned from YouTube to pay for my university fees so I didn't have a student loan. By my second year I realised I wanted to do YouTube full time but I finished my degree anyway just in case I ever needed a back-up option. Although I qualified with a 2:1 there was never any question that I was going to do anything but YouTube. My dad was initially wary of the whole thing, as I think he thought it was a scam, but he soon realised that I really could do YouTube as a job.

JJ was also doing really well on YouTube at the time and we used to Skype regularly. Me and Tobi eventually met up with him at a YouTubers outing at Alton Towers in 2012. I suppose that was the beginning of the Sidemen, as after that meeting, Simon, Vikk, Ethan and Harry soon joined us, and the rest as they say is history.

EMPLOYMENT HISTORY

Sky Sports
For my school work experience my mum knew someone who worked at Sky Sports editing the shows, so I managed to get into the studio in Isleworth for a week. It was pretty cool but I didn't meet anyone famous.

Bank
I went to work with my dad in the City for a few weeks, as I think he was trying to get me into banking. Sadly, I didn't enjoy it that much, probably to my dad's disappointment. I wanted a more creative job.

EDUCATION AND QUALIFICATIONS

Ravensbourne University	Digital Film Production	2:1
Bexley Grammar School	Two Bs and two Cs	
Bexley Grammar School	One A*, ten Bs, three Cs	

INTERESTS

Gaming
YouTube
Football
Business
Nando's

SKILLS

Ability to trickshot in shooting games.
Lethal with a sniper.
Formula 1 Level Standard of driving
Best defence in FIFA.

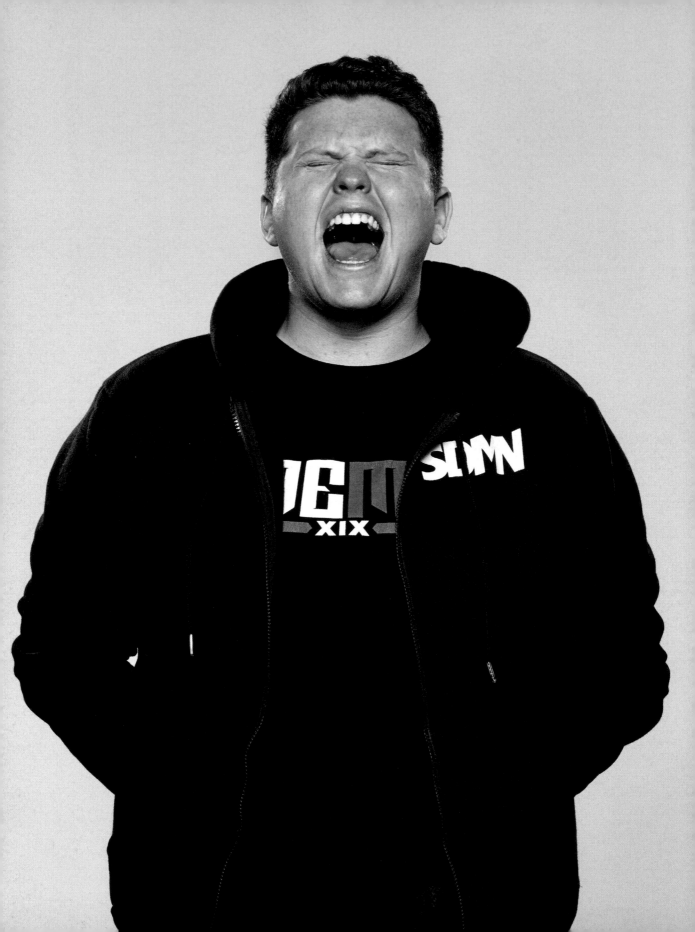

BEHZINGA

ETHAN
(A.K.A. BEHZINGA)

D.O.B: 20 June 1995
Birthplace: London

YouTube Main Channel: Behzinga
YouTube Second Channel: Beh2inga

Instagram: Behzingagram
Snapchat: RealBehzinga
Twitter: @Behzinga

E. **Here we go ladies and gentlemen; it's your boy Behzinga and what better way than to tell you a little bit about myself than through some nawty Essex-style postcards? Just check out some of the crazy stuff I got up to...**

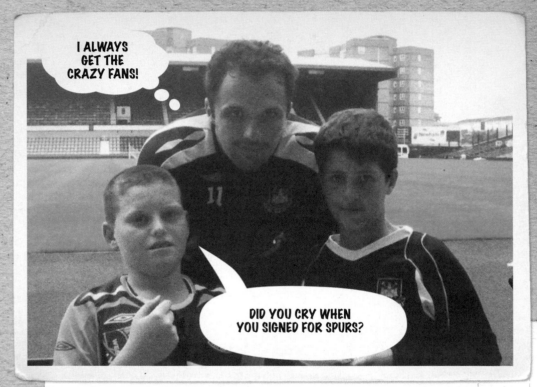

I was born on 20 June 1995, just a stone's throw from Upton Park, the stadium where my favourite football team, West Ham United, played. Back in the day my dad's mate knew our old striker, Bobby Zamora, and he used to get us tickets. While Bobby was a ledge, my heroes growing up were Hammers legends Paolo Di Canio and Carlos Tevez. In the picture I'm posing with former Hammers winger Matthew Etherington. For some reason I look like I'm bricking it but I was loving it. Honestly!

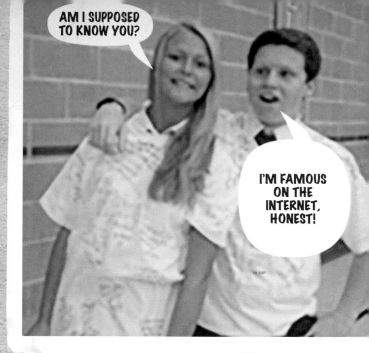

My parents got divorced when I was quite young so my mum, Ruth, brought me up. As you've seen on a few of my FIFA pack videos, she's a right old barrel of laughs. She's like my best mate and I definitely get my laugh from her. Poor Mum, when I was really small I accidentally tipped hot water from the kettle over my arm. I needed a skin graft, which really hurt, but it wasn't her fault. She still beats herself up about it but she shouldn't because she's an absolute star. When I started making some money the first thing I did was buy a car for her. She's a mobile hairdresser, so she really needed it, and I needed her to be able to drive to see me to give me a short back and sides when my barnet was getting a bit long!

That's me at my old stomping ground, Romford's finest educational establishment, Marshall's Park. It wasn't too bad looking back. I was a right little bugger, and I once got a week's suspension for having a fight. It was decent though as I spent the whole time playing games.

I remember always having to sneak out at lunchtime to go to the chip shop. The teachers would be on patrol but nothing was getting in the way of me getting a battered sausage! Probably the most embarrassed I've ever been was on a non-uniform day. When the teacher left the room I stood up on her desk – only for my trousers to fall down to my ankles. Everyone was pointing and laughing. I had an absolute mare. Now I always make sure I wear a belt!

BEHZINGA

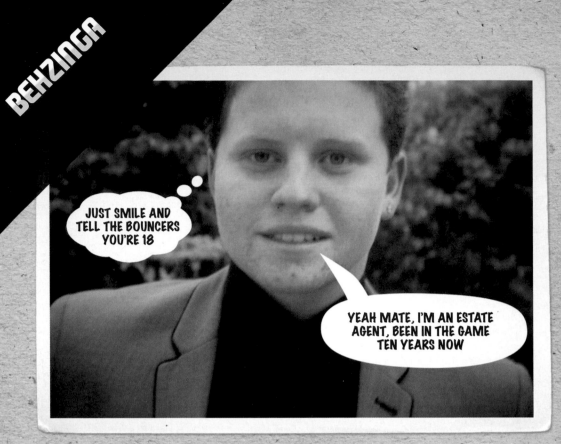

JUST SMILE AND TELL THE BOUNCERS YOU'RE 18

YEAH MATE, I'M AN ESTATE AGENT, BEEN IN THE GAME TEN YEARS NOW

Other than being a YouTuber I've never actually had a proper job. I know, I'm a lucky so-and-so as I really don't know what else I would have done. I suppose the only job I've ever had was knocking on people's doors and asking if they wanted me to clean their car. They obviously didn't like the look of me as I barely made enough for a McDonald's Happy Meal! If YouTube stops working out, don't be surprised if I knock on your door with a bucket of water and a sponge.

I swear I'm Spongebob's biggest fan! I've watched every single one of his cartoons and as I write this I'm even wearing some Spongebob socks. The other guys laugh at my Spongebob T-shirt but that's cool, it takes a legend to know a legend :)

Growing up, any self-respecting kid round my way would be at Basildon Bowl on a Saturday afternoon. While I was decent at bowling I really loved bossing other kids at Quasar. I was pretty sick at it too! It was actually good practice for Call of Duty…

BOWLING IS A SPORT THAT'S RIGHT UP MY ALLEY!

BEHZINGA

BEST MOMENTS

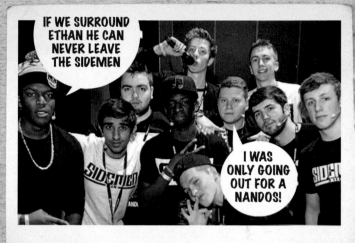

FIFA MANIA

IF I OPEN MY MOUTH WIDE ENOUGH I CAN EAT A WHOLE BATTERED SAUSAGE!

I WONDER WHAT ELSE HE CAN FIT IN THERE...

NO, THE TIME MY PANTS FELL DOWN IN SCHOOL ISN'T ON HERE!

IF WE SURROUND ETHAN HE CAN NEVER LEAVE THE SIDEMEN

I WAS ONLY GOING OUT FOR A NANDOS!

None of my mates used to watch YouTube growing up but I loved watching Call of Duty montages. Josh was killing it at the time so I used to watch everything he put out. Becoming a YouTuber wasn't really something on my mind though as at this point I had decided I wanted to be a games developer...

In 2011 I finished school and enrolled in South Essex College to study games development, where I did stuff like 3D modelling, coding and web design. But even though I passed the course something else had started to take up all my time – YouTube.

CAN I JUST SKIP SCHOOL AND GET TO THE PART WHERE I'M A MILLIONAIRE?

I uploaded my first video on YouTube under the name 'Behzinga' on 5 May 2012. The name was actually a catchphrase from one of my favourite shows *The Big Bang Theory* – Sheldon always used to say 'Bazinga' when he was being sarcastic and I just adapted the spelling. I used to stream a lot of COD to begin with but things really took off when I posted FIFA 14 videos...

I met JJ through Josh and Tobi and we started to play FIFA together against other people. Sadly we were horrible as a team. I blame JJ for hogging the ball. Anyway, after that my subscribers really went crazy.

It was mad seeing millions of people suddenly watching me play games, but it really hit home when we all went to Insomnia in 2015 as the Sidemen. I felt like a proper star! There were thousands of people waiting to see us and chanting our names. It was sick! And I gotta admit, I love it!

VIKK
(A.K.A. VIKKSTAR123)

D.O.B: 2 August 1995
Birthplace: Guildford

YouTube Main Channel: Vikkstar123
YouTube Second Channel: Vikkstar123HD

Instagram: Vikkstagram
Snapchat: Vikkstar
Twitter: @vikkstar123

Since things on YouTube took off I've been asked quite a few times to tell people about myself. As I've still got all my old school notes I decided to stick them together to tell my story. Sorry for the mess – my teachers never could read my homework.

When people ask me what I would be if I wasn't a YouTuber I tell them that I always wanted to be a bin man. Well, I did when I was small anyway, as I used to think they were really cool. Apparently I also wanted to be a 'chameleon'. I used to get my words jumbled up, so when I told people I wanted to be a 'comedian' it came out wrong. People probably thought I was really weird wanting to be a lizard but at least it made them laugh, which I suppose was the point if I wanted to be a comedian.

I grew up in Guildford but I only lived there until I was nine as my family moved to Sheffield. Being up north was hard at first, as I moved around a few schools, so I was always the new kid.

In Guildford I went to Woodstreet Infant School while in Sheffield I went to Dore Primary, Ecclesall Primary and then Silverdale Secondary School.

I was OK though, as I could always occupy myself. My parents made me learn lots of different instruments, like the drums, piano and violin, while my two older brothers got me into gaming. I remember playing GTA when I was super-young. My parents would have gone crazy if they had found out what the game was actually about!

My favourite subject in school was physics but I was terrible at art. The only decent thing I ever made in art was a clay polar bear but when it went in the kiln it turned to rubble… When we had exams I used to study religiously. I was so determined and would be disappointed if I ever had a mark below 90%. Thankfully, I usually got straight As. I was never really into things like football but I used to really like swimming so I joined the Dronfield Dolphin Swimming Club and would train five times a week.

While I was a quiet kid I was also a bit of an entrepeneur. In primary school I noticed that bendy rulers were popular so I bought lots of them for £1 and then sold them for £2. That soon ended though when everyone in my class had bought one! I made a lot of money but had totally saturated my market. In high school I also became a sweet mogul! After the school shut down the vending machines, to try and make us eat more healthily, I actually went to a wholesaler and bought huge tubs of sweets, which I would then sell to my classmates. It was like I was selling drugs; I had to hide the sweets from the teachers. In the end I got busted as the school canteen was losing so much money and they realised it was because of me!

It's amazing that I actually do something like YouTube as growing up I never watched television. All the guys laugh at me because I've never even seen *The Lion King*! I think the only thing I would watch was space documentaries on the Discovery Channel, but other than that regular TV just didn't interest me. I was just obsessed with the internet, especially playing online mini-games.

When I first became aware of YouTube it was pretty much just videos of people hurting themselves. I remember one video with a guy trying to slam-dunk a basketball on a trampoline and it going really wrong. I watched that so many times. It was hilarious!

Eventually I made my own account but registering a name was a nightmare. At school it was cool to be a gangster at the time so I tried to register 'Vikster' but it was already taken.

I changed it to "Vikstar" but that was ~~stil~~ taken too. Then I tried "Vikstar123" but even that was taken. I couldn't believe it. Finally I tried **'Vikkstar123'** and it was available. So that's why I am 'Vikk' with two **K**'s!

While I thought YouTube was funny I didn't take it seriously until some of my friends started sharing videos on there of them playing COD. I thought that was incredible, so uploaded a few videos just to show my friends what I was doing. I had no intention of getting other people to watch me but gradually I noticed that my videos were getting 70–80 views a time, which was really surprising.

Knowing people from outside my group were watching inspired me to improve, so I started doing voiceovers and gradually built up over 1,000 subscribers. Probably the most thrilling moment was when YouTuber ONLYUSEmeBLADE told his subs to check me out and overnight I went from 1,000 subs to 4,000. I couldn't believe it. Soon it became impossible to keep what I was doing from people at school. I think they thought it was a bit weird at first, but when I got recognised by an Austrian guy on a school ski trip I think some of them started to think it wasn't so bad.

I had always intended to go to university, in fact I had even been accepted by UCL to study natural sciences, but YouTube slowly began to take up all my time. I think my parents were worried about me but soon they saw that I could actually make a living doing this so they let me defer uni for a year to see where YouTube took me. It turned out to be the best decision I ever made.

However, with all my friends going off to uni I spent all my time in my room making videos. My subscribers were going up and up but I soon found that I was lonely as no one was around. By this stage I knew JJ and Josh from conversations on Twitter and had even met them at a few gaming events. We were all looking to get our own place, so it seemed a good idea to move in with each other so we could make videos and keep each other company. It wasn't like we had any grand plan to be the Sidemen, the fans really made it happen, but we all get on really well and have had some amazing times.

TOBI
(A.K.A. TBJZL)

D.O.B: 8 April 1993
Birthplace: Hackney, London

YouTube Main Channel: TBJZL
YouTube Second Channel: TBJZLPlays

Instagram: Tobjizzle
Snapchat: tobjizzle
Twitter: @Tobjizzle

T. **To tell you guys my story I've dug really deep to put together my ultimate scrapbook. Oh man, there's some embarrassing things here…**

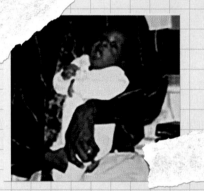

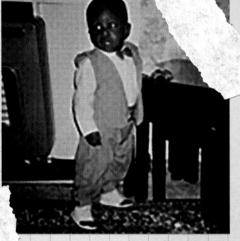

I was born on 8 April 1993 in Hackney, London, and this photo was actually taken just a few days after I was born. Look how cute I was! I don't think I've grown much since but I definitely talk more than I did. And if you think my real name is TBJZL you'd be wrong. Back in the day I was just plain old Tobi before my life as a YouTuber took off.

Here I am posing in the family living room at just two years old. Check out my suit and bow tie! My mum always used to make me look my best and it's a trait people say I've continued as I must admit I love my clothes, especially baseball hats! I'm not too sure if I could pull this outfit off any more though.

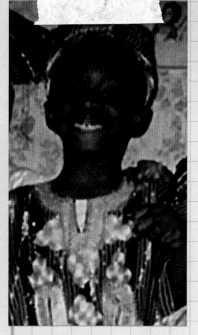

This is me posing for my school photo at St. Dominic's Roman Catholic Primary School and I look pretty sweet, right? Well, when I was six I got into real trouble when I was caught throwing some stones on to a roof with a couple of friends. A teacher caught us red-handed and went mad. They called my parents and everything.

If you had asked me what I wanted to be at this age I probably would have told you an air traffic controller. I used to play flight simulator games on the PC for hours. I was obsessed, particularly when someone told me that air traffic controllers made lots of money!

As you can see, I'm really proud of my Nigerian heritage. In fact, when I was younger I used to get dressed up in Nigerian attire for my birthday. I've actually still got a lot of family in Nigeria, although I've only visited twice. I'd love to go again soon though as the food is incredible, particularly jollof rice with chicken and plantain. Thankfully, my mum cooks a lot of Nigerian food so I've been eating it for ever.

It looks like I gave the Nigerian outfits a miss for this birthday but you can see my little brother Manny chilling by the side of me. We've always been really close and it helps that we both love football and computer games. Our parents were pretty strict though. They always made us do our homework before we could play any games. Sometimes we'd have to play in secret and hope we didn't get caught. All our practice paid off in the end though as Manny is also on YouTube, and doing really well. If you haven't visited his channel check out Manny.

tbjzl

Here I am in Year 7 of Bexley Grammar School. This is where it all began really as this is where I met Josh. We weren't in the same class, but had a similar group of friends, and ended up walking home together every day. I was pretty chilled in school. I seemed to get along with most people and even in Year 7 I was playing football with the older kids in Year 11. I was a decent student as well, although I have to admit I was a little lazy.

I've always loved football. For as long as I can remember I've supported Manchester United and loved following players like Giggs, Scholes, Beckham and Ronaldo. This picture was taken just before I took part in a tournament for my junior team, the mighty Kingfisher JFC. I've always been quick and tricky so I tended to play up front or on the wing. I scored a few hat-tricks in my time as well and I always enjoyed a cheeky nutmeg. The team's tactics used to be to just lump the ball over the top for me to run onto and slot past the keeper. It was simple stuff but I scored a lot of goals that way.

This was the last day of school before we had to sit our GCSEs. You can see Josh by the side of me wearing the blue shades. I ended up getting 7 As, 4 Bs and one C. I was buzzing to get an A in geography though. My teacher was always on my case and predicted I would get a D. I guess I showed him!

This is me and Josh at our Year 11 prom, which was on a boat on the Thames. Josh had already started dabbling in YouTube by this point but I really wanted to be a music producer. I used to love messing around with a program called Fruity Loops and loved listening to all types of music, although 'Where Is the Love?' by the Black Eyed Peas was, and still is, my favourite song. I can actually play quite a few instruments as well. I had a piano teacher and I taught myself how to play the guitar and drums. Back in primary school I also learnt how to play the recorder, although I can only play 'Three Blind Mice'.

I hear they are looking for the next James Bond at the moment, what do you think? This is me at my Year 13 prom, which was in a hotel in London. While I look smooth, I was working in the chilled section in Asda at the time. Although I didn't last long. It was way too cold for me.

Soon after this I was accepted to study computing at Coventry University. Even though Josh was doing really well on YouTube, it still wasn't really something I thought of doing as I still wanted to be a music producer. However, I did used to like watching NigaHiga and Ray William Johnson. I would watch their videos religiously and thought they were hilarious. I actually met NigaHiga in Vegas recently, which was really cool for me and an honour.

While I was in university I started to dabble in YouTube, having seen how well Josh was doing. I remember I was in one of his videos playing football and afterwards two random girls recognised me. I thought that was really cool! At first I wasn't sure what to focus on but Josh encouraged me to go for gaming. It took a while to really take off, but I soon found people from all over the world were watching my videos and I was also making enough money to not need a part-time job in university.

When I was in my second year things were going so well that I signed with Machinima and that's when I realised that when I finished my degree I might be able to do this full time. Since then it's all gone beyond my wildest dreams, especially being able to do this with the guys.

31

(A.K.A. KSIOLAJIDEBT)

D.O.B: 19 June 1993
Birthplace: London

YouTube Main Channel: KSIOlajidebt
YouTube Second Channel: KSIOlajidebtHD

Instagram: KSI
Snapchat: Therealksi
Twitter: @KSIOlajidebt

JJ. YO! It's your boy KSIOLAJIDEBT and I suppose you're here cos you want to know a bit more about me? Well, so did this Nigerian scammer, and seeing as I've already told him everything about me I might as well let you see our emails and save myself some work. Man, this did not go well…

From: Dr George Surugaba
To: KSI

Dear Beloved Friend,
My name is Dr George Surugaba and I am your friend from Lagos. I am seeking an avenue to transfer $30 million out of the country immediately and am relying on you brother to help with this transaction. If you can provide me with your information then I am willing to split the funds 50/50.
Remain blessed,
Dr Surugaba

From: KSI
To: Dr George Surugaba

Yo! George!

Don't I know you man? Didn't you sell me those sunglasses in Napa last summer?

Anyway, that sounds dope! Here's all my info so you can send me the dough!

I was born on 19 June 1993 in London but grew up in Watford. Apart from Oceana and Vue Cinema there wasn't a lot to do but I used to love going to watch stuff like *Independence Day* and *Spiderman*. Oh yeah, there's a sick Chiquito's there as well!

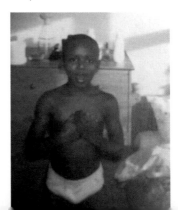

I went to Berkhamsted Independent School but I wasn't like I am now. I swear! I was a total nonce who wouldn't say anything. When Facebook first hit the scene I used to add random people just so I could pretend I was popular. Some of those people are only just accepting my friend request now. True story!

Back in the day I just liked chilling, eating chicken, beating up my little bro Deji and playing on the N64. Man, I would spend hours playing Goldeneye and Super Smash Bros, or if I was watching TV checking out *Courage – The Cowardly Dog* and *Dragon Ball Z*. Oh yeah, and I also loved *Tracy Beaker*. Brrooooooooo, the actress MONTANNA THOMPSON was so hot!!!! OMG I was obsessed. Actually, hold up, I'm gonna look her up right now, just for research…

I suppose I wasn't too bad in school, as I got an A in GCSE maths but things got bad, real quick for my A levels and I flopped big time. I swear, if it wasn't for YouTube I'd be working in KFC right now. I even got kicked off doing the Duke of Edinburgh Award. For real! We were meant to be going on a hike but I just bounced and hit up McDonald's. I was hungry man!

Anyway bro, send me the money and let's do this!

Your brother from another mother,

KSI

From: Dr George Surugaba
To: KSI

GS

Heavenly brother, a thousand blessings! I knew I could count on your valued friendship. However, before we proceed please let me know your details so I can immediately wire the money.
Yours,
Dr Surugaba

KSI

From: KSI
To: Dr George Surugaba

Boss man!

I was thinking, are you like a for real doctor, cos I got a nasty rash I could really do with you looking at…

Anyways, you want my details? OK, I suppose I was decent at football in school. I used to play at the back and just wind people up, then when they reacted I would dive and scream. I suppose I was a bit like Pepe for Real Madrid. I was flat out hated but I knew karate so I could look after myself. Check out my certificate!

Oh yeah, I did a work placement at HMRC for a bit, but pretty much spent all my time looking at Hjerpseth videos on YouTube. And I'm telling you man, it's a good job I started getting into YouTube, as after I dropped out of school I even got turned down for a job at McDonald's. They told me I was overqualified but I had just failed my A levels! So, who the hell actually works there?

So yeah, it was YouTube or bust bro so I set up a channel called KSIOLAJIDEBT. It's a weird name but KSI was basically the name of a Halo clan I used to be in back in the day, Olajide is my first name, and BT was for British Telecom. Pretty random, I know, but soon I started dropping some videos of me playing FIFA and waited for things to blow up. But it was hard to get subs, as I didn't tell anyone I was doing it. Seriously bro! It was like a top-secret operation as no one in school really got YouTube so they would have bullied the hell out of me if they found out. And I had a rep to uphold! I was the token black guy in school so I couldn't let my bros down. Check out my pic of me receiving an award. I took being black serious!

While it took a while to work out what equipment I needed, and how to edit stuff, in 2011 I started to commentate on some of my FIFA videos and things really started to take off. At the time I was still in school but it soon became clear that I could do this full time. I don't think my parents were too happy but they're cool with it now. I think when I bought my Lambo they realised this was all legit!

A lot of YouTubers tend to be close, so when we were both starting out me and Josh used to hit each other up on Skype to talk about videos and games. Soon we started hanging out and he introduced me to his bro, Tobi, and I introduced him to this kid called Simon, who I used to beat up in school. It was jokes though, honest…
So, yeah, we added our mates Vikk, Ethan and Harry to the gang and now we're the Sidemen. It's mad how things worked out but times are good man.

Your boy,

KSI

Ps. Send me the money quick, I've just seen a sick Lambo!

From: Dr George Surugaba
To: KSI

My brother KSI,
Perhaps it might be easier if you firstly wired me the admin fee for this transaction so we can speed things up. Please wire $10,000 to me at Western Union, Lagos. Once they have the money they will send you the $30 million.
Your friend,
Dr George

From: KSI
To: Dr George Surugaba

George, how's Nigeria? Seen any lions lately?
Just sent you the money! When you send me the thirty mill can you also send me a new pair of sunglasses?
The ones you sold me in Napa broke : (

From: KSI
To: Dr George Surugaba

George?… George?

JJ. So yeah, some dude called Dr George Surugaba is probably bouncing around Nigeria right now on a gold-plated lion. And I still don't have my sunglasses!

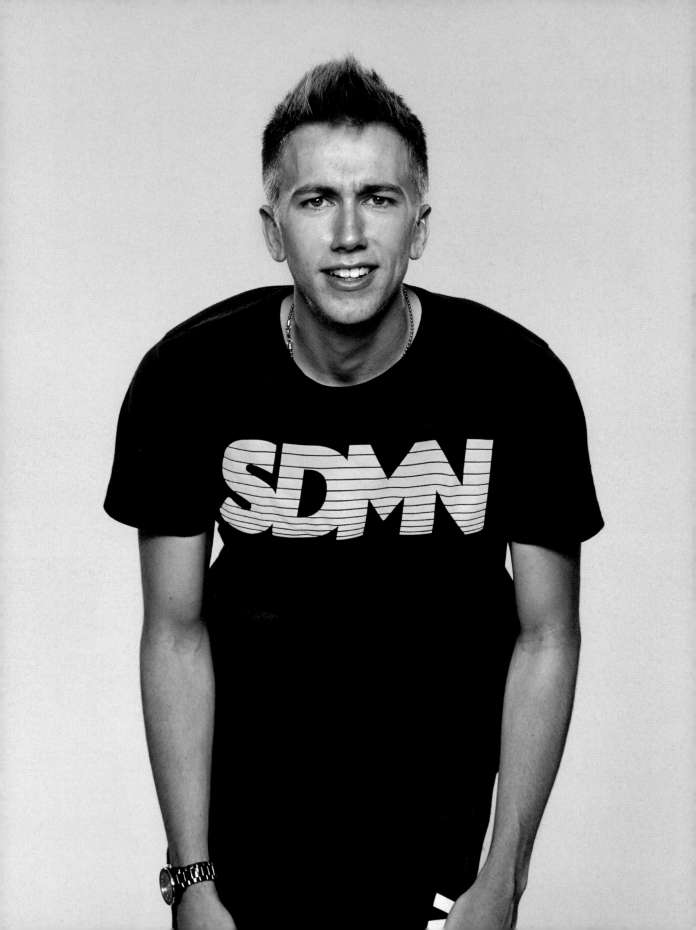

SIMON
(A.K.A. MINIMINTER)

D.O.B: 7 September 1992
Birthplace: Hemel Hempstead

YouTube Main Channel: Miniminter
YouTube Second Channel: MM7Games

Instagram: miniminter7
Snapchat: miniminter
Twitter: @miniminter

s. **Way before the likes of Facebook and Twitter I used to have a social media profile on a website called MySpace. It's long gone now but I thought I'd reactivate it just for this book. Here we go...**

Simon Minter

Location:
Hemel Hempstead,
United Kingdom

Profile views:
347

Online Now!

General Info

D.O.B:
7.09.92

School:
Berkhamsted School

Job:
Temptations factory

Music
Currently listening to:
'In the End' by Linkin Park

Simon is in your extended network

Websites

msn

My Space Favourites

GoldenEye
PES 6
Linkin Park
Merlin's FA Premier League 2000 Sticker Album
Friends
Family Guy
Pokemon

MySpace Crush

Jojo

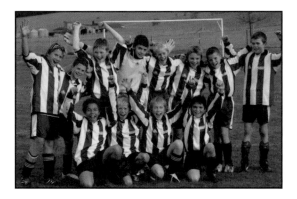

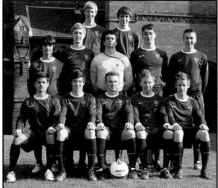

Pictures

Simon's Blurbs

Date: 18 September 2005
Finally had enough of that kid in my year, JJ, today. We just hate each other. I don't even know why but after history he gave me a look and I snapped. Before I knew it we were fighting on the floor and he had me by the throat. The teachers stepped in and now they are trying to make us be friends. That will never happen. I never want to be in the same room as him. We have nothing in common. I HATE HIM! I... HATE... HIM!!!

Date: 27 April 2006
Won player of the year for the school football team! Next stop Leeds United!

Date: 3 July 2006
Back to France again on another family holiday. It's nice enough but we go every year and Mum always wants to take us around cathedrals! ARRRGHHHHHHHH!!!!

Date: 29 January 2007
Been looking at this thing called YouTube with JJ. There's a funny video called 'The Star Wars Kid' that everyone is watching. JJ has set up an account but I don't think he'll do anything with it.

Date: 15 July 2009
Yeah boi!!!! One A star, two As and nine Bs for GCSEs.

Date: 29 January 2010
JJ has started to post some videos on to his YouTube channel. He doesn't want anyone in school to know but I've been helping him out. He's got a couple of hundred subscribers, which is really cool considering he's just playing games and having a laugh.

Date: 17 July 2011
Uhhhhhh decent A level results but didn't get into the uni I wanted. On the bright side going to work in the Temptations factory for a few months so I can save enough money to go on a gap year. Some of the guys are going backpacking in Thailand so might join up with them but really fancy coaching football somewhere.

Date: 28 June 2012
Wow! Amazing two months teaching football in Ghana! Struggled to get on the internet, and had to shower with a bucket, but saw some cool things, and even sat on a crocodile. Roll on Thailand!

Date: 15 August 2012
So glad I decided to go to the East Coast of America rather than Thailand. Landed in Texas and then made my way up to NY, Philadelphia, Washington, Orlando and Miami. I've eaten way too many burgers though and I suppose I should start thinking of preparing for university…

Date: 8 September 2012
Things are really blowing up for JJ on YouTube. I've been helping him film some of his videos and he's thinking of setting up a clothing line called 'Beast', which he wants me to help with. Wish I didn't have to go to uni.

Date: 27 September 2012
Freshers' week at Hull University where I'm studying criminology. The next three years are about to go crazy. TOGA! TOGA! TOGA!

Date: 3 October 2012
I didn't think I was that good at FIFA but I'm killing everyone in my halls. I've even started to film some of my games and have tried to do some commentary. I don't think I'll upload anything but it's still fun to do, certainly more fun than going to lectures.

Date: 21 November 2012
Helping JJ film in London today. Met a guy called Tobi, who is friends with another YouTuber JJ knows called Josh. Seemed a cool guy! Went to Nando's afterwards. JJ made the waitress dress as a Teletubby. Jokes!

Date: 7 December 2012
So nervous, decided to post my FIFA video on YouTube. I've learnt a lot from JJ. I'm still not sure it's any good but I've got nothing to lose…

Date: 15 December 2012
My video has got four views : /

Date: 18 December 2013
No more Hull or criminology for me. Way too much theory. Way too many essays. Suppose I better get a job, although JJ has asked me to help him out.

Date: 14 April 2013
Did a collaboration video with JJ's brother, Deji. He's doing really well on YouTube as ComedyShortsGame. We attempted to eat sixty chicken nuggets each in twenty minutes. I managed over forty. He did about eleven. My channel is now up to 30,000 subscribers! Insane!

Date: 16 February 2014
Me, JJ, Josh, Tobi and another YouTuber called Vikk have all moved into a house together in Kent. I needed to move out as the internet at home was a nightmare. It was taking days to upload videos. Should be cool living with other YouTubers but not sure how I'm going to cope with JJ!

Date: 22 March 2014
We did our first group video today! There was me, JJ, Tobi, Ethan, Vikk, Calfreezy and Callux. We did a crossbar challenge and my subs exploded afterwards up to 133,000.

Date: 27 May 2014
Still can't believe how mad yesterday was. Me, Josh, Ethan, Harry, JJ, Tobi and Vikk went to Thorpe Park. We're kinda known as the Sidemen but have never filmed anything together before so I can't believe the response we got! The kids in the park went nuts when they saw us and when Vikk posted his vlog it had millions of views straight away. Guess I can kiss any thoughts of working in the factory goodbye for now!

HARRY
(A.K.A. WROETOSHAW)

D.O.B: 24 November 1996
Birthplace: Alderney

YouTube Main Channel: W2S
YouTube Second Channel: W2SPlays

Instagram: wroetoshaw
Snapchat: wroetosnap
Twitter: @wroetoshaw

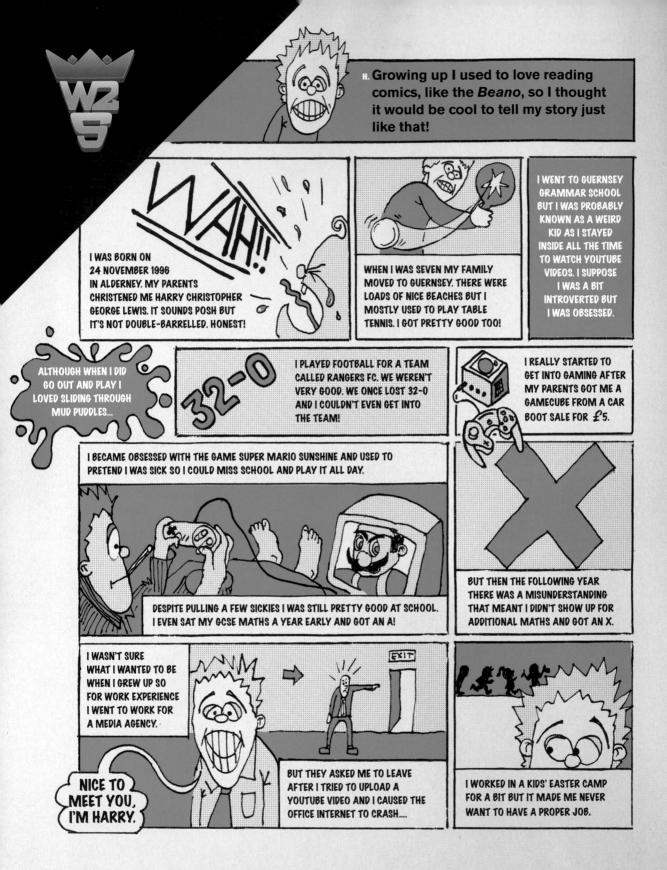

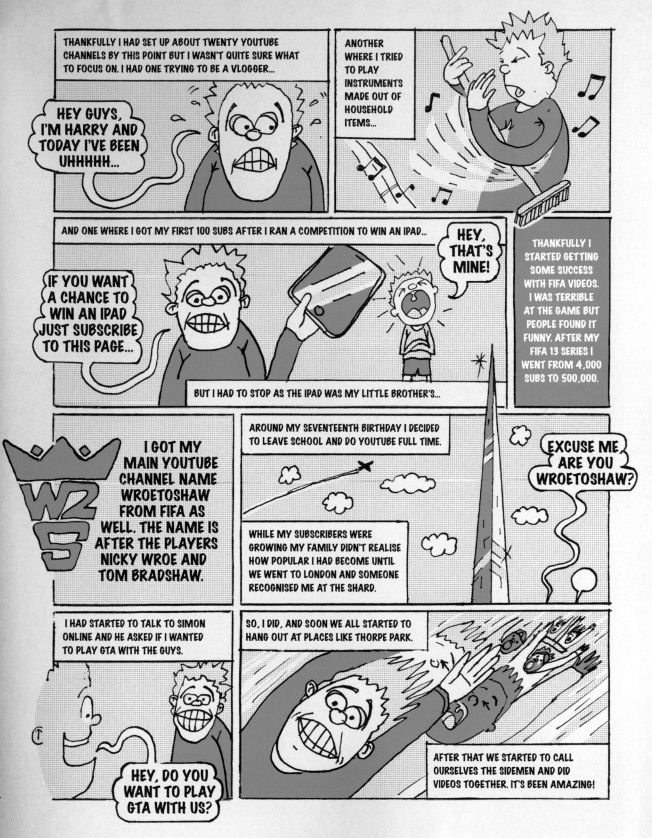

ETHAN'S SALT MAZE

 When I was a nipper I used to love building salt mazes for slugs! The stuff is poisonous to them so as soon as they slithered over it, it was game over. I wasn't that cruel though. When they took a wrong turn I would pick them up and let them start again. I'd even try and encourage them to go the right way. I tried my best. Honest!

Anyway, cos I'm in a nostalgic mood I've built my very own salt maze for your slug to go through. But with this one, as soon as you lift the pen from the paper, or double back, then you're dead! Sorry slugs! You've got to be on your game to get through this maze!

SIDEMEN TODDLER PICTURES

All right, you can tell we've discovered the internet and games by now because things are starting to get a little weird. See if you can guess who is who this time round!

a)

b)

c)

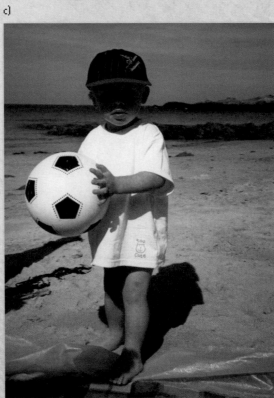

53

Answers: a) Vikk; b) Tobi; c) Harry; d) JJ; e) Simon; f) Ethan; g) Josh

HOW THE SIDEMEN MET

SEPTEMBER 2004 – SCHOOL

Josh and Tobi meet while at Bexley Grammar School. Although they are not in the same class they have a mutual group of friends and end up walking home together every day.

JJ and Simon also meet at Berkhamsted School. For the first two years they hate each other's guts, with their beef culminating in a fight to the death with swords and nunchakus. Not really. They actually threw a few limp-wristed punches at each other and then JJ choked Simon out. Afterwards they are forced by their teachers to become friends. They do so, reluctantly.

2004

Spec Ops Series - The Pit
(Veteran) w/aMOODIEswede

Zerkaa ☑

▶ Subscribe 2M

40,727 views

＋ ➤ ⋯ 👍 308 👎 10

Modern Warfare 2 Care Package
Kill

KSI ☑

▶ Subscribe 14M

613,170 views

＋ ➤ ⋯ 👍 7,920 👎 267

9 DECEMBER 2009

Josh uploads his first YouTube video, 'Spec Ops
Series – The Pit (Veteran)', which he was pretty
decent at and remains one of his favourite games
of all time.

13 JANUARY 2010

JJ uploads his first YouTube video, 'Modern
Warfare 2: Care Package Kill'. Back in the day
everyone was playing this and many claim it's what
really kickstarted gaming videos on YouTube.

24 JUNE 2010

Vikk uploads his first YouTube video, 'MW2: Insane Game Winning Killcam'.

This is possibly the best killcam ever, by Vikstar123. Just Watch...

MW2 INSANE Game Winning Killcam! Triple Quickscope + Collateral - Vikstar123

 Vikkstar123 ☑
▶ Subscribe 3M

82,215 views

Sniper Lobby with Followers!

tbjzl TBJZL ☑
▶ Subscribe 2M

18,949 views

👍 378 👎 20

GAMESFEST 2011

Vikk meets JJ at GamesFest in Birmingham. Vikk has no idea who JJ is but remembers his friends used to love his videos. Their memories of this momentous occasion are a little foggy but Vikk remembers JJ's loud laugh. Soon after they follow each other on Twitter.

17 APRIL 2012

Tobi uploads his first YouTube video, 'Sniper Lobby with Followers'. Once again, COD was not only responsible for hours of fun but for launching many of our careers as YouTubers.

EUROGAMER 2011

Vikk meets Josh and Tobi at Eurogamer in London. Vikk and Josh had played COD online together but had never met until this point.

5 MAY 2012

Ethan uploads his first YouTube video, 'Forza 4 Drift Video'. The graphics and gameplay on this game were unreal! Plus you could slide with stock cars, Pro Am cars, made up wraps, and almost every D1GP and Formula Drift car ever created.

Forza 4 Drift Video - Skyline R34

Behzinga ☑

▶ Subscribe 1M

15,921 views

👍 374 👎 14

Fifa 12 | Trade To Transfer Ep 1 | Podolski

W2S ☑

▶ Subscribe 7M

281,714 views

👍 5,002 👎 393

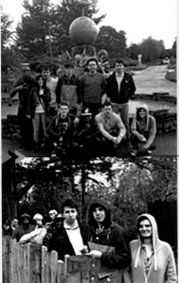

27 APRIL 2012 – ALTON TOWERS

Josh, Tobi and JJ meet at a YouTubers day out at Alton Towers. This is the first time JJ has ever got drunk and it is not a pretty sight. After passing out Josh and Tobi bury him in Lego. JJ recommends not riding rollercoasters with a hangover. It's not big and it's not clever. Stay in school kids!

26 JULY 2012

Harry uploads his first YouTube video, 'FIFA 12: Trade to Transfer'. It might have taken a while to initially master but this remains one of the stand-out FIFA titles and is quite possibly the best football game of all time.

NOVEMBER 2012 – NANDO'S

Simon helps JJ and Callux film a 'Get Hyper' Teletubbies video in London. Tobi also turns up, as he was on his way back from university and had arranged to meet Callux. Tobi has already met JJ but this is his first meeting with Simon. Afterwards everyone goes to Nando's, where they make the waitress dress as a Teletubby. Sadly the day is all in vain as soon after posting the video the BBC makes them take it down. It probably had something to do with La-La and Tinky-Winky getting it on...

AUGUST 2013 – GAMESCOM

Vikk meets Simon for the first time at Gamescom in Germany, with Tobi, JJ and Josh also in attendance. Everyone is there just to check out the convention but Simon is actually JJ's cameraman for the event.
At some point all the guys hang out in the EA Lounge and Simon remembers the first conversation he ever had with Vikk, where he had to explain the differences between the old and new FIFA. Vikk didn't get it then and he doesn't get it now.

DECEMBER 2012 – FUNKY BUDDHA

Simon and JJ meet up with Josh on a wild night out in London. Apparently they all end up in Funky Buddha but no one can actually remember what happened. Although that's not to say they drank a lot as they all acknowledge they are lightweights.

NOVEMBER 2013 – WESTFIELD

Ethan meets Josh, Tobi, Simon and JJ at Nando's in Westfield. Everyone has been playing GTA online together for a while by this stage, and the Sidemen are just about becoming a thing, but no one has actually met Ethan in the flesh yet so this is kinda like a blind date. Looking back everyone agrees it was very weird.

JANUARY 2014 – NEW YORK

Josh and Harry are invited to take part in Kick TVs FIFA Invitational in New York and end up staying in the same hotel. They know of each other already but this is the first time they actually hang out.

MARCH 2014 – EUROGAMER

Josh introduces everyone to Harry for the first time. Sadly JJ isn't present due to 'The Incident'...

16 FEBRUARY 2014 – SIDEMEN HOUSE

The stars align perfectly as Vikk wants to move to London, JJ wants his own place, Simon needs to live somewhere with quicker internet while Josh has had enough of living next to a takeaway. The solution? Move into the Sidemen house together!

MAY 2014 – THORPE PARK

All the Sidemen appear on video for the first time for a Thorpe Park vlog. And from this video onwards the Sidemen officially become a thing! Hurrah!

2014

THE SIDEMEN ASSEMBLE

v. It's actually pretty amazing when you read how we all got into YouTube and then became the Sidemen.

J. Yeah, it's kinda like that movie...

H. *Dumb and Dumber?*

s. No, that would just be Ethan and JJ!

E. Oi!

T. The Hangover? I think our trip to Vegas could definitely have been based on that.

JJ. I actually think it's more like *Straight Outta Compton*. We are like seven guys from the ghetto joined together in a struggle against the authorities.

JJ, you're from Watford! It's the least ghetto place there is!

s. And the only struggle JJ has is going to the gym.

J. I was actually thinking we are kinda like the Avengers.

H. Being a superhero would actually be cool. You could just fly around all day in your underwear.

v. You do that anyway!

H. Oh yeah : /

Being a superhero would be so sick! What would our powers be?

J. Let's have a look...

JJ. I can already see this is going to go badly wrong.

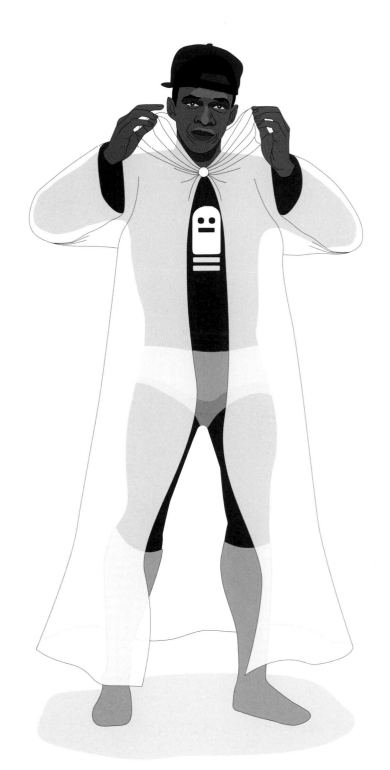

TBJZL
A.K.A GHOST

v. If Tobi was a superhero he would definitely be called Ghost.

E. Yeah! It always amazes me how Tobi goes missing for a few hours every day.

JJ. I call it 'ghosting'. He disappears all the time. You literally can't get hold of him.

T. I don't even know where I go. I just seem to go off the grid then realise where I am a few hours later.

J. Well that doesn't sound at all dodgy!

H. If Tobi's going to be Ghost his special power would have to be that he disappears.

T. That doesn't sound like much of a power. I do that anyway!

J. Yeah, but if Tobi has one weakness it would have to be bad drivers.

S. Oh yeah, he always gets road rage.

T. Only to myself though. I just curse behind the wheel.

H. But then you get distracted and take wrong turns.

T. Yeah, I suppose bad drivers are my weakness. I've got to be honest though, after this I don't think Marvel are going to call.

VIKSTARR123
A.K.A DR HMMMM

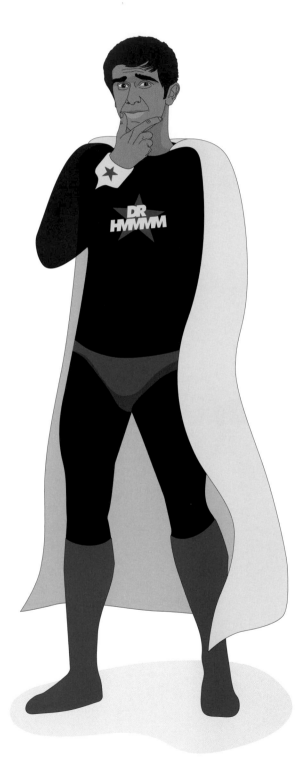

JJ. Vikk's special powers definitely wouldn't be his strength!

V. Maybe it's just a hidden power and I'm actually really strong.

S. Have you ever been to the gym?

V. No.

S. Then your power can't be strength.

H. But he does sit on the fence a lot.

T. Yeah, he always weighs up two sides of the argument with some clever insights.

J. So his power would be that he's super-smart.

E. But his weakness is that sometimes he can't get off the fence.

H. We should probably call him Dr Hmmmm because he's smart like a doctor but when he considers things he always goes 'Hmmmm'.

V. Dr Hmmmm? I actually quite like that. It would have made a cool YouTube name…

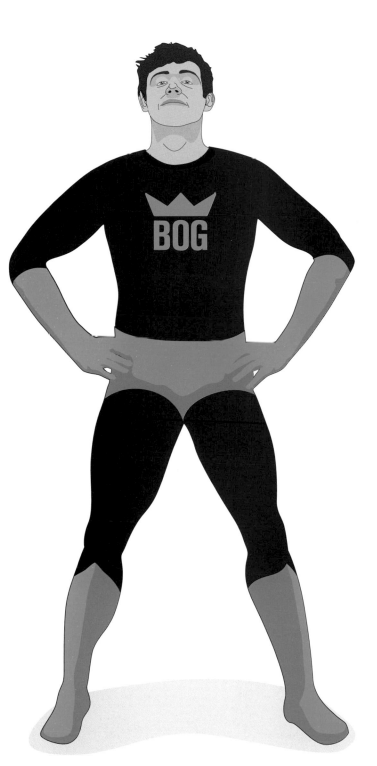

HARRY
A.K.A BOG MAN

V. Harry's name would definitely be Bog Man!

H. Why Bog Man? Why can't I have a cool superhero name, like uhhhhhh… Chocolate Thunder!

E. You've got to have a name that is something to do with you!

H. What's Bog Man got to do with me?

J. Because Joe Weller always used to say 'bog' and called you 'Bog Man.'

H. I want a cooler name than that.

T. OK, we are a democracy in the Sidemen so let's put it to the vote. What does everyone think?

V. Bog Man.

E. Bog Man.

J. Bog Man.

S. Bog Man.

JJ. Bog Man.

T. Bog Man.

H. Chocolate Thunder!

T. Bog Man it is. Sorry Harry.

E. His powers would definitely be doing things which people don't think he can.

V. Yeah, he always rises to the occasion.

H. That's a rubbish power!

S. He is good at throwing chairs though.

JJ. He could be like Thor, except with a chair instead of a hammer.

J. But what about his weakness?

H. I suppose it would be birds as every time I fly back to Guernsey the plane gets hit by one and we have to turn back. I'm the worst superhero ever!

ZERKAA
A.K.A BEARDY MAN

s. I don't think we even need to discuss Josh's superhero name. It's pretty obvious it has to be Beardy Man.

J. Well that's original!

V. His weakness would definitely be a razor. Can you imagine Josh without a beard?

H. He'd look like a baby seal!

J. I look nothing like a seal!

JJ. His special power would definitely be putting people to sleep.

J. Because I've got a soothing voice?

E. No, because you're boring!

J. You can't put that in the book!

T. OK, like I said before, we are a `democracy in the Sidemen. Do you want a vote?

J. Uhhhhh boring Beardy Man it is then. The picture better make me look really cool!

s. You're talking about a designer, not a miracle-worker.

J. I sometimes wonder how we became friends : /

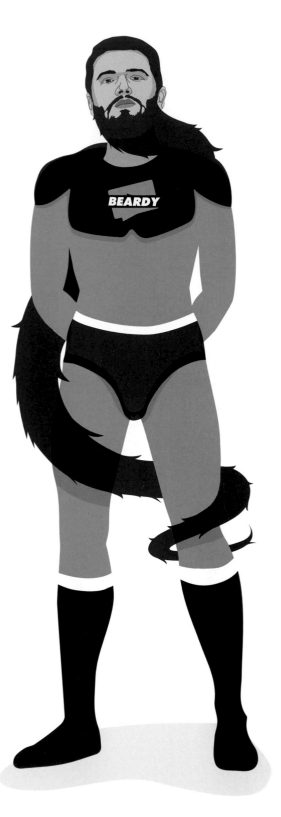

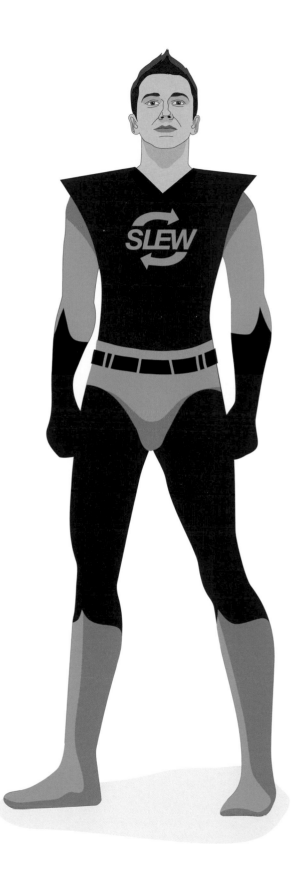

MINIMINTER
A.K.A SLEW MAN

JJ. All right, I feel like as I've known Simon the longest I should get to name him.

S. Oh great…

JJ. You definitely have to be Slew Man!

E. YES!

S. Why Slew Man?

JJ. Because you're disrespectful…

H. And mean.

T. Yeah, he does tend to destroy people's confidence.

E. He made me cry once.

V. Come to think of it, I don't know why we are friends with him.

S. Uhhh guys, I am still here you know.

J. His powers would definitely be making people cry.

JJ. Yeah, and his weakness would be he loses friends.

T. He's definitely going to die alone.

S. Uhhhh guys, hello?

V. He also can't stand clickbait so that should definitely be another weakness.

S. I'm going to my room, ooooo, 'Have you seen what this reality TV show star has been doing?' Click!…

[If you would like to support Simon at this sad time then just tweet the guys using the hashtag #stopsimonabuse.]

63

H. JJ has to be Beast!

JJ. Because I'm such an animal? :)

S. The only thing that's beasty about you is your man boobs.

JJ. And that's why you're called Slew Man!

H. You've got to be Beast because it's the name of your old clothing line and it sounds cool.

JJ. All right, I can live with Beast.

J. His power would definitely be his anger.

V. Yeah, he loves smashing things when he's mad. Especially control pads when he loses at FIFA.

E. But his weakness would be pronouncing words.

JJ. I can pronounce every word!

S. Say claustrophobic.

JJ. …….. THERE YOU GO, DESTROYING MY CONFIDENCE AGAIN!!!

V. See! Look how angry he gets!

S. Stay in school kids!

J. His other weakness would be women.

E. Lol! Definitely.

S. And his lyrics.

JJ. I swear I'm gonna…

V. Hey, where's Tobi? Tobi?

………………………………

E. He's ghosted again

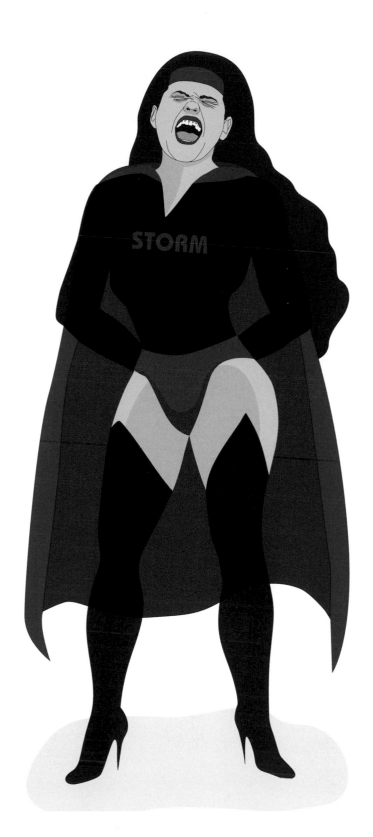

BEHZINGA
A.K.A STORM

E. I've actually got a good name for myself.

S. You can't name yourself; otherwise we would have all picked cool names.

E. All right, let me say it, then you can decide.

T. Well we are a democracy…

E. All right, if I was born a girl my mum was going to call me Storm.

H. That's amazing! Let Ethan be Storm. At least one of us has to have a proper superhero name.

S. No way! Not when I'm Slew Man!

J. It would probably make him happy and you have made him cry before…

E. Pllllleeeeeaaaaaasssseeee :)

S. Uhhhh OK, fine! But if he's Storm the picture has to be the female version of him!

V. YES!

JJ. And his power has to be his laugh. Every time he laughs everyone laughs with him.

E. I think that's the nicest thing you've ever said about me.

JJ. I'm not cruel like Slew Man!

S. Hold up, I have Ethan's perfect weakness, but I feel like if I say it you're just going to say I was mean.

T. Surely his weakness should probably be his driving?

J. Tobi is the new Slew Man!

E. Hey! I've passed my test now!

JJ. Only after a million tries! I think they were just sick of you in the end so said you passed.

S. The driving thing is even better than what I had. I was just going to say he gets really claustrophobic.

E. Oh yeah, I hate confined spaces. That actually is my real weakness.

THE ULTIMATE SIDEMEN

H. I was just thinking, you know we used to call ourselves 'The Ultimate Sidemen'?

J. Yeah…

H. Well, what would the ultimate Sideman look like?

V. Like, if we put together all our best parts?

JJ. That would be dope! We'd be like a zombie Sideman.

E. As Josh is the only one who shaves we'd have to have his beard.

J. And Simon's long arms so we can reach stuff. Simon's pretty good at football as well so we'd have his feet.

S. Thanks guys :)

V. But Tobi's probably the fastest so we'd need his legs.

JJ. Ethan's laugh would be pretty funny.

H. We would definitely need JJ's hair.

J. Yeah, but which style?

E. Definitely the blonde Mohawk!

JJ. Sweet!

E. All the girls seem to like Harry so we should probably have his face.

H. Amazing! Let's see what the ultimate Sideman looks like

V. Uhhhhh guys….

J. What?

V. You haven't mentioned me? : (

H. Oh yeah, uhhhhhh……

T. Vikk's got really nimble fingers as he's good at playing instruments.

H. Perfect! But what's he going to wear?

J. Sidemen clothing of course!

S. You're all business Josh, and that's why we love you!

Ultimate Sideman

DETAILS

Heritage

Lifestyle

Appearance

Sleep	8 hrs
Recording videos	6 hrs
Editing videos	6 hrs
Being in a Skype call	2 hrs
Working out	1 hrs
Eating	1 hrs
Partying	0 hrs
Going Outside	0 hrs
Hours left to assign	**0 hrs**

Vik	Harry	JJ	Simon	Josh	Tobi	Ethan

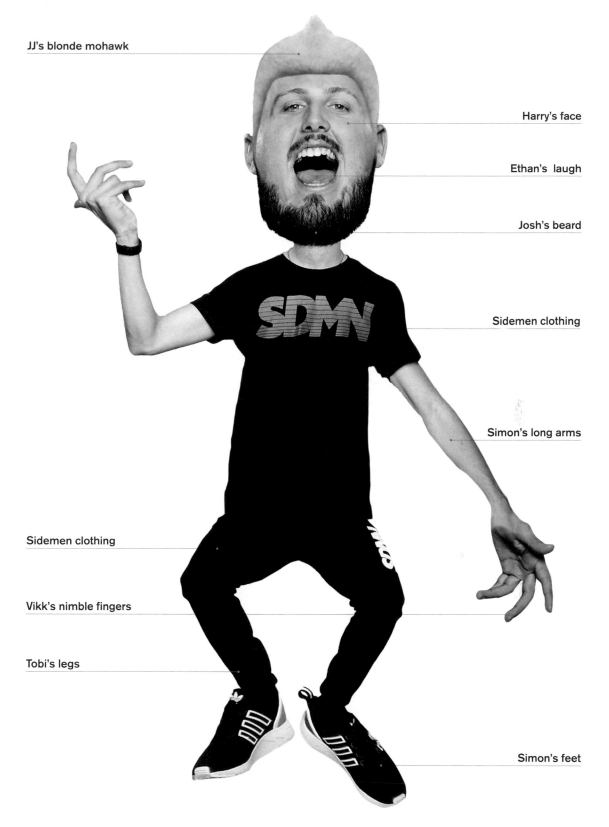

JJ's blonde mohawk

Harry's face

Ethan's laugh

Josh's beard

Sidemen clothing

Simon's long arms

Sidemen clothing

Vikk's nimble fingers

Tobi's legs

Simon's feet

THE SIDEMEN DRAW WHERE THEY LIVE

To be honest, we thought this should have been really easy. I mean, all we had to do was draw where we lived. It was that simple!

For the Sidemen house Josh was going to draw the first floor, JJ the second floor, Simon the third floor and Vikk the back garden (we actually forgot we had a trampoline until Vikk drew it!). But things went downhill as soon as we saw JJ's effort. Some of the walls he had drawn were bigger than our rooms! Simon couldn't help but add some 'constructive criticism', which JJ didn't take well.

As those guys tore to shreds their respective efforts, Tobi, Harry and Ethan each drew their own flats. Again, the standard was low, with 'Harry's Flat of Dreams' sounding a lot better than it looked. We hate to think what 'Harry's Flat of Nightmares' would look like : /

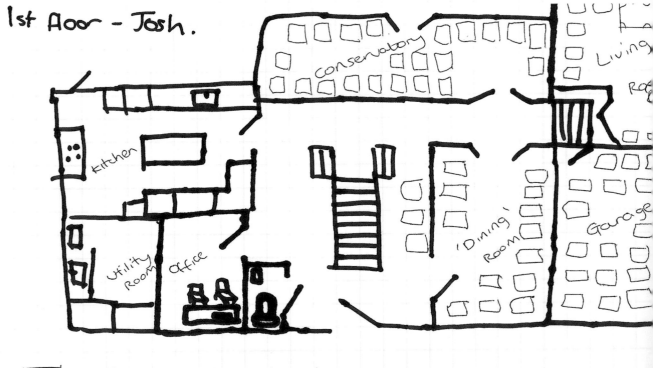

1st floor - Josh.

kitchen

conservatory

Living Room

Dining Room

Garage

Utility Room

Office

☐ - Sidemen clothing box

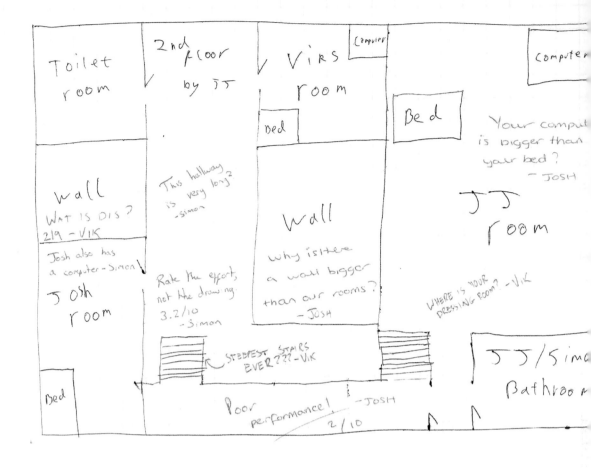

Toilet room

2nd floor by JJ

Virs room

Computer

Computer

Bed

Bed

Your computer is bigger than your bed? – JOSH

Wall

WHT IS DIS? 2/9 – VIK

Josh also has a computer – Simon

Josh room

This hallway is very long? – Simon

Rate the effort, not the drawing. 3.2/10 – Simon

Wall

Why is there a wall bigger than our rooms? – JOSH

JJ room

WHERE IS YOUR DRESSING ROOM? – VIK

STEEPEST STAIRS EVER??? – VIK

Poor performance! – JOSH 2/10

JJ/Sim Bathroo

Bed

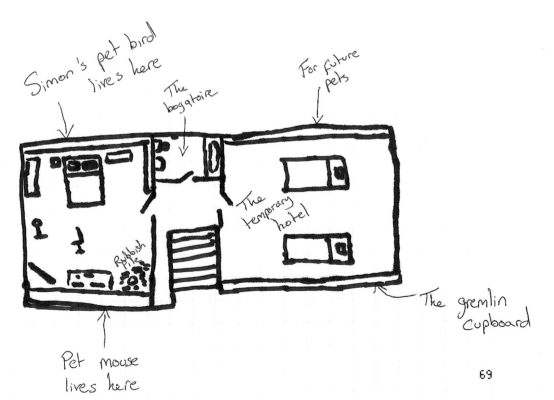

Simon's pet bird lives here

The bogatoire

For future pets

The temporary hotel

Rubbish pile

The gremlin cupboard

Pet mouse lives here

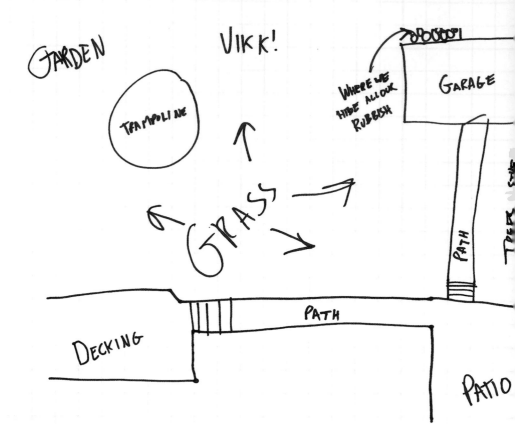

GARDEN VIKK!

TRAMPOLINE

GRASS

WHERE WE HIDE ALL OUR RUBBISH

GARAGE

PATH

TREES N STUFF

DECKING

PATH

PATIO

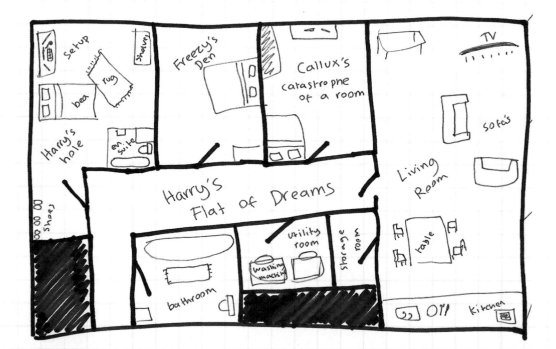

Setup

Shelving

rug

bed

Harry's hole

en suite

shoes

Freezy's Den

Callux's catastrophe of a room

TV

sofa's

Living Room

Harry's Flat of Dreams

bathroom

utility room

washing machine

storage room

table

Oil

kitchen

Benzinga's Flat!

Upper floorplan (labels):

- Bedroom
- Office — Door
- Store Room — Door
- En suite
- Door
- Corridor — Door
- Door
- Wall
- Bathroom
- Walls
- Main Room

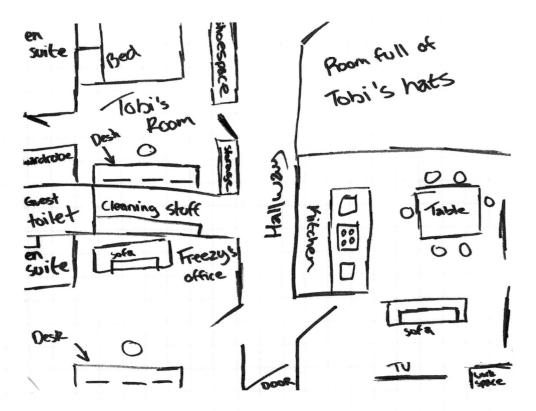

Lower floorplan (labels):

- en suite
- Bed
- shoespace
- Tobi's Room
- Desk
- storage
- wardrobe
- Guest toilet
- Cleaning stuff
- en suite
- sofa
- Freezy's office
- Desk
- Room full of Tobi's hats
- Hallway
- Kitchen
- Table
- sofa
- TV
- workspace
- DOOR

HOUSEMATE ASSESSMENT

Name: SIMON MINTER

Time lived in house:

2 ½ Years

Tidiest Housemate?

Vikk

Dirtiest Housemate?

JJ

Loudest Housemate?

Vikk

Most likely to lend you something?

Josh

Most likely to steal something?

JJ

Best in the kitchen?

Josh

Worst in the kitchen?

Vikk

Bathroom habits?

There was a rubber glove by JJs toilet?

Housemate you've come closest to throttling?

JJ

Nicest thing a housemate has done?

JJ cooks us steak / Josh picked me from London when I passed out.

Housemate rating out of 5:

JJ	Simon	Vik	Josh
1 ½	5	2	4

HOUSEMATE ASSESSMENT

Name: Olajide Olatunji

Time lived in house: 2 ½ years

--

Tidiest Housemate?

Vik

Dirtiest Housemate?

JJ

Loudest Housemate?

Vik

Most likely to lend you something?

Simon

Most likely to steal something?

JJ

Best in the kitchen?

~~Josh~~ Simon

Worst in the kitchen?

Vik

Bathroom habits?

Simon, hes used my bathroom for 2 ½ years

Housemate you've come closest to throttling?

Simon

Nicest thing a housemate has done?

Simon wrapped my room with christmas paper
(Everyone being my friend

Housemate rating out of 5:

JJ	Simon	Vik	Josh
S	4.2	4.1	4.2

HOUSEMATE ASSESSMENT

Name: Josh

Time lived in house:

2 ½ years

Tidiest Housemate?

Vik

Dirtiest Housemate?

JJ

Loudest Housemate?

Vik

Most likely to lend you something?

Josh

Most likely to steal something?

JJ

Best in the kitchen?

Josh

Worst in the kitchen?

Vik

Bathroom habits?

Vik leaves hair in the sink

Housemate you've come closest to throttling?

JJ

Nicest thing a housemate has done?

Simon going Costa/ Tesco /Nandos on a regular basis

Housemate rating out of 5:

JJ	Simon	Vik	Josh
2	4	3	5

74

HOUSEMATE ASSESSMENT

Name: VIK

Time lived in house:

2.5 YEARS

--

Tidiest Housemate?

JOSH

Dirtiest Housemate?

JJ

Loudest Housemate?

JJ

Most likely to lend you something?

JOSH

Most likely to steal something?

JJ — STOLE MY TRIPOD!

Best in the kitchen?

JJ

Worst in the kitchen?

VIK

Bathroom habits?

JJ

Housemate you've come closest to throttling?

JJ

Nicest thing a housemate has done?

JOSH MOVED HIS CAR AT 6AM FOR ME

Housemate rating out of 5:

JJ	Simon	Vik	Josh
4.5	4.8	7	4.8

GUEST ASSESSMENT

Name: TOBI

Average time for the door to be answered?

60 seconds

Who is most likely to answer the door?

Josh/Simon

Who is most likely to offer you food or a cup of tea?

Simon

Best tea maker?

N/A

General standard of food or ~~cup of tea?~~

Decent

Most sociable housemate?

Simon

Most introverted housemate?

Vikk

Overall cleanliness of house?

Not bad for 4 guys tbh

Room to avoid at all costs?

JJs -

Areas for improvement?

More frubes + ribena + coco pops + percy pigs

Guest ratings of housemates out of 5:

JJ	Simon	Vik	Josh
3	~~4~~	3	4

5 - he bought frubes

GUEST ASSESSMENT

Name:

Ethan Payne

Average time for the door to be answered?

Depends on Josh spying via kameral's.

Who is most likely to answer the door?

Josh / Vikk

Who is most likely to offer you food or a cup of tea?

No-one

Best tea maker?

Not a clue, I hate tea

General standard of food or cup of tea?

Nandols is pretty good

Most sociable housemate?

Josh

Most introverted housemate?

Simon

Overall cleanliness of house?

It works

Room to avoid at all costs?

JJ's

Areas for improvement?

Swimming pool

Guest ratings of housemates out of 5:

JJ 3 Simon 4 Vikk 3, Josh 5

GUEST ASSESSMENT

Name: Harry

Average time for the door to be answered?

Depends how lazy they're feeling, bring a tent
and sleeping bag in case

Who is most likely to answer the door?

Josh

Who is most likely to offer you food or a cup of tea?

None of them, maybe JJ/Josh

Best tea maker?

They're all hopeless

General standard of food or cup of tea?

Decent, often home cooked rather than takeaway

Most sociable housemate?

Simon

Most introverted housemate?

Vik/Josh

Overall cleanliness of house?

Respectable 7/10

Room to avoid at all costs?

JJ's

Areas for improvement?

The garden, its too empty

Guest ratings of housemates out of 5:

JJ	Simon	Vik	Josh
2	4	2	3

↑ I slept on his spare matress

↑ rarely see him

THE SIDEMEN HOUSE ASSESSMENT RESULTS

Much of our time together seems to be spent in the Sidemen house. Vikk, Josh, JJ and Simon obviously live there but Tobi, Harry and Ethan come over to drink tea and steal our food. Man...

Anyway, as we are the Sidemen we like to keep our standards high not just online but offline as well. So, we thought we'd rate each other as housemates as well as see what our guests thought. It's safe to say some of this went down like a lead balloon, here are the results of our voting...

Tidiest housemate?

Dirtiest housemate?

Loudest housemate?

Most likely to lend you something?

Most likely to steal something?

Best in Kitchen?

Worst in kitchen?

Worst bathroom habits?

Housemate you've come closest to throttling?

THE SIDEMEN HOUSE PET

Lately we've been considering getting a house pet. The only thing that has stopped us is that we can't feed ourselves sometimes, let alone worry about feeding a pet. Also, JJ is convinced it will eat us in our sleep.

Another thing that has stopped us is that we can't even decide what type of pet we want. Some of us want a dog, others a cat, while there have also been calls for a lizard and even a monkey. In the end, we decided to just cut to the chase and design the perfect 'Sidemen Pet' by each being allowed to pick a body part.

J. All right, I'll kick us off by giving him a T-Rex face and jaw so he can eat people who get on our nerves.

S. I've got a really cool idea. I'm going to give him the neck of an owl so the T-Rex head can spin 360 degrees.

T. I'm going to give him long pink flamingo legs just because it makes no sense.

E. Well I was well up for having a dog, and I love those dogs with big floppy ears, so let's give him some of those.

H. A panda body would be pretty cool. Who doesn't like pandas?

LL. My boy has to have a rhino horn right in the middle of his head. He'd look such a badass!

V. I've always really liked lions so let's give him a lion's tail.

When it came to naming our fabulous beast we knew something like 'Spot' just wouldn't suffice. We needed something catchy, funny, and unique. In the end I think we got it just right. So, we are happy to introduce to you...

... CLICKBAIT KEITH

RULES TO BEING A SIDEMAN

We always get asked, 'How can we become one of the Sidemen?' To be honest, there aren't any strict criteria. It's not like we held interviews to be in the Sidemen, and were looking for certain things, it kinda just happened. Trust us, if we'd held interviews none of us would have got in!

But because we love you guys, and like to be helpful, we got together round the kitchen table to discuss what we think makes us work as a group. It doesn't make pretty reading but if you still want to know how to make it as a Sideman then here are our rules:

Once you're in the Sidemen you can't make any new friends.

You must be able to laugh at yourself (and Ethan).

You must turn up to all Sidemen meetings, even if you have a driving lesson (Ethan) or if you only just went to bed (Vikk).

You must only wear Sidemen branded clothing.

You must have two phones, one for business, one for pleasure. You must be contactable on at least one of those phones at all times or we will assume you are dead and replace you.

Never send people explicit photos of yourself. The last thing we need is a Sideman's todger going viral (ahem Harry).

09

08

07

Eat Nando's. If you don't like peri peri chicken then we are going to find it hard to get along!

Be part of the Illuminati. Yes, all right, we finally admit it, we are Illuminati. Will you all stop asking us now?

Be nocturnal. We are like vampires. We work all night and sleep all day. Why do you think none of us have tans?

THE SIDEMEN IN THE KITCHEN

OK, we hold our hands up; we are not renowned for our culinary skills. In fact, there is a very simple reason why so many of you associate us with the likes of KFC and Nando's: we hardly ever cook.

However, that's not to say we can't. Each of us has our very own signature dish that we whip out for very special occasions, like when we get Ronaldo in a pack opening :) So, if you're ever struggling in the kitchen, are broke, too lazy to go shopping, or simply can't cook, why don't you give one our dishes a try.

SIDEMEN DISCLAIMER:

THE SIDEMEN ARE NOT HELD LIABLE FOR THE TASTE OF THEIR DISHES OR FOR FOOD POISONING. READER'S DISCRETION IS SERIOUSLY ADVISED!

ETHAN'S POOR MAN'S PASTA

E. Hear ye, Hear ye! Ladies and gents, back up because The Money King presents his royal deliciousness, also known in parts of the realm as Ethan's Poor Man's Pasta! Yes, that's right, this is a meal fit for a king but can be made on a pauper's budget so listen up and prepare to tuck in.

All right, before we get cracking you're gonna need to get yourself down to Tesco. Avoid the sweets aisle (unless you fancy a treat for dessert) and make sure you pick up:

INGREDIENTS

Gluten free pasta – It's absolutely essential you get the spiral pasta. I can't stress this enough. And check me out eating gluten free! Bet you never thought I was so healthy.

Butter – Any brand will do but if you're pushing the boat out get yourself some Lurpak.

Italian herbs and seasoning

METHOD

Now we're all set to hit up the kitchen and make a masterpiece. This is what you need to do:

1. Boil water in a saucepan (you know it's boiled when it starts bubbling but make sure it doesn't get too hot as it will go everywhere).

2. Pour your pasta into the saucepan.

3. Wait until your pasta is 'al dente'. Ha ha I bet you didn't think I knew foreign lingo like that but it basically means the pasta is good to go. Now you want to make sure it's in the water for around 7–8 minutes. This is absolutely key so you better time yourself.

4. When your pasta is al dente (see, you know what I mean now so you've just learnt something new from your boy Behzinga!) drain the water.

5. Put 3–4 knobs of butter on top (he he 'knob').

6. Add herbs.

7. Give it all a good old shake.

8. Serve into a bowl.

9. Add salt and pepper

10. All hail the king!

TOP TIP

Serve in a bowl rather than on a plate to blend all the flavour together

TOBI'S SIGNATURE DISH

T. OK, I know I've cheated here but to be honest I don't have much time to cook and we all know you'll enjoy my signature dish more than the others'!

INGREDIENTS
£12.45 cash

METHOD

1. Leave the house.

2. Get into your car.

3. Drive to Nando's.

4. Order:
Medium veggie pitta
Ask for avocado, pineapple and halloumi inside
A side of peri peri chips
Mix up Fanta and coke to drink

5. Demolish

TOP TIP

Don't get caught speeding on your way otherwise your meal might be more expensive than usual : /

SIMON'S MEAL
FOR SIMON AND JOSH

S. As Josh and me are usually up and about at the same time we sometimes take turns to cook for each other. Sweet, I know, but it's not like we have a candlelit dinner or anything like that. Honest! Anyway, if you fancy a Josh and Simon special here you go:

INGREDIENTS

Beef and red wine ravioli
Cheese and tomato tortellini
Tomato mascarpone sauce
Parmesan cheese
Cathedral City pre-grated cheddar cheese
Salt
Italian herbs

METHOD

1. Put the ravioli and tortellini into boiling water.

2. Add salt and Italian herbs.

3. Cook tomato mascarpone sauce.

4. Remove the water when the pasta is cooked and add the tomato mascarpone sauce.

5. Chuck a load of Parmesan cheese and pre-grated cheddar on top.

6. Keep adding cheese until there is a mini mountain.

7. Eat!

TOP TIP

Be sure to mix in the tomato and mascarpone sauce thouroughly before serving, leaving no tortellini uncovered

JOSH'S MEAL
FOR JOSH AND SIMON

J. Come to think of it, my meal for Simon is actually pretty similar to his meal for me. Maybe that's why we only like cooking for each other?

INGREDIENTS

500g minced beef
Dolmio Bolognese sauce
Farfalle pasta
Cheddar cheese
Parmesan cheese

METHOD

1. Cook the mince in a pan until it's brown.

2. Turn down the hob.

3. Add Dolmio sauce.

4. Boil water in a saucepan and add pasta.

5. Grate the cheese.

6. When the pasta is cooked remove the water from the saucepan with a colander.

7. Put the pasta and mince on to a plate.

8. Liberally sprinkle the Parmesan grated cheddar.

9. Serve to a very happy Simon.

TOP TIP

Buy your cheddar cheese pre-grated to save some effort

THE VIKK SPECIAL

V. OK, first we need to go to Tesco and buy:

INGREDIENTS
Hovis wholemeal bread
Wiltshire smoked ham
Red Leicester cheese

METHOD
When you're done go home, spread out two slices
of the bread and put slices of the cheese and ham
on to them.

1. Stick the sandwich into a toastie machine.

2. Leave it until the cheese starts bubbling.

3. Open the machine, take your toastie out,
allow to cool.

SIDE DISH
Prepare a side dish of:
Apple
Banana
Frube
Hula Hoops
Dairy Milk

Once your toastie has cooled put all the food on
a plate, take it to bed and eat!

TOP TIP

Eat the Dairy Milk and the
Hula Hoops at the same
time for a taste explosion

HARRY'S CHEESY BEANY PASTA

H. This dish might not win MasterChef but it's an absolute banger! It's cheap. It's tasty. And it's quick! What more do you want? But before you get started you're going to need the following

INGREDIENTS

Farfalle pasta
Heinz Baked Beans
Pre-grated cheese
Mixed herbs
Salt and pepper

METHOD

All right, that's the easy bit out of the way, now here's the method to my madness:

1. Put the pasta in a saucepan of water and boil until it's cooked. Remember the water should be bubbling otherwise it's not hot enough.

2. When the pasta is almost finished put the beans into another saucepan and start to cook. If you're really lazy you can even put them in the microwave.

3. Drain the pasta over the sink (not on the floor!).

4. Sprinkle the pasta with the herbs and salt and pepper and give it a good old mix with a wooden spoon.

5. Add the beans to the pasta and mix with the grated cheese.

6. Spoon your delicious feast into a bowl and serve with a cup of tea. AAAAHHH :)

TOP TIP

Blow on your food before eating to avoid burning your tongue

THE STEAKS ARE HIGH

JJ. Alright, I hope you like meat because JJ is gonna give you a big fat slab. You'd expect nothing else would you? ;)

Anyway, now I've got the meat joke out of the way (I've been waiting to use that all day) then let me tell you the story of how I make this badboy…

INGREDIENTS

Fillet steak
Salt and pepper
Butter
Oregano

METHOD

1. I make my way down to Tesco and I pick up a juicy fillet steak. I don't care about the weight. I don't discriminate!

2. I get back to the house and I leave the steak out for thirty minutes and watch it like a newborn baby as it slowly defrosts. When it's ready I use my magic hands to massage the steak. Be tender with it but still firm. Show that steak who's boss

3. When your steak is feeling nice and relaxed sprinkle some salt and pepper on it to make it taste good. I usually add herb and spice blend as well to add some more flavour.

4. Turn on the stove, stick a pan on the hob, wait for it to heat up, then throw the steak on it. If you don't want the steak to stick you might want to grease the pan up with some butter. And no, I don't treat my ladies like my steak. When I'm with my ladies I grease them up with…

5. … My bad. I was getting carried away. Where were we? Oh yeah, you've just put your steak in the pan. Wait three minutes then turn that badboy over. Think of it like it's on holiday and getting a good tan so you want to make sure you hit up the front and back. I'm black so I don't know what it's like to tan but I know it's better to be even all over.

6. I like my steak medium rare so I cut into it to make sure the middle is nice and pink. If it is then we are ready to roll. Take it out of the pan, sprinkle some oregano on top, and tear into it like a wild beast.

7. What? You want side dishes? Don't be such a wuss. Real men just eat meat!

TOP TIP

Run your hands under hot water to ensure your hands are warm when massaging the meat

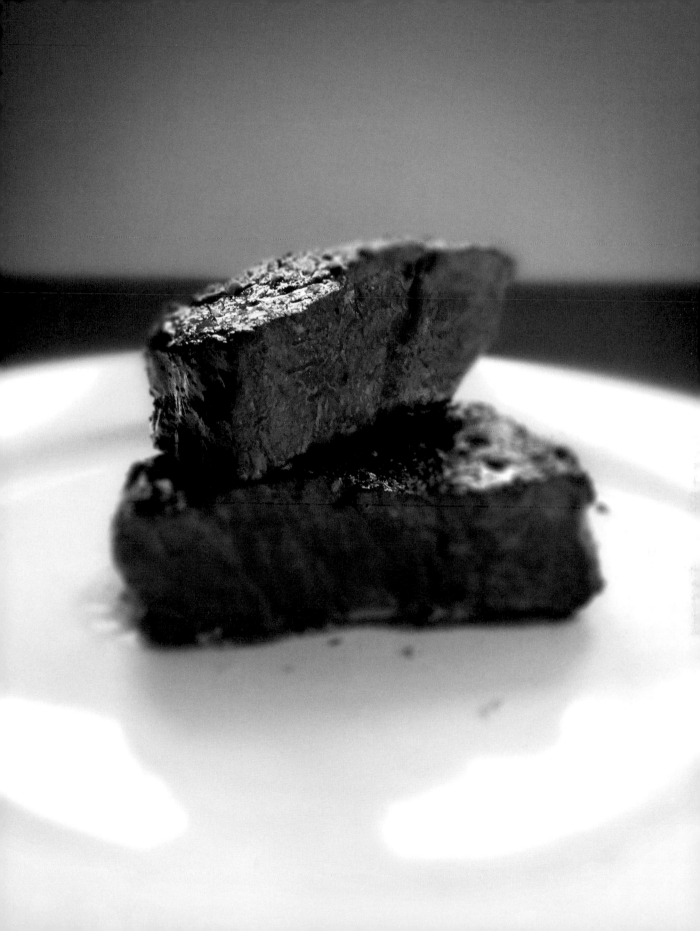

THE SIDEMEN'S SIDEMEN [AND GIRL]

We may be the Sidemen but we also have our very own 'Sidemen'. Don't get confused. Do you think we can run our lives all by ourselves? You really don't know us at all do you? To pay props to the legends who help our days go smoothly we thought we would share with you just who they are, and what they do!

NAME:
LEWIS REDMAN

AGE: 22
FROM: South East London
JOB TITLE: 'The Merch King'

TELL US ABOUT YOURSELF:

I went to school with Josh and Tobi so that's how I know all the guys. I remember when Josh first got an Xbox when he was about fourteen. He started filming himself playing COD just to show us some of the cool stuff he was doing, as well as to prove some of the kills if he was in any COD competitions. That's when it all began really as no one else was doing anything like that at the time.

Josh, Tobi and me used to play Xbox non-stop. We would play long into the night and would talk of nothing else. We were obsessed by games. People in our school probably thought we were geeks but we didn't care. When Josh first started doing YouTube I think people thought it was a weird thing and you could never do it as a job. I guess he proved them all wrong!

After school, as Josh and Tobi really started getting into YouTube, I went to Canterbury University to study film, radio and television. After I qualified I worked for an advertising agency in London for six months as an unpaid intern. At the same time Josh and the rest of the guys had started selling Sidemen merchandise so asked me to help out.

I initially only worked for two days a week but there were so many orders coming through it was clear they needed someone full time. When my internship came to an end they offered me a job but I decided to turn it down to work with my friends instead. It's been an unbelievable few years and I love watching the merch division continue to grow and grow.

NAME:
FREYA NIGHTINGALE

AGE: 22
FROM: London
JOB TITLE: 'The Merch Queen'

TELL US ABOUT YOURSELF:

I grew up in, London near Josh. I've actually known Josh for quite a while as we were introduced by friends but our relationship really started around five years ago when I liked one of his pictures on Facebook. Josh commented back and soon after we were dating. It's all very random but has worked out well.

 After finishing college and a stint of working in retail, I worked as an estate agent for a year and a half and absolutely hated it. Josh could see I was miserable so he asked me to help out with the Sidemen merchandise. I initially said no, because I wanted to do my own thing, but the guys were getting so many orders they needed an extra pair of hands so I said I would help out for a month. A month turned into over a year and I have to admit, I love it. It's very laidback, and the guys are always good fun, while me and Lewis always have a laugh working together.

A TYPICAL DAY FOR LEWIS AND FREYA:

We usually get to the main Sidemen house around 12.30 and sift through emails and print out any orders that have come through. It's mad how many orders the guys get from all over the world. There are thousands of them, so we have to work quick to sort out the UK orders from the international orders before taking the UK orders to the post office and then waiting for our mate, Steve, from DHL, to pick up the international orders from the house.

When all the orders are done we tend to look for new products, and suppliers, so the Sidemen range always stays fresh. Usually, when the guys wake up, we have a meeting to discuss the orders that have come through and then we go through some potential new projects. Once business is out of the way we tend to have a cheeky game of FIFA, and order a Nando's. It's the best job ever!

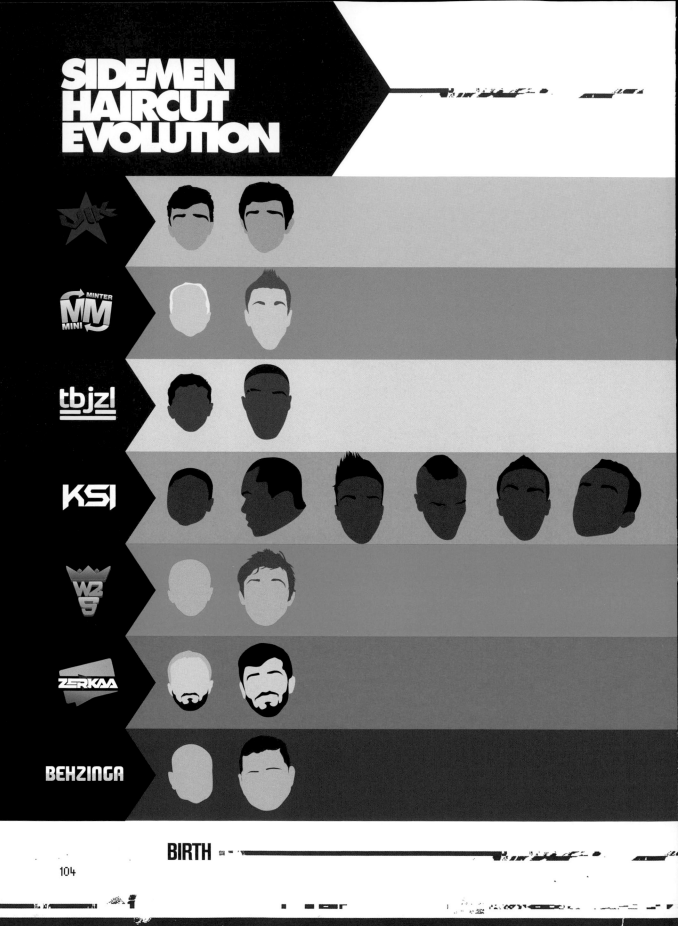

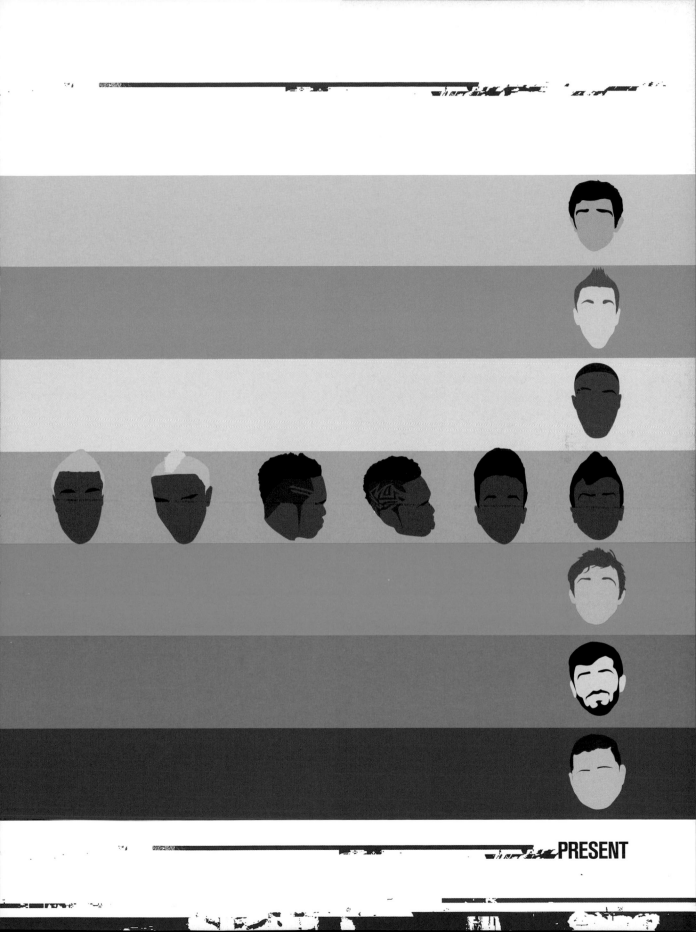

PRESENT

VIKK'S LANDMARK VIDEOS

This is possibly the best killcam ever, by Vikstar123. Just Watch...

MW2 INSANE Game Winning Killcam! Triple Quickscope + Collateral - Vikstar123

Vikkstar123 ☑

▶ Subscribe 3M

82,215 views

FIRST VIDEO
MW2 INSANE GAME WINNING KILLCAM!

It's crazy to think that I made this was way back in June 2010 when I was only thirteen. MW2 had surpassed all expectations, and was somehow even better than it's predecessor so it's fair to say I was obsessed with it. However, when I made this video I actually had no plan to get into YouTube and didn't even film the video myself – my friend did. In hindsight the clip wasn't that special but at the time I thought it was the greatest thing that had ever happened.

I was so excited I posted it on my channel and sent the clip to a lot of COD channels that did things like 'Kills of the Week', hoping I would be chosen. I actually made it into one of them, which was amazing and got me my first fourteen subscribers!

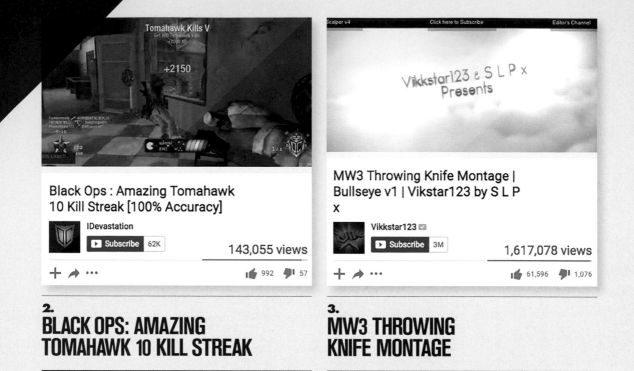

Tomahawk Kills V

Get 800 Tomahawk kills
+2000 XP

+2150

**Black Ops : Amazing Tomahawk
10 Kill Streak [100% Accuracy]**

IDevastation

▶ Subscribe 62K

143,055 views

👍 992 👎 57

Scalper v4 Click here to Subscribe Editor's Channel

Vikkstar123 & S L P x
Presents

**MW3 Throwing Knife Montage |
Bullseye v1 | Vikstar123 by S L P
x**

Vikkstar123 ☑

▶ Subscribe 3M

1,617,078 views

👍 61,596 👎 1,076

2.
BLACK OPS: AMAZING TOMAHAWK 10 KILL STREAK

The video is basically me doing a really cool kill
streak, with a tomahawk, on Black Ops, which was
then rivalling MW2 for my affections. After I had
edited the clip I uploaded it to my channel, while also
sending it to other COD channels so they could post
it and credit me.

A few days later my brother messaged me saying
'Vikk, your clip is on the official COD Facebook page!'
I was so excited because I knew that page had over
one million likes so would be incredible exposure.
I thought I would now get a lot of people checking out
my channel. But when I clicked on the link it took me
to another COD channel, which had used my clip but
hadn't credited me!

I was only a small channel at the time, so I
couldn't get YouTube to intervene, while it took
a few days for the channel who put the video up to
do anything. By that time it was too late as all the
interest had died down. I was so gutted. I thought
this was my big chance and that I had blown it.

3.
MW3 THROWING KNIFE MONTAGE

This is still one of my most popular COD videos,
and I posted it way back in 2012. MW3 was earning
praise for it's stunning visuals, new challenges,
and it's addictive multiplayer.

Back in 2012 people would spend hours playing
COD to collect their best sniper kills and then edit
them into a montage video. Josh was one of the best
at doing this and I really used to enjoy his videos.
However, to stand out from the crowd I knew I had
to do something different.

I had always liked throwing knives in the game
so I thought I would do a montage of throwing knife
kills. In total I must have spent sixty hours playing
the game to film enough cool kills for a video but
when it was done it looked amazing. I was only
sixteen at the time, so was still studying in school,
but every day I would come back home to see it had
thousands more views. Back then YouTube was only
a small community so for any video to get hundreds
of thousands of views, as this one did, was a big deal.
I was so proud but I don't think my parents or friends
knew what to make of it.

XBOX 360 GIVEAWAY!!!

Vikkstar123 ☑

▶ Subscribe 3M

95,938 views

👍 7,206 👎 667

House Tour / Setup Video - Vikkstar 500k Special ft KSI, Zerkaa & Miniminter

Vikkstar123 ☑

▶ Subscribe 3M

3,335,988 views

👍 72,604 👎 995

4.
XBOX 360 GIVEAWAY!!!

This is one of my favourite videos and one that set me apart from just being a gamer! There was a weird phase on YouTube during the console war period, between PS3 and Xbox, where it was cool to film yourself destroying a console. People were coming up with more and more random ways to destroy them and I thought some of the videos were so funny.

When my friend told me that his Xbox had stopped working I knew I had an opportunity to make my own video so I bought it off him for £20. At the time I was doing a lot of throwing axe videos on COD so I thought that would be a cool way to destroy it. I remember I set the Xbox up in my back garden and then destroyed it doing loads of crazy stunts with the axe, like jumping off the trampoline.

The response to the video was mixed. Some loved it while others understandably hated to see a console being destroyed, not realising it was actually broken. However, I remember I sent the clip to JJ, who I didn't know too well at the time, and he thought it was hilarious.

5.
SIDEMEN HOUSE TOUR

We had been in the Sidemen house for around six weeks and during that time I had hit 500,000 subscribers on my channel, so I thought this would be a cool way to celebrate.

It was actually a spur of the moment video, and just consisted of me doing a tour of the house with the guys. I didn't expect it to get that much interest but the fact it did proved to me that people were starting to get interested in who we were as people, rather than just as gamers. It's still one of my most popular videos and gets a lot of comments. It's crazy to think that just four years after my first video I was in a position to get a house with my friends, which is all thanks to YouTube and you guys :)

JOSH'S LANDMARK VIDEOS

Spec Ops Series - The Pit
(Veteran) w/aMOODIEswede

Zerkaa ☑

▶ Subscribe 2M

40,727 views

👍 308 👎 10

FIRST VIDEO
SPEC OPS SERIES –
THE PIT (VETERAN)

Although this was filmed in 2009 I had already been making videos for around a year on some of my older channels. But because I was now filming in HD I decided to set up a new channel, ZerkaaHD. These days everyone shoots in HD but back then it was still quite rare.

The video itself was pretty basic. It's just me and my friend aMOODIEswede trying to get through a mission as quickly as possible, but because I loved playing the game so much I was pretty rapid and thought it might show me in a good light. aMOODIEswede also had a bigger following than me on YouTube at the time, which really helped as a lot of his fans checked out my channel.

I only really showed the video to Tobi, and a few of my friends in school, I wasn't embarrassed or anything but it didn't feel like a big deal and I knew only certain people would get it.

Crossbar Challenge

Zerkaa ☑

▶ Subscribe 2M

1,340,925 views

👍 13,303 👎 1,593

San Andreas | E012 - About This Channel

ZerkaaPlays ☑

▶ Subscribe 1M

12,542 views

👍 382 👎 4

2.
CROSSBAR CHALLENGE

This video was actually filmed during a media class in school. It is literally just me and my friends copying Soccer AM's 'Crossbar Challenge.' No one was really doing it on YouTube at the time so I thought it would be fun.

By this point I still hadn't shown my face on YouTube so I decided to once again cover it by placing a ball over it. I was still in school, and I suppose I wanted to separate being Josh from being Zerkaa. I just wanted to be low-key and wasn't comfortable with the fame thing. In a weird way covering my face made my videos even more mysterious as people really wanted to know who I was.

3.
SAN ANDREAS – ABOUT THIS CHANNEL

This was the video that launched my second channel ZerkaaPlays. On ZerkaaHD I had been predominantly playing FIFA but I was getting a bit bored of doing that. However, whenever I played any other game on my channel people would seem to get angry so I thought this second channel would give me a lot more freedom to play whatever I wanted, and what better way to launch it than playing San Andreas! Sure, it might have been old school even back then but the gameplay is still second to none.

I was in my first year of university at the time and I have to admit I was finding it hard to study, socialise and make videos. For a few months YouTube actually took a back seat, as it was hard to keep up with everything, but this channel was, and is, so much fun. It really got me excited to play as many games as possible and mix it up.

FIFA 14 | ZERKAA AN
UNDERDOG? | KICKTV
INVITATIONAL

KICKTV Gaming

Subscribe 228K

69,262 views

1,985 19

1,000,000 SUBSCRIBERS

Zerkaa

Subscribe 2M

495,475 views

28,165 136

4.
FIFA 14:
ZERKAA AN UNDERDOG?

By now I had been making YouTube videos for
around five years and I still hadn't shown my face.
But when I was invited by KickTV to take part in a
FIFA tournament in New York I knew it would be hard
to avoid. I actually talked to JJ, Simon and Tobi about
it and we all agreed it would be impossible to cover
up as they would want to interview me. What made
my decision for me was that FaceCam was becoming
a big thing on YouTube so I knew I was going to have
to do it sooner rather than later.

 In the end it wasn't too bad, and as I was about
to finish university I suppose it marked the time when
I knew I was going to do YouTube full time and really
embraced being Zerkaa.

5.
1,000,000
SUBSCRIBERS

Some of the guys have done crazy videos when they
hit one million subscribers but mine was low-key,
which I suppose suits me. I just thanked all you fans
for helping me reach such an amazing milestone.
The funny thing is, at the start of January I only had
870,000 subscribers but after the Sidemen did a FIFA
tournament it really grew all our channels so almost
out of nowhere I added another 130,000 subscribers.
It just goes to show that collaborations really do
work and it's even better when they are with your
best mates.

HARRY'S LANDMARK VIDEOS

Fifa 12 | Trade To Transfer Ep 1 | Podolski

W2S ☑

▶ Subscribe 7M

281,714 views

👍 5,002 👎 393

FIRST VIDEO
FIFA 12:
TRADE TO TRANSER EP1

This wasn't actually my first YouTube video ever but it was my first on my WroetoShaw channel. I never used my actual name in my channels because I didn't want anyone to know what I was doing. It was all top-secret stuff so I needed to come up with an obscure channel name. In the end it was very random but Nicky Wroe and Tom Bradshaw were two of my favourite players on FIFA, so my brain thought 'WroetoShaw' was a good name for a channel. If I had known I would one day have millions of subscribers I might have spent a little longer thinking about it.

FIFA 12 is one of my all-time favourite games. I would play for hours in my room but the video was basically me just transferring players for coins. No one was doing it on YouTube at the time so I thought it could catch on. It ended up getting 100 views, which was mostly because I was commenting on other people's videos and trying to get them to watch my channel. That sort of thing used to work back then but I don't think it does any more.

Team Of The Season PINK SLIPS - BLUE FELLAINI - Fifa 13 Ultimate Team

W2S ☑

▶ Subscribe 7M

324,202 views

👍 4,807 👎 102

➕ ↗ •••

My New Car...

W2S ☑

▶ Subscribe 7M

9,897,396 views

👍 203,551 👎 21,886

➕ ↗ •••

2.
TEAM OF THE SEASON PINK SLIPS – BLUE FELLAINI

If I could pick any video that truly launched my channel it would be this one. I thank God every single day that he made me so bad at FIFA. It is actually a miracle I am as bad as I am because I love the game so much and probably play it more than anyone I know.

I actually stole the idea for the video from JJ. He would play random people on Twitter for players and whoever lost would have to transfer a designated player to the winner. The thing that made my videos stand out though was I was so bad at FIFA. People were literally lining up to play me and those watching thought it was hilarious. I took a real beating but at least people liked it.

It's funny looking back because when I was filming myself playing FIFA I used to go so mad that I could only film my videos when my family were out of the house. It was a taboo thing. We never actually talked about it but they would just mysteriously leave. I remember I was playing JJ at 10 p.m. one time and my whole family literally left the house and went for a walk in the dark. I thought they had left me : (

3.
MY NEW CAR…

This was just a joke but the views went through the roof. I was driving a Range Rover at the time and had taken it to get wrapped. The guy who did it for me owned the gold Ferrari in the picture so I filmed myself next to it and jokingly said it was mine. At the time YouTubers weren't really showing their cars off, and because it was such a crazy car, the video went viral before I could say anything. In the end people thought it was actually my car for months. I think they were quite gutted when they bumped into me and saw me in my Range Rover.

GREATEST FIFA PACK OPENING OF ALL TIME

W2S ☑
▶ Subscribe 7M

31,591,112 views

👍 434,881 👎 44,306

I Found My Old Videos...

W2S ☑
▶ Subscribe 7M

6,344,102 views

👍 191,751 👎 7,901

4.
GREATEST FIFA PACK OPENING OF ALL TIME

Oh boy, this is definitely my most embarassing video but it's also my most popular so it's kinda like what was invented first, the chicken or the egg. Actually scrap that, it's nothing like that at all.

Anyway, the video is literally just me opening a pack on FIFA, which turns out to be the best pack ever! I got everyone you could want, Ronaldo, Messi, Ibrahimovich, Robben, and every time I got one of them I lost my mind. I went so over the top. I was screeching and shouting so loud I almost lost my voice.

It's amazing to think that this video has had over 27 million views! I think it's the most viewed FIFA video of all time on YouTube, which is mind-blowing. I might not be great at the game but I definitely had the best pack opening ever! And this is why the game is so great. You can suck really hard but get moments of joy like this.

5.
I FOUND MY OLD VIDEOS...

I had been searching for this video for so long and never thought I'd find it. Basically, when I was younger I used to film myself singing song parodies, like Justin Bieber. I know, I was a weird kid. When I found the video I almost didn't upload it, because I was so embarrassed, but I thought it would really show my fans who I was.

It's funny looking back, as I was actually a really shy kid, and would never perform in public, but I just loved being in front of a camera. It's cool to think that I've gone from doing that to doing YouTube as my job! It's my dream to be doing this and I know just how fortunate I am. It's still just me in front of a camera in a room but at least people are watching these days :)

Modern Warfare 2 Care Package
Kill

KSI ☑

▶ Subscribe 14M

613,170 views

👍 7,920 👎 267

FIRST VIDEO
MODERN WARFARE 2 CARE PACKAGE KILL

Bro, this is where it all began! I was just chilling, playing Modern Warfare 2 – which was a total bad ass game. I think I got four kills in a row, which meant I got a care package. I remember I threw the care package at the wall, and it bounced off and fell through the roof. I didn't think much of it but then twenty seconds later, when one of the enemy was coming up to get me, the care package suddenly fell on their head and killed them. Man, it was so funny! I was so happy I had managed to record it, I knew it would look so sick on YouTube, because back in the day posting clips of MW2 seemed to be the whole reason for YouTube's existence.

People seemed to like it. I got my first thirteen subs anyway, which I thought was major at the time. The only thing is, I couldn't tell anyone because I thought they would laugh at me. The only person in the world who knew I had uploaded it to YouTube was my bro, but he didn't care. To be honest he was probably just avoiding me like hell cos I used to give him sick RKOs and make him beg for mercy.

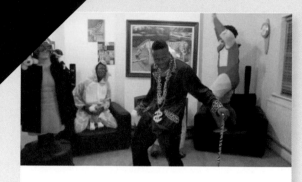

Harlem Shake (Black Edition)

KSI ☑

▶ Subscribe 14M

18,611,101 views

👍 219,959 👎 9,973

➕ ➤ •••

Droideka - GET HYPER (Official Video)

KSI ☑

▶ Subscribe 14M

23,690,972 views

👍 320,887 👎 6,343

➕ ➤ •••

2.
HARLEM SHAKE (BLACK EDITION)

This was my first video that properly blew up. For real!

My parents had never been in a video with me before. In the end I persuaded them that it was a good idea and I can't believe they fell for it!

We set everything up in my living room and it basically just started with me touching myself while my parents were chilling in the background. When the chorus dropped we just went nuts. My bro was dressed as a horse, my dad was Iron Man, while my Mum was in crazy African clothes doing a mental dance and then suddenly Simon hopped across the screen. As for me, I wore a pimp suit and poured milk all over myself. I thought I was such a badass but my mum made me clean it up as soon as we were done as she thought it would stain the floor.

I couldn't believe the response it got. Within a few days it had millions of views. I had kept the whole YouTube thing from most of my friends up to then but suddenly I had loads of Facebook messages asking if I was in the video!

3.
DROIDEKA GET HYPER

OK, the story behind this is actually pretty jokes. So, I found the song 'Get Hyper' on YouTube and used it to play over my 'Top 5 Goals of the Week' videos. The song wasn't a big deal at the time but people just flat out loved it on my video and it really started to blow up. It got to the point where Droideka was signed because of it.

What really blew my mind was as soon as Droideka was signed he needed to make a video for the song so I was asked to be in it! I thought that was so cool. The video went nuts as well. It got over 22 million views. After that things started to get serious but to be honest I was having too much fun to notice. I just loved making videos and it never felt like a job. I knew damn well I could have been working in McDonald's so I was straight up loving life.

KSI Reacting to Teens Reacting To KSIOlajidebt

KSI ☑

▶ Subscribe 14M

20,090,676 views

👍 411,565 👎 4,155

KSI - Lamborghini (Explicit) ft. P Money

KSI ☑

▶ Subscribe 14M

47,336,983 views

👍 1,019,756 👎 75,698

4.
KSI REACTING TO TEENS REACTING TO KSIOLAJIDEBT

I'd say that this is the video that really helped me get an American audience. The Fine Bros are massive in the USA and they hit me up on Twitter to ask if they could use some of my videos for their USA audience to react to. I was so psyched, because I really liked their stuff, and knew it would be great coverage for me. It was a really funny, although some dude kept saying 'Touchdown!' every time I scored a goal on FIFA. When I made my own video, reacting to how the Americans had reacted to me, that dude made me smash so many computers. It was all good though, as they were my dad's old ones and didn't work any more.

5.
LAMBORGHINI

Ever since I was a kid I wanted a Lamborghini so bad. I didn't know how I was gonna get one but I knew I just had to drive a Lambo. Thanks to YouTube I was in a position to buy one, which was the happiest day of my life. I swear I was smiling for Africa when I drove it home.

So after buying a Lambo I knew there was something else I now had to do; write a song about it! At the time I was working with Sway and when I told him my idea I think he thought I had lost my mind. But when I played him the beat, my verse and the chorus, he was down with it. We soon got P Money in to drop a verse and he absolutely killed it. As soon as I heard it I knew I had to do another verse after his or people were gonna say he destroyed me. He just went in so hard I had to try and keep up.

The reaction to the video was just insane! It's had over 40 million views and the song even got in the top 40. It was way beyond anything I had ever expected and made me so happy. I gotta thank the fans for that. You guys made my dreams come true :)

SIMON'S LANDMARK VIDEOS

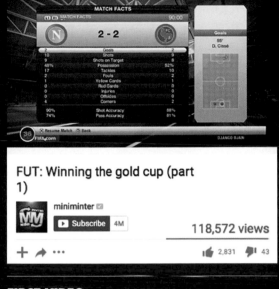

FUT: Winning the gold cup (part 1)

miniminter

▶ Subscribe 4M

118,572 views

👍 2,831 👎 43

FIRST VIDEO
FUT: WINNING THE GOLD CUP

When I made this I was in my first few weeks of university and found that while I had been average at FIFA in school I was amazing against people in my halls. That gave me a lot of confidence so I decided to film myself winning the Gold Cup. It was nothing special, but because I had seen how JJ had edited his videos I thought I might be able to do something fun with it.

I honestly took two months editing this video. I was so nervous, and kept finding reasons to change it. Finally, I left university in December 2012 and I knew it was now or never. I didn't tell anyone I uploaded the video, not even JJ, and that's probably why only two people saw it. Despite that I enjoyed the experience so much, and had nothing better to do, so I decided to keep making videos.

Nugget Challenge Ft.
ComedyShortsGamer

miniminter ☑

▶ Subscribe 4M

2,859,414 views

👍 39,378 👎 449

Football with TBJZL

miniminter ☑

▶ Subscribe 4M

6,245,749 views

👍 73,565 👎 681

2.
NUGGET CHALLENGE FEATURING COMEDYSHORTSGAMER

After I dropped out of university I spent all of my time at JJ's house. His younger brother, Deji, who was a prominent YouTuber too, was also hanging around so whenever JJ wasn't about we used to play games and stuff. After a while he suggested we do a video together, which I was well up for as we had become good friends.

At the time Deji would spend around £30 a day on Chinese food. He would eat it for every meal of the day! We ended up having an argument over who could eat more before I suggested we settle it like men, and have an eating challenge. The rules of the challenge involved seeing who could eat the most chicken nuggets in twenty minutes. I remember we went to McDonald's, and bought a ridiculous amount of nuggets, before going back to Deji's for the challenge. It was pretty pathetic in the end. After eleven nuggets Deji wanted to stop the challenge for a break! I ended up eating forty nuggets so completely destroyed him, but there were so many still left over. I never want to see a chicken nugget ever again!

3.
FOOTBALL WITH TBJZL

Round the corner from Tobi's place there is a little five-a-side pitch so we took a ball over and just filmed ourselves messing around. It was all really simple stuff so when we uploaded it we didn't expect it to get any sort of reaction. To our surprise it blew up! Me and Tobi had no idea why but I suppose it was because it was my first video with one of the Sidemen and other YouTubers weren't really doing football videos at the time. The video still keeps on racking up views. Me and Tobi still can't believe it but we're glad people still seem to enjoy it.

Q&A SIDEMEN EDITION | WITH TBJZL

miniminter

▶ Subscribe 4M

4,557,081 views

👍 58,794 👎 563

BEST VIDEO EVER - 1 MILLION SUBSCRIBER SPECIAL!

miniminter

▶ Subscribe 4M

2,375,171 views

👍 103,759 👎 718

4.
Q&A SIDEMEN EDITION WITH TBJZL

By this stage I had just moved into the Sidemen house, and was cutting back my work with Beast Clothing because things were really beginning to take off. JJ had been having huge success doing Q&As but he stopped doing them for a bit, because he was always getting asked the same questions. I decided to try and do them but fans started commenting that I should do a series of Q&As with the Sidemen, which I thought was a cool idea so I decided to question Tobi first.

I sent out a tweet saying 'Hit me up if you have any questions for Tobi' and my feed went crazy. The video with Tobi, and the Q&As with the rest of the guys, were really popular and just showed me that the fans were really interested in who we actually were.

5.
BEST VIDEO EVER – 1 MILLION SUBSCRIBER SPECIAL!

I had seen that I was inching closer to one million subscribers so I asked the fans what I should do to celebrate. They hit me up with all sorts of outrageous suggestions, like skydiving, so I decided to try as many as I could.

I started the video eating a ghost chilli, which made it hard to breathe, before Vikk poured water over me, Josh slapped me with whipped cream and JJ shot me with a BB gun. At the end of the video I told the fans that unfortunately I wouldn't be skydiving before the video suddenly cut to black and then to me jumping out of a plane!

Less than two years after dropping out of university I had one million subscribers. I still can't believe it. I couldn't have done it without the help of all of the guys or you!

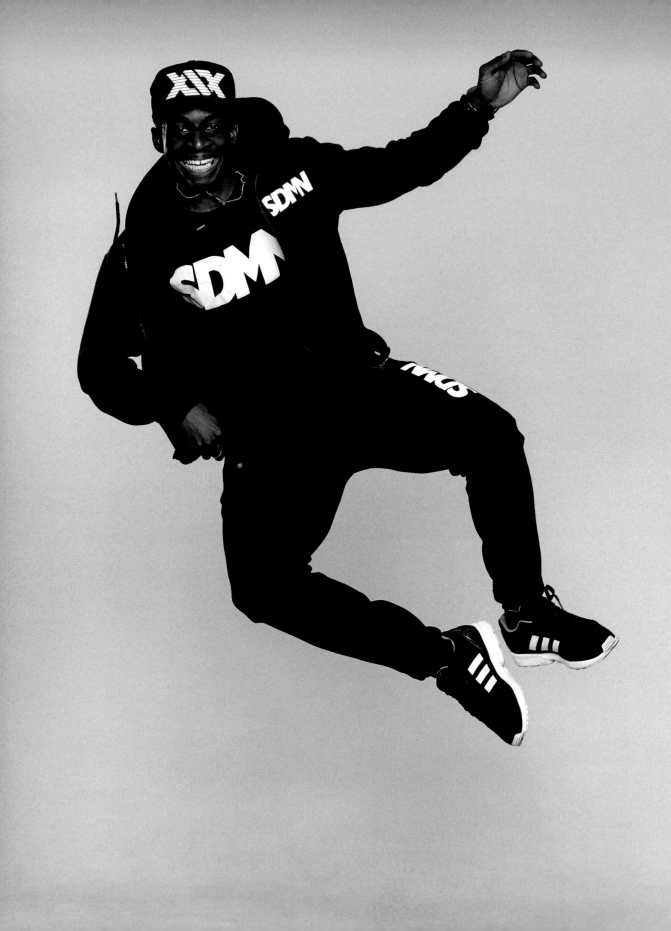

Sniper Lobby with Followers!

TBJZL ☑
▶ Subscribe 2M

18,949 views

+ ➔ •••

👍 378 👎 20

FIRST VIDEO
SNIPER LOBBY
WITH FOLLOWERS

Before I really got into YouTube I had a big Twitter
following, purely because I used to interact a lot
on there.

I remember I asked my followers if anyone
wanted to jump into a livestream lobby on Call
of Duty and around eighteen people joined in.
This game was my life back in the day and getting
loads of people involved on the multi-player
guaranteed hours of fun. Anyway, while we were
just mucking around, what we had done when
I edited it into a video looked cool so I thought
I'd upload it to my new channel TBJZL. I had had
a few different channels over the years but this
was the first video that launched the channel
I'm most known for.

I was in my first year of uni in Coventry at
the time, and while there wasn't a huge reaction
to the video the people who saw it thought it was
good. It made me want to keep it up and improve.

Epic Ball Control Vine!

TBJZL ✓

▶ Subscribe 2M

850,852 views

👍 15,258 👎 73

WEEK IN THE LIFE OF TBJZL!

TBJZL ✓

▶ Subscribe 2M

1,175,693 views

👍 30,390 👎 239

2.
EPIC BALL
CONTROL VINE

This was my first video that ever went viral. It only lasts six seconds but it's still really cool.

It was the first time all of the Sidemen played football together and was the day JJ filmed the crossbar challenge video, which really blew up. When we were messing around JJ kicked me the ball and I did this amazing bit of ball control. I don't think I could ever pull it off again to be honest but it was perfect. I was so stunned when I did it I turned to the video camera and said 'Oi, is that recording?' I was so happy we got it!

After I uploaded it it got picked up by external websites and went viral. It was mad. It's always the random, unplanned stuff that seems to do the best.

I was in my third year of uni at the time but the reaction to the video made me start to think that maybe I could do YouTube full time. I definitely started to devote more time to making videos. After this things really started to pick up momentum. It's amazing what can be achieved in just six seconds. I know what you're thinking... stop that!

3.
A WEEK IN THE
LIFE OF TBJZL

I knew I had a particularly cool week coming up, and had been thinking of doing a behind the scenes video for a while, so I thought this would be a good opportunity.

The week was crazy as I went to Jme's music video shoot for 'Test Me', did a Rule Em Sports video with JJ and then went to Insomnia 55 with the guys. When we were there we met fans for three days straight. I couldn't believe how many people had turned up just to see us. It was really humbling.

When I edited the video it came to over thirty minutes, which is usually way too long for a YouTube video but I thought it was an accurate account of my life so maybe the fans would like it. Thankfully they did!

TBJZL vs WORLD'S HOTTEST
CHILLI!!! *PUKE WARNING*

tbjzl TBJZL ☑
▶ Subscribe 2M

2,175,246 views

👍 67,044 👎 400

Meeting Kevin Hart and Ice Cube!
"RIDE ALONG 2 MANCHESTER"
VLOG

tbjzl TBJZL ☑
▶ Subscribe 2M

559,014 views

👍 24,405 👎 118

4.

TBJZL VS WORLD'S HOTTEST CHILLI!!!

This is all Simon's fault! He did a video where he ate the world's hottest chilli, a Carolina Reaper, and then challenged us all to do it. I was there when Ethan did his and he was not in a good way at all. I really feared for his life.

Despite that I couldn't back down from Simon's challenge, even though my mum begged me not to do it. I thought I would be OK, as I had grown up eating spicy food, but this was another level and the first time I had really put myself in any danger for a video.

The heat wasn't that bad but once it hit my stomach I couldn't breathe! I had to throw it up, which made me feel better but my throat was still on fire. A lot of people thought I took it like a champ, especially compared to Ethan, but I'll never do it again.

5.

INTERVIEWING KEVIN HART AND ICE CUBE

Wow! This was so mental! Our manager hit us up and said that Universal had been in touch asking if any of us wanted to interview Kevin Hart and Ice Cube in Manchester to help promote their new film *Ride Along 2*. Me and Ethan loved the first *Ride Along*, while Kevin Hart was my favourite comedian, and Ice Cube is one of the true godfathers of rap/hip hop, so I just couldn't turn it down.

The whole day was great, although we didn't get as much time with them as we had hoped because they were so busy. Still, what an experience. I look back at stuff like that and I can't believe some of the unbelievable opportunities I've had and they couldn't have happened without the support of you guys so, thank you!!

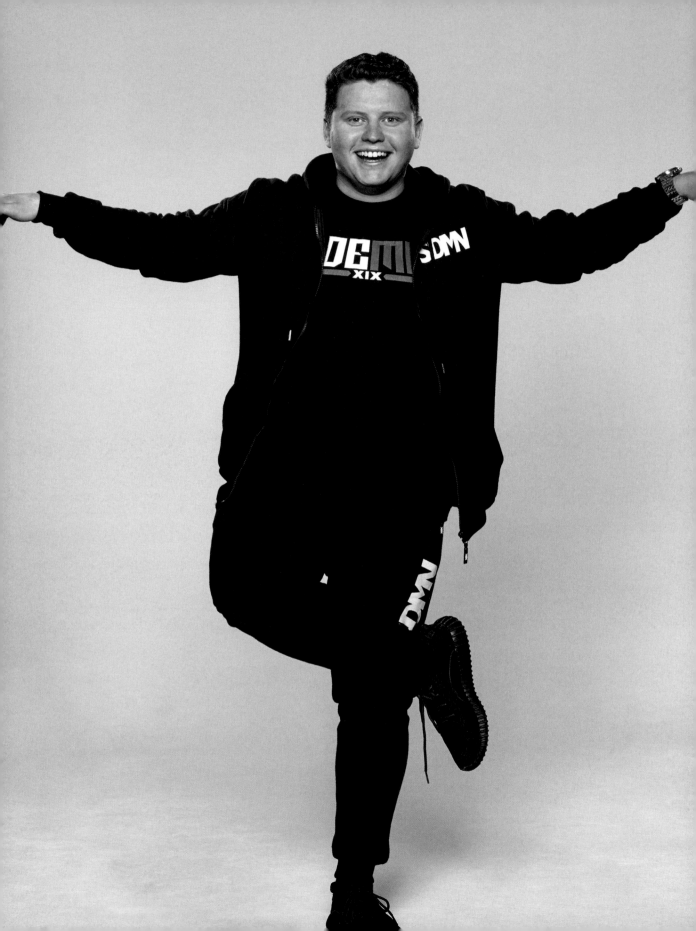

BEHZINGA

Forza 4 Drift Video - Skyline R34

Behzinga ☑

▶ Subscribe 1M

15,921 views

👍 374 👎 14

0:41 / 3:03

FIRST VIDEO
FORZA 4 DRIFT VIDEO

I'd actually been making videos for a few years by this point but with juggling school and college I hadn't uploaded consistently. This time around I vowed it was gonna be different so set up Behzinga and swore I would take it seriously. I've always loved racing games where you can drift, so I thought this would be the best way to kick things off. It wasn't as if it was a revolutionary video or anything like that but it was solid enough and gave me a platform to build from.

At the time I was studying game design in college, so quite a few guys in my class had YouTube gaming channels. It wasn't like we all went around giving it the big one or anything but we also felt like we didn't need to hide what we were doing. While I planned to upload consistently I still never thought about doing YouTube as a job. It was just a bit of fun really. However, when it came time to think about going to uni I had started to make a bit of money so thought doing YouTube full time might be possible. I actually went to an interview at Southend Uni but was so bored it almost made my mind up for me to hit YouTube head on.

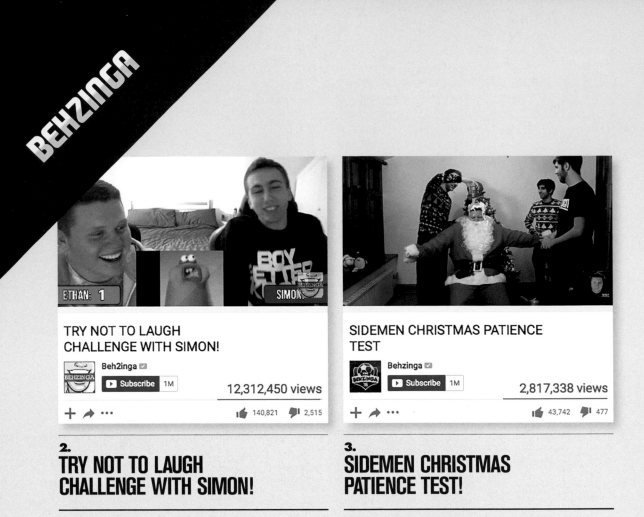

TRY NOT TO LAUGH
CHALLENGE WITH SIMON!

Beh2inga ☑

▶ Subscribe 1M

ETHAN: 1

SIMON!

12,312,450 views

👍 140,821 👎 2,515

SIDEMEN CHRISTMAS PATIENCE
TEST

Behzinga ☑

▶ Subscribe 1M

2,817,338 views

👍 43,742 👎 477

2.
TRY NOT TO LAUGH
CHALLENGE WITH SIMON!

On my main channel, Behzinga, I had mainly been
posting games like FIFA so I had set up a second
channel, Beh2inga, to do some more real life stuff.

God only knows why this is my most popular
video ever but I think it has something to do with
people enjoying my laugh and me literally laughing
at everything. To be fair we also got really lucky as
for some reason YouTube stuck this video at the top
of its search engine for 'Try not to Laugh' challenges,
which are really popular.

I'm made up it did so well as by now I was doing
YouTube full time, which was a little scary. It's not
like many people have gone before us to do this so
we are kinda winging it with no safety net. You can't
rely on anyone else, and you've got to be so self-
disciplined. I think people I went to school with are
surprised I can be disciplined because I was
a nightmare in class, and could never concentrate.
It took me finding something I love doing to really
find my focus and it just goes to show that school
isn't always the be all and end all.

3.
SIDEMEN CHRISTMAS
PATIENCE TEST!

I think I'm right in saying that this is the first time
me and the guys had a strategy to film videos for
each of our individual channels together, which would
then encourage our fans to watch them all. Again,
it was another challenge video, which always seem
to be really popular. All I had to do was sit there
like Santa Claus and let the guys pour all sorts of
Christmas related stuff over me until I could take
it no more. There was ketchup, whipped cream,
gravy granules, yoghurt, Xmas pudding, mince pies,
ham, eggs, and cake before a bottle of blue WKD
finished me off. Thankfully we had a plastic mat
down so it was easy to clear up afterwards, although
it took a good few days to wash the smell of Xmas
pudding out of my hair.

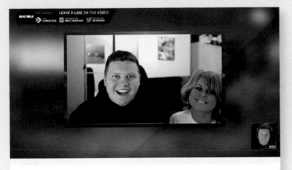

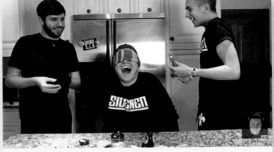

MY MUM OPENS SPECIAL PACKS!

Behzinga ☑

▶ Subscribe 1M

2,215,660 views

👍 55,851 👎 883

SIDEMEN WHAT'S IN MY MOUTH CHALLENGE?!

Behzinga ☑

▶ Subscribe 1M

2,519,128 views

👍 52,322 👎 443

4.

MY MUM OPENS SPECIAL PACKS!

This was such a cool video. My mum pretty much brought me up, and we are like best mates, so to do a video together was unreal. She's actually just an older, sillier version of me, which I know is hard to believe. Ever since I started YouTube she encouraged me all the way while still kicking my ass if I said I wasn't going to college.

At the time a few YouTubers were roping their reluctant parents into videos and they seemed to do really well. My mum was different though. She was bang up for doing a video and laughed the whole way through it, even though we were just doing a pack opening. She still bangs on about doing another video all the time. She should just set up her own channel. She'd be a star. Thankfully everyone who saw the video thought she was hilarious as well. Not that I ever doubted that would be the case.

5.

SIDEMEN WHAT'S IN MY MOUTH CHALLENGE?!

I can never work out whether my challenge videos are popular because people like seeing me in pain or because of my laugh? Anyway, if you keep watching them I'll keep doing them. This one was filmed in the Sidemen kitchen and just consisted of Simon and Josh putting household items in my gob, like a banana with a condom. Don't ask how I know what a condom tastes like but I got it straight away, which is actually pretty weird….

Anyway, some of the stuff was so gross I snorted it out of my nostril and in the end I got proper tense. Still, it was all jokes I suppose…

THE
SIDEMEN'S
LANDMARK
VIDEOS

Oh man have we done some crazy things over the last few years, all in the name of entertainment. There have been a lot of tantrums, quite a few injuries, but a hell of a lot of laughs along the way.

So, for us these are our top five Sidemen videos, which were not only a lot of fun to make, but which you guys seemed to really enjoy as well.

THORPE PARK VLOG with The Sidemen

Vikkstar123

▶ Subscribe 3M

5,067,494 views

👍 95,020 👎 1,159

1.
THORPE PARK VLOG

This was the first time all seven Sidemen appeared in a video together but we never realised it would be such a big deal. We had spontaneously arranged for us to have a day out at Thorpe Park so Vikk decided to make a vlog about what we got up to.

We ended up having a great day out, going on all the rides and playing on a few stalls, but what really blew our minds was just how many people recognised us. Everywhere we went we seemed to be swamped by fans, particularly JJ, who almost started a stampede. It was so much fun.

One of the highlights of the video is right at the very end. As Vikk is just signing off Harry goes to jump on his shoulders but totally takes him out in the process. We thought he had killed him but it was still hilarious.

THE SIDEMEN HELIUM
CHALLENGE!

miniminter ☑

▶ Subscribe 4M

24,508,942 views

👍 277,058 👎 2,754

CROSSBAR CHALLENGE!!!!!

KSI ☑

▶ Subscribe 14M

37,797,449 views

👍 385,197 👎 4,570

0:02 / 3:28

2.
THE SIDEMEN
HELIUM CHALLENGE

This was filmed in the Sidemen house's back garden.
Harry missed out but it was still total jokes. Simon
came up with an idea to have him, Ethan and JJ sat
on chairs with Tobi, Josh and Vikk standing behind
them. The three on the chairs would inhale helium
and try and make each other laugh. Whoever laughed
was then egged by the person standing behind.
It all got pretty wild, and was a nightmare to clean
afterwards but it was worth it to see JJ freak out when
he got egg in his eye and beg for mercy in a high-
pitched voice. And Ethan's laugh is just legendary
in this.

The video also got over 22 million views, which
is just unbelievable!

3.
CROSSBAR
CHALLENGE!!!!

This video got over 35 million views! That's literally
insane! How does that even happen? It's just us
guys at the London Soccer Dome having a great
time doing the crossbar challenge and it's our most
successful video. To be fair, the editing is absolutely
hilarious. It really elevates it, and shows what you can
do with such a simple concept. The highlights were
definitely Vikk hitting the crossbar (we went full-on
crazy) and Simon's trick shot right at the end.

DIZZY PENALTY SHOOTOUT
CHALLENGE!

miniminter ☑

▶ Subscribe 4M

11,337,575 views

👍 116,856 👎 1,407

SLIP 'N' SLIDE FOOTBALL
CHALLENGE

W2S ☑

▶ Subscribe 7M

16,726,258 views

👍 242,655 👎 2,732

4.
DIZZY PENALTY
SHOOT OUT CHALLENGE

Another Sidemen football video and another classic
dreamt up from Simon. The aim was simple: we had
to put our head down on a baseball bat, spin round
ten times and then take a penalty. Sounds easy?
You better check yourself because it was so damn
hard. By the time we got to the penalty spot we could
barely stand, let alone see the ball. Wearing a Go
Pro on our heads really showed just how all over the
place we really were and also added something extra
to the video.

5.
SLIP 'N' SLIDE
FOOTBALL

This gem of an idea was dreamt up by Harry, and it
almost killed him!

We all rocked up to some pitches in Leytonstone,
which is in between where we all live, and we were
not quite sure what Harry had in store. When we
arrived he had some tarpaulin, Fairy Liquid and
water. It was all a bit strange until he explained we
would put the tarpaulin down on the penalty spot,
cover it in Fairy Liquid and water, and then try and
take a penalty. Oh yeah, we had to do this while also
wearing a onesie and with Tesco bags on our feet!

It sounds ridiculous, and it was, but man it was
so damn funny! Harry literally almost broke his
neck when he fell over but somehow the rest of us
managed to survive, just… And it was all worth it just
to see Simon blast in a volley from the slip 'n' slide
right at the end.

THE SIDEMEN'S DREAM VIDEO
(IF MONEY WAS NO OBJECT)

OK, so we thought about this long and hard, and we think we've basically come up with the best video idea ever...

It would be set at The White House. And we would have bad boy paintball guns. On our team we would have the Secret Service backing us up, so we would be absolutely lethal. And we would be up against a team of celebrities led by President Obama and the First Lady. They would have people like Kevin Hart, David Beckham, Will Smith, The Rock and Drake.

If it was all square at the end then Messi and Ronaldo would take part in a penalty shootout on the White House lawn to decide the winner.

We actually need to make this happen. Anyone got Obama's number?

YOUTUBE INSPIRATION GUIDE

Coming up with ideas for videos can be hard damn work. Sure, we could bang out a video every day, but we like to give you guys the very best and that can sometimes be hard when we've just suffered a brutal FIFA defeat (although that can also make for a great video).

So, to help us out, and to help give you inspiration for your own videos, we've come up with a game. All you have to do is pick your favourite fast food restaurant and Premier League football team from the list below and you have an idea for a video! Sure, it's random as hell but some of these videos could be hilarious! Watch out for our videos from this list and send us yours, using the hashtag #sidemenvideos! We'd love to see the madness we've unleashed!

WHAT'S YOUR FAVOURITE FAST FOOD RESTAURANT?

MCDONALD'S
Play a computer game with

KFC
Play football with

BURGER KING
Play a prank on

DOMINO'S
Play a musical instrument while dressed as

SUBWAY
Vlog about

NANDO'S
Do a rant about

PAPA JOHN'S
Do a pack opening with

PIZZA HUT
Build a model of

WHAT PREMIER LEAGUE FOOTBALL TEAM DO YOU SUPPORT?

LEICESTER CITY
Your toothbrush

EVERTON
A sandwich

ARSENAL
A loaf of bread

SWANSEA CITY
Spongebob

TOTTENHAM
Your mate's good-looking sister

WATFORD
Your mate's underwear

MAN CITY
Your mate's good-looking brother

WEST BROM
The worst item of clothing you own

MAN UNITED
Your weird uncle

CRYSTAL PALACE
Justin Bieber

SOUTHAMPTON
Your mum

BOURNEMOUTH
Your mum's dress

WEST HAM
Your dad

SUNDERLAND
A football

LIVERPOOL
Emile Heskey

BURNLEY
Superheroes

STOKE CITY
A Nigerian scam artist

MIDDLESBROUGH
The Queen

CHELSEA
Drake

SHEFFIELD WEDNESDAY
A dirty dog

THE ULTIMATE YOUTUBE EQUIPMENT GUIDE

STARTER EQUIPMENT

ELGATO GAME CAPTURE HD60
For filming gameplay

LOGITECH C920 WEBCAM
For FaceCam footage

IPHONE
For vlogging

PS4
For playing games

A LAPTOP/COMPUTER
For playing games and editing and uploading your video

ANY HEADSET MICROPHONE
To record your voice

WINDOW'S MOVIE MAKER/ IMOVIE
For editing your videos

LAMP
To light your videos

MICROSOFT PAINT
To design thumbnails for your videos

PROFESSIONAL EQUIPMENT

ELGATO
For capturing gameplay

CANON HF G30
For FaceCam recording

CANON G7X
For vlogging

CANON 70D
For filming real-life videos, like
challenges or playing football

PS4, XBOX ONE, GAMING PC
For playing games

**SONY VEGAS PRO/ADOBE
PREMIERE PRO**
For editing videos

**RODE BROADCASTER
MICROPHONE**
To record your voice

SOFT BOX LIGHTS
To light your videos professionally

ADOBE PHOTOSHOP
To design thumbnails for
your video

DUAL MONITOR SET-UP
To allow you to edit your video
on one screen while at the same
time seeing what it looks like
on the other screen

YOUTUBE DO'S AND DONT'S

DO's

DO record content that you actually enjoy, not just what's popular. Trends come and go but if you concentrate on things you enjoy you'll at least have some fun. And you might even be responsible for starting a new trend.

DO be unique. Look for a new angle, game or editing process that no one else is really doing. When Josh started making videos of himself playing COD very few people were doing the same thing, so he really stood out.

DO network with other YouTubers. As you've seen with the Sidemen, we only came to know each other by getting in touch over social media and then hanging out at various YouTuber events. It's amazing how much we've learnt just by being around each other.

DO have a good relationship with your fans. Success on YouTube is only possible if you appreciate your fans and respect them. Competition is fierce, so as soon as you forget your fans they will swiftly move on to someone else.

DO upload regularly. Fans want to see regular content. If you don't keep up not only will you disappoint them but they will also eventually go elsewhere.

DO stick to a schedule. Let fans know when they can expect your videos to drop so they can watch out for them.

DO be active on social media. Having a presence on multiple social media platforms allows you to broaden your reach, meaning you can get content out to as many people as possible.

DO be a collaborator. Sometimes it's good to mix things up by inviting someone else to take part in one of your videos. Some of our biggest videos have been when we've worked with others, not least as the Sidemen.

DO mix up the locations of your videos. If you use the same location for every video people will soon get bored. Try and make it as visual and exciting as possible.

DO film videos using a mix of cameras. For some videos it's worth using different cameras to get different visuals. This worked really well in our dizzy penalties video. We could have just filmed it on a video camera, and it would have worked, but the addition of the GoPro made the video.

DO choose your video title carefully. You want the title to be intriguing enough for people to click. If it's too on the nose it sounds boring, so try and think up a new angle.

DO design thumbnails that pop out. When people decide to watch a video, often their decision is solely made on the thumbnail they see on YouTube. If you can't design one yourself, it's worth investing in someone to design a thumbnail for you. There's loads of places you can go these days to get this done and it's so worth it.

DO choose your upload time carefully. You probably want to upload at night as that is when most people will be online, so they are more likely to view your video.

DONT's

DON'T put numbers in your name. OK, Vikk's name is Vikkstar123, but he picked his name before he had even contemplated becoming a full-time YouTuber. You need to pick a name that is easy for people to remember.

DON'T put a game in your name. While that game might be cool now, your name will date very quickly once its popularity has worn out.

DON'T burn bridges. Sometimes situations blow up and it's tempting to kick off. We've found that it's best to always try and be respectful and to deal with any disputes maturely. You never know when you might bump into the person you're arguing with or might even need their help.

DON'T send explicit pictures. It's amazing how quickly a naked picture can get around the world these days. It's not only embarrassing but also has the potential to kill your career.

DON'T worry about what others think about you. When we all started off our friends, teachers and even some of our parents thought we were mad. If we had listened to half of them we would have given up YouTube a long time ago.

Choose your sponsors carefully. While it's great to have companies offer to pay you to promote their products in your video, you should only promote things you would use yourself and that fit in naturally with your videos. Fans can tell if you're just doing it for the money and it's a major turn-off.

DON'T rush into contracts. It's always a good idea to have a lawyer or a clever friend or relative check over any contracts to ensure you're not signing your life away.

DON'T use content that is copyrighted. We know it can be tempting to use a certain song to go with your video but if you don't have permission YouTube will take your video down and then it has all been for nothing.

THE SIDEMEN SCHOOL PICTURES

As we'd just started school you'd think we'd look down-hearted but, looking back, we all look pretty psyched. Maybe your school years really are the best of your life? Hmmmmm, then again, maybe not. Anyway, see if you can tell who is who this time!

a)

b)

c)

d)
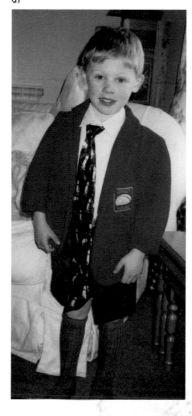

e)
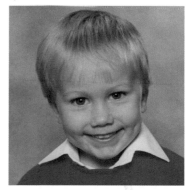

f)
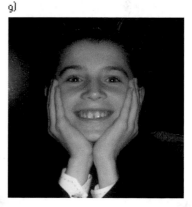

g)

Answers: a) JJ; b) Tobi; c) Vikk; d) Harry; e) Simon; f) Ethan; g) Josh

THE SIDEMEN SCHOOL REPORTS

Some of us have tried to forget the horrors of our school reports, whereas others are quite proud. However, you might be surprised to learn which school report is whose. See if you can have a guess!

a) ## Social Development and Attitude to Work

is very helpful, considerate and polite towards his peers and adults alike. He is a capable boy who works well in all lessons. He usually settles down quickly and gets on with the task in hand. He has good ability and can do very well when he works to his potential.　has a good relationship with all the children in the class and is popular and friendly boy.　has tried to concentrate on his tasks much more in recent months and this has really helped improve his quality of work. He is motivated by success and therefore takes more pride in the quality and presentation of his work than before.　has been a pleasure to teach and I wish him success for the future.

b) is still a little erratic: talented, he cuts corners in producing work: he should ensure the full answering of questions and completing work to the best of his ability. I liked his work on the early part of Genesis: he should maintain this standard.

c) <u>Head of House Report</u>

I am pleased to see that　has worked better in some of his classes and improved his grades, especially in Business Studies, History and Religious Studies. However, a lack of concentration and immaturity, still remain an issue in some of his subjects. He must put a lot more effort into Spanish, as　reports that he is still not taking the subject seriously.

represented the School in the U15C football side and participated in the inter-house football and swimming competitions this term. He also continued to participate in the Duke of Edinburgh Award Scheme.

I look forward to some harder work from　next term

d) **Maths :** is an able mathematician who has shown that he can tackle complex mathematical problems. He achieved 85% in S1 89% in C1, and 82% in C2. Homework is always completed to a good standard and he can be relied upon to work independently and, although he shows excellent self-motivation skills, he is willing to seek advice when it is required. is always willing to make a positive contribution to class discussions and works cooperatively with others.

has a genuine interest and desire to take his science studies to the next level. His subject teachers clearly outline his strengths in both character and academic ability. is a responsible and dedicated student and I am confident that he will continue with his excellent work ethic therefore I wholeheartedly recommend him to study natural sciences.

e) **Progress:** is a lively member of the class who has produced some good work, although he has a tendency to become distracted at times. has rehearsed and performed a variety of pieces from different genres as part of a group, and has learnt the basics of music reading. We have recently explored composition using ICT.

Areas for improvement: must aim to concentrate fully during lessons, and to listen carefully and participate during class discussion. should also be confident with the new terminology and topics learnt this year so that these can be built upon in Year 8.

f) **HOY Comment:**
Whilst is evidently an intelligent student there are far too many comments in this report that make reference to a lack of focus or concentration in class, in this report. He is a very charming and likeable young man, with a sharp sense of humour, and this may be his saving grace at times, but he must now learn the value of applying himself, both for his benefit and that of his fellow students.

g)

Subject	Target	Attainment	Attitude to Learning
Biology	A*	A	1
Chemistry	A	B	2
English Language	A	B	1
French	A*	A*	1
Geography	A*	A*	1
Latin	A*	A	2
Mathematics	A	A	1
Music	A*	A	1
Physics	A*	A	1
Religious Studies Full Course	A	A	2
Spanish	A*	A	1
Physical Education			1

Answers: a) Ethan; b) Simon; c) JJ; d) Vik; e) Josh; f) Harry; g) Tobi

149

A DAY IN THE LIFE OF THE SIDEMEN

Being in the Sidemen can be pretty full-on. There's social media to check in with, videos to make and edit, meetings to attend… not to mention keeping track of where Tobi is. But it's all cool. We do it because we love it, and who else gets to play computer games with their mates for a job?

10 A.M.

Tobi and JJ are usually the first of the Sidemen to rise. They both immediately check in with all of their social media accounts to see if anything has happened while they've slept.

JJ claims he goes for a run at around 10.30 but we think this has happened once in all the time we have lived together! Simon once went for a run with him and found it was quicker to walk. True story.

11 A.M.

Vikk goes to sleep after working through the night.

Ethan's alarm goes off. He turns back over and apparently 'regulates' himself for the next hour, whatever that means…

Harry wakes up. He lies in bed, stares at the ceiling and contemplates his life.

Tobi has a shower and grabs some breakfast.

After his run JJ claims he has a protein-rich, nutritious, breakfast but again, we don't think this has ever happened.

12 MIDDAY

Harry gets out of bed, has a shower, remembers to brush his teeth but forgets to brush his hair.

Ethan finishes 'regulating' himself and slowly begins to rise from his bed like a newborn lamb, ready to seize the day.

JJ tries to think of new video ideas so plays UFC to 'unwind'. We can tell he is up as we can hear him throw his controller against the wall when he loses.

Tobi gets down to business and starts to make and edit videos for his second channel.

So, if you've ever wondered what a typical day is like for us then we've accounted for every single hour below. Who knew Harry has four showers a day?

1 P.M.

After his first shower of the day Harry checks all of his social media accounts and scans the internet for inspiration.

Ethan rummages around the kitchen for something to eat. He usually fancies a good old-fashioned fry-up but realises he hasn't been shopping in weeks so settles for a bowl of Cheerios.

2 P.M.

Simon wakes up. He jumps out of bed, goes to his desk, and starts to edit videos.

JJ claims he starts to record a video around this time…

Harry orders some food for breakfast. While he waits he makes a nice cup of tea.

Ethan has a pleasant browse through social media and has a good laugh at animal videos.

Around 2.30 p.m. Josh wakes up. He looks at the time, realises it's too early, so hits the snooze button on his alarm.

3 P.M.

Tobi finishes his first video of the day so decides to reward himself with some food.

Harry needs some fresh air to stimulate his mind so he usually heads to Westfield, where he walks around aimlessly, and buys things he doesn't need.

Josh turns off his annoying alarm and checks his social media accounts through bleary eyes.

Ethan continues to be distracted by animal videos and loses track of time.

Simon realises he hasn't eaten anything so heads to the kitchen. Usually this is a fruitless exercise, as he knows no one has been shopping, so he has to make do with a packet of crisps for breakfast before he heads back to his desk to continue to edit.

JJ is exhausted so has a 'power' nap.

151

4 P.M.

Ethan drags himself away from his computer and paces the room to try and think of video ideas. After three minutes he gives up and instead gouges his eyes out on FIFA.

Simon finishes editing. He has a shower to try and think of new video ideas. He seems to spend a suspiciously long time in there so he must be thinking really hard…

Josh gets out of bed and has a shower (not with Simon). He then treats himself to a Dr Pepper for breakfast.

JJ gets up from his nap, feeling refreshed. He intends to start recording a video but instead plays FIFA.

Tobi claims he starts to complete 'personal chores' but we refer to it as 'ghosting', as no one knows where he goes, and he never actually tells us what these 'personal chores' are. If you ever spot Tobi around this time tweet us a picture with the hashtag #tobighosting.

5 P.M.

Harry returns from Westfield and decides he needs a shower after exposing his skin to the outside world.

Ethan records himself playing FIFA.

Simon only emerges from the shower when he has a new video idea. When he's ready he usually starts to record for his main channel.

Vikk's alarm goes off. Everyone in the house can hear it but he sleeps right through.

Josh begins editing and uploading videos for the next few hours.

6 P.M.

VIKK WAKES UP! After half an hour of avoiding any light piercing his blinds like a vampire, he staggers up and heads to the shower.

Tobi, Harry, JJ and Ethan start to edit videos.

Simon frantically starts editing. As soon as he is finished he treats himself to a snack.

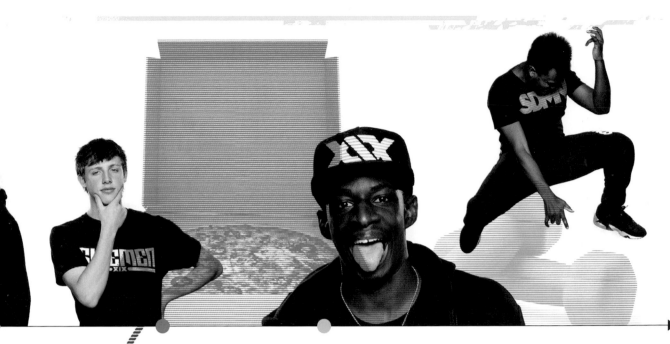

7 P.M.

Harry procrastinates by watching random YouTube videos.

Ethan finishes editing and feels like a boss.

Vikk has cereal for breakfast while the others contemplate a takeaway.

Josh starts to record a video.

8 P.M.

Harry actually has no idea what he does during the next few hours. We interrogated him with a bright light to find out but he refused to break. We think this is when he secretly sees his other friends but he should know that is frowned upon in the Sidemen.

Ethan begins rendering his latest video.

JJ posts his video on his channel and makes lunch.

Josh is all business. He sits down with Lewis and Freya, the self-proclaimed 'Merch King and Queen', and discusses the latest news on the Sidemen clothing line.

Tobi continues to edit his video. He's a perfectionist so it apparently takes time. Not that we would know as during this period he won't answer or return any calls.

Vikk begins to record Minecraft videos.

9 P.M.

Simon finishes editing and vows to find food, no matter what, even if it means leaving the Sidemen house…

Josh forages for food in the house. He realises there is none so texts Simon and asks him to pick something up.

JJ claims that he goes to the gym for the next two hours but we have to be honest with you all, this is a total lie. Again, if you ever spot JJ in the gym or doing any form of exercise please tweet us a picture with the hashtag #JJexercise.

Tobi also claims he goes to the gym at this time. As he doesn't live in the main Sidemen house we have no idea if this is true, but he is in decent shape, so we are prepared to believe him.

Vikk starts to plough through his emails and social media.

It's chill time for Ethan. Yeah boi!

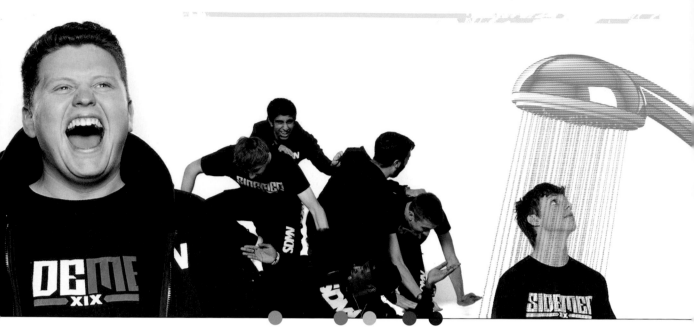

10 P.M.

It's Sidemen Skype call time. Usually everyone chats about video ideas but more often than not we just end up laughing at random stuff, oh, and Ethan.

11 P.M.

Simon, Josh, Vikk, Ethan and Tobi start to record videos.

JJ 'makes' himself dinner. When we say 'make' we mean he either drives to Nando's (if it's still open) or orders a takeaway.

12 MIDNIGHT

Harry is back! He immediately has a shower because he feels dirty.

JJ devours his food while watching random YouTube videos and playing games.

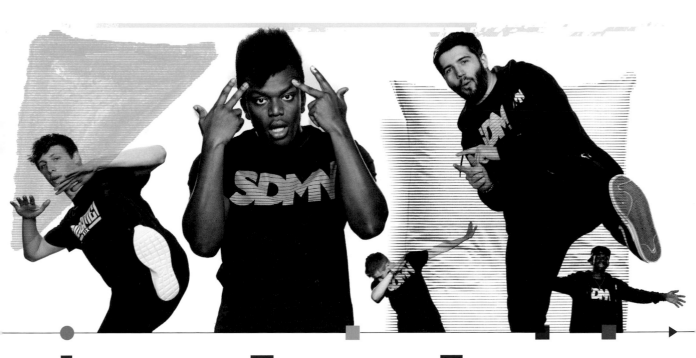

1 A.M.

With the others already hard at work, Harry starts to record videos.

2 A.M.

Ethan begins to unwind by watching more random YouTube videos.

Vikk makes a sandwich, usually his 'Vikk Special'!

Josh and Simon make meals for each other. Awwww sweet…

JJ goes to bed after a long day. That gym workout must have really taken it out of him…

3 A.M.

Simon and Josh go back to editing and procrastinating.

Vikk records more Minecraft videos.

Tobi and Ethan hit the sack (not together!). ZZZZZZZZZZZZ

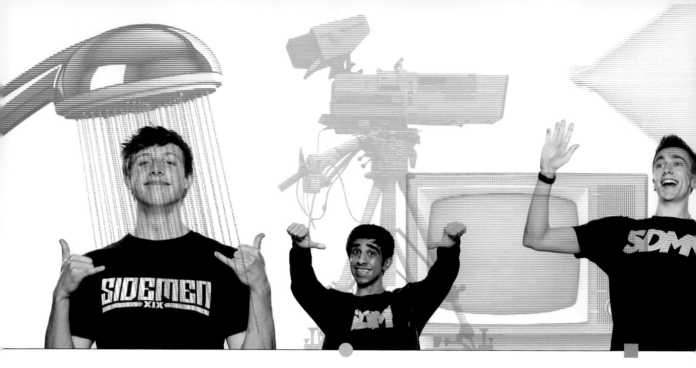

4 A.M.

Harry has a shower, although he stresses he doesn't wash his hair, a body wash will suffice, then goes to bed. Weird : /
 Vikk plays DOTA 2.

5 A.M.

Vikk records more videos. Josh also records more videos.

6 A.M.

Simon sets his videos to render, gets into bed, watches TV and slowly falls asleep.

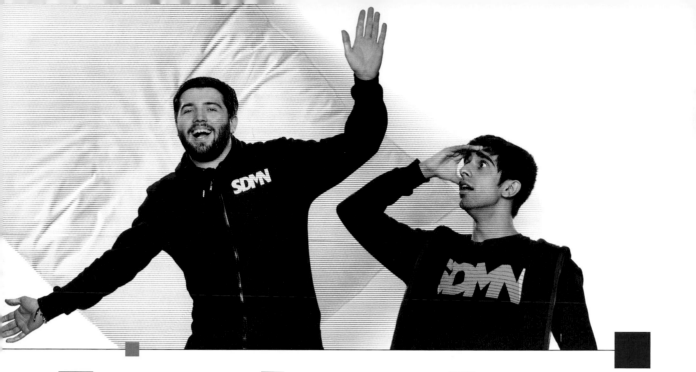

7 A.M.

Josh finishes editing his videos and finally goes to sleep.

8 A.M.

Vikk sees the sunrise. He edits and sets videos to upload.

9 A.M.

Vikk looks at the time and wonders why he is still up. He starts to think it might be a good idea to go to sleep but instead plays some games…

v. Y'know how sometimes people say we look like certain celebrities?

t. Like who?

v. Well everyone used to confuse Simon with Simon from The Inbetweeners.

s. That happened one time.

jj.

s. All right, it's happened a few times but it's just because we have the same name.

j. And the same haircut.

t. And you're a similar height.

h. You do actually dress like him as well.

jj. Hold up, let's compare them...

SIMON

s. All right, so we look a bit like each other, but I've been mistaken for someone else as well.

t. Who?

s. I'm only going to tell you if we all play the game.

jj. Telling each other who they look like? I'm so down with that. I'm definitely Drake :)

s.

v. We can't say what we think we look like, only what other people, and the other Sidemen think we do.

j. Oh great, this should be fun...

T. I actually look like Andrew Wiggins.

J. Who's Andrew Wiggins?

T. He plays in the NBA for the Minnesota Timberwolves.

S. Wait a minute, we just said we weren't allowed to pick ourselves.

JJ. Yeah, you can't just pick a cool, good-looking guy from the NBA, and claim you look like him. If we are doing that I'll just say I'm Justin Bieber.

J. Justin Bieber is white.

JJ. Are you saying I can't be white just because I'm black? That's so racist!

T. Hold up, take a look at him and see for yourself. If you don't think I look like him then you can choose someone else.

V. Hmmmmmm, he does actually look really like him.

H. Come to think of it, I've never seen Andrew Wiggins or Tobi in the same room…

E. You don't even know who Andrew Wiggins is!

H. He's that basketball player.

J. You only know that because he just told you!

JJ. Tobi is getting all the cool things in this book! When is it my turn?

S. All right JJ, we will do you next :)

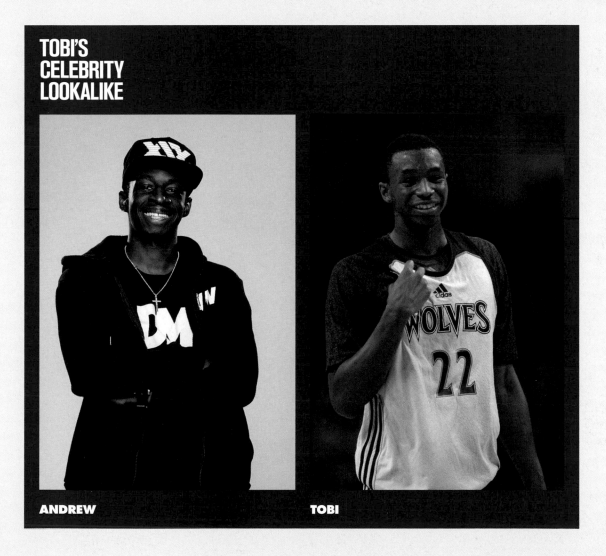

TOBI'S CELEBRITY LOOKALIKE

ANDREW

TOBI

JJ. Guys, I know we're really busy with book stuff and making videos so I've saved you the hassle and found my celebrity lookalike…

J. That's a male model?
JJ. I know, the likeness is uncanny :)
S. No way! You're not having that.
E. Hang on! What about Deji? He's a celebrity, and looks just like him.

JJ. That's because he's my brother!
H. I sometimes get you confused.
JJ. Why? Because we are both black?
H. NO! Because you do look really alike.
JJ. No way am I having Deji as my lookalike. I'm way better-looking than him and he's not even a proper celebrity.
T. To be fair JJ looks a lot like Nedum Onuoha, the QPR player.
JJ. My brother from another mother! That's what I'm talking about!

JJ'S CELEBRITY LOOKALIKE

JJ

NEDUM ONUOHA

V. Shall we just get this over and done with
E. You're Dev Patel!
H. Who's that?
J. He's the guy from Slumdog Millionaire.
H. Oh yeah! HA HA HA!
V. You guys only say I look like him because he's the only famous Asian person you've heard of.
S. I know AJ from EastEnders but you don't look like him.

JJ. Why are you even complaining about being Dev Patel? He's a really good-looking guy!
J. All right JJ, steady on.
JJ. I'm just saying!
E. He might be the only famous Asian person I know but you still look just like him.

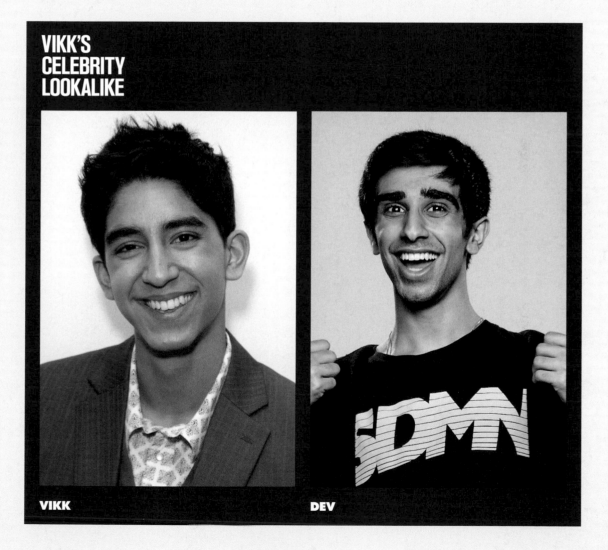

VIKK'S CELEBRITY LOOKALIKE

VIKK DEV

J. All right, here we go, hit me with it…

S. ………..

J. I'm only twenty-three! I don't look that old!

S. You do.

V. I think it's just because you're quite mature.

JJ. Yeah, and you can grow a beard, which none of us can.

T. Uh, I can.

E. So can I.

JJ. Ethan, there is no way you can grow a beard!

H. I've been trying for two years : (

V. Josh actually looks a lot like the lead singer from that band A Day to Remember.

J. Thanks Vikk :) This could have been a lot worse.

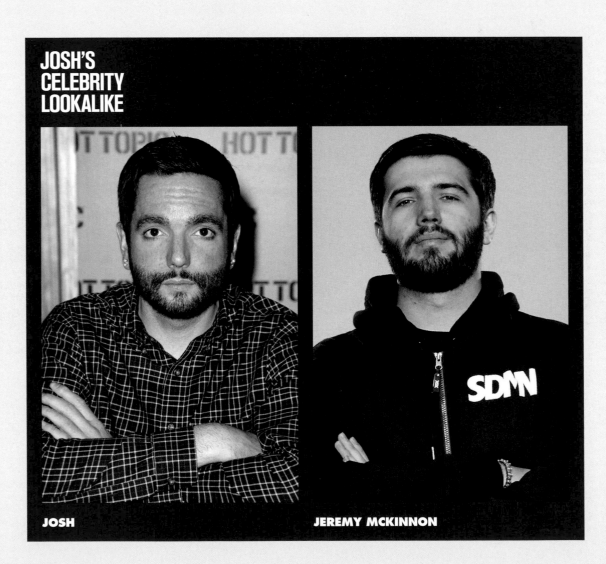

JOSH'S CELEBRITY LOOKALIKE

JOSH

JEREMY MCKINNON

JJ. This is the one I've been waiting for!

J. Hang on, where is Ethan?

S. I've just texted him. He's having a driving lesson.

JJ. So we can pick his lookalike without him being here? This is gonna be total jokes!

V. You know who Ethan does look like?

T. Who?

V. Mr Tumble from that CBeebies kids' show.

JJ. HA HA HA YES!!!

H. I love that show! Uh I mean, I used to like it when I was a kid...

S. Ethan just texted and said he looks like James McCarthy from Everton.

V. Hmmmm that does actually look just like him.

JJ. No way is he having a Premier League footballer! He's not even here!

T. True! If he can't be here then he will have to put up with what the group decides...

E. Hey guys, sorry I'm late. Did you go for James McCarthy?... Oh for #### sake!

ETHAN'S CELEBRITY LOOKALIKE

ETHAN

MR TUMBLE

jj. I thought we just agreed that Simon looks like Simon from The Inbetweeners?

j. We did but he said it was too obvious and he actually looks like someone else.

t. He's definitely going to pick someone really good-looking now.

e. After you lot just landed me with Mr Tumble there is no way he can pick anyone cool.

s. Oh hello everyone :)

v. So, come on, who is your other lookalike?

h. That does look a lot like him.

jj. No way! He can't go from an Inbetweeners actor to a top footballer. If he is going to be a footballer it better be a really bad one.

s. I think you'll be pleasantly surprised. Gentlemen of the Sidemen, I give you, Sunderland's very own reserve goalkeeper, Pantilimon…

jj. I can deal with that.

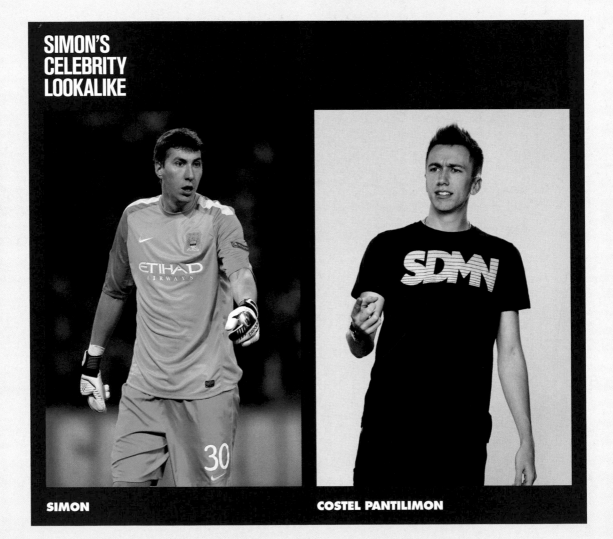

SIMON'S CELEBRITY LOOKALIKE

SIMON

COSTEL PANTILIMON

164

J We are going to need someone who looks really young and fresh-faced for Harry.

S. The opposite to you then?

J. Thanks Simon!

E. I was thinking, he looks a bit like Macaulay Culkin.

V. He's not young and fresh-faced.

E. No, like old school Culkin, from *Home Alone*.

H. Oh yeah :) I love that film! It would actually be really cool to be home alone and build all those traps.

T. But you live by yourself, so you are home alone…

H. I never thought of that. I should probably build some traps when I get back to stop any burglars.

JJ. Yo, you should probably start using Culkin's photo on your ID.

H. Why?

JJ. You may actually start getting in to places ;)

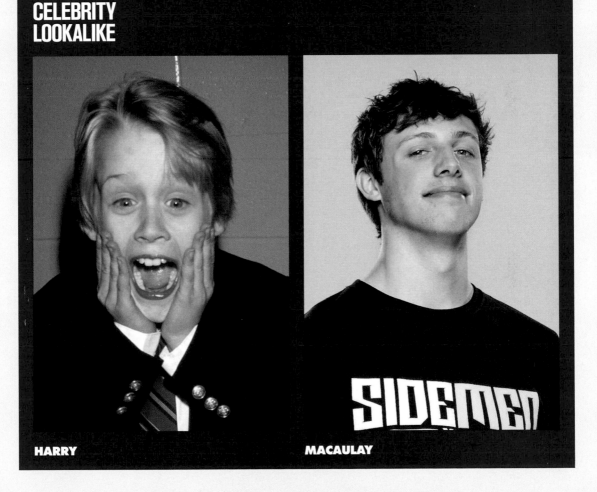

HARRY'S CELEBRITY LOOKALIKE

HARRY

MACAULAY

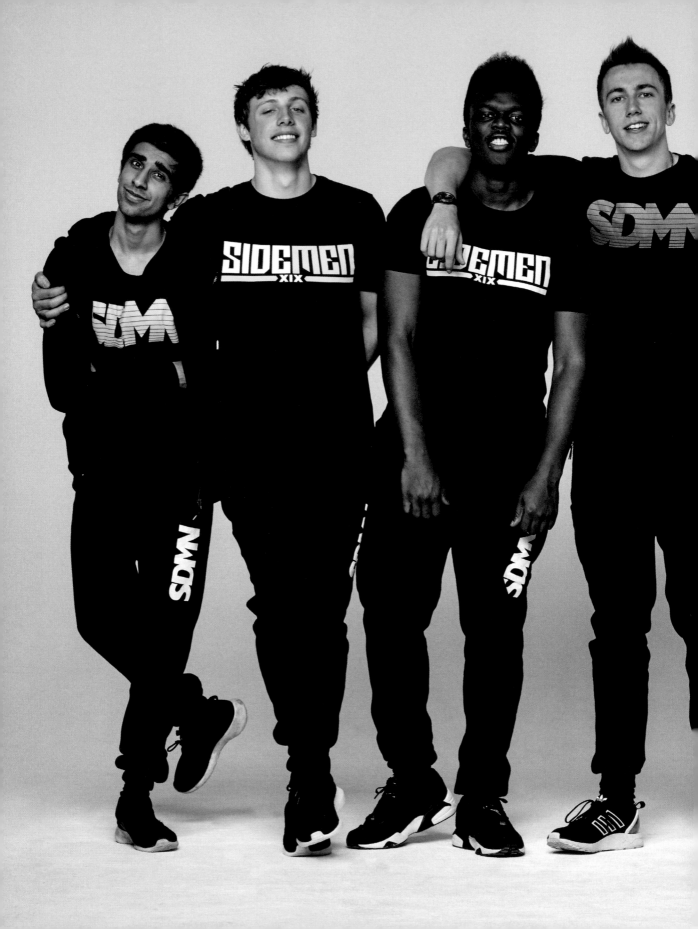

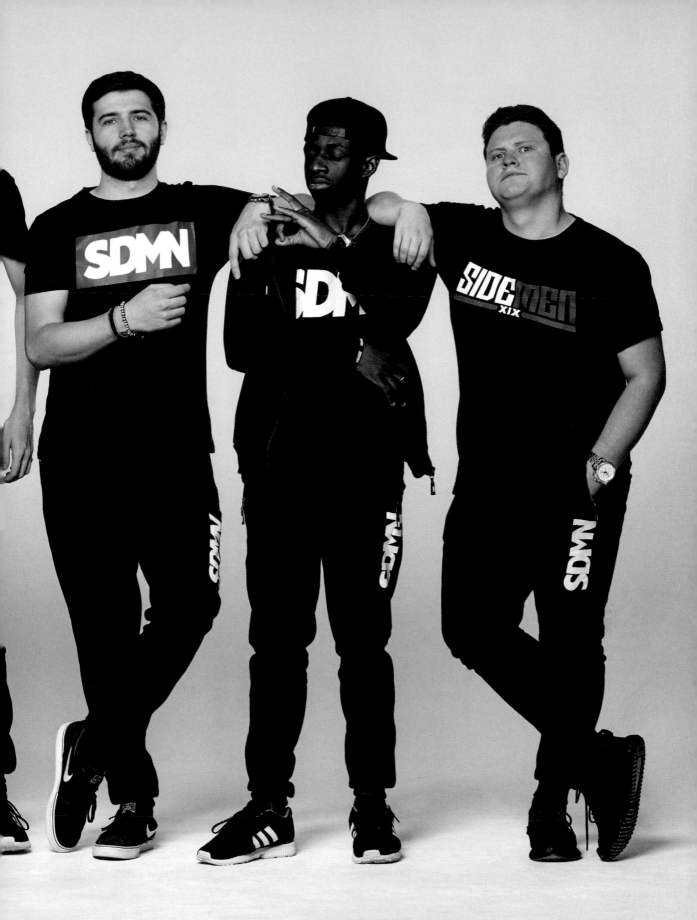

THE SIDEMEN'S MADLIBS STORY

We like to keep you guys on your toes so we thought it would be cool to do a Sidemen 'madlibs' story. However, when we tried to explain how this works to some of the group (not mentioning any names) there were some blank faces. A few of the more enlightened Sidemen tried to explain what a noun, verb, adverb and adjective were but we might as well have been speaking Chinese.

Anyway, after a long English tutorial, some broken chairs and a Nando's to soothe relations, we just about managed to get everyone on board. But if this is alien to you too then don't worry, we'll explain how it works. So get your dunce caps on, and prepare to be taught by the Sidemen (apart from JJ and Ethan, who still don't get it and are in a mood!). Madlibs is a story where you fill in the gaps with a noun, verb, adjective or adverb.

A noun is an item, a thing.

A verb is an action word, something you do.

An adjective is a word that describes a noun.

An adverb describes a verb.

All right, you with us? Sweet! But if you're not then just turn the page because we give up. However, if you are then simply fill in the following story and tweet a screenshot of it to us! We want to see just how messed up our fans really are!

The Sidemen INSERT VERB was INSERT ADVERB. The NOUN were ADJECTIVE, and most of the guys were INSERT ADJECTIVE into their INSERT NOUN, doing what they do best, INSERT VERB.

Feeling hungry JJ went INSERT VERB and INSERT VERB the INSERT NOUN, only INSERT VERB Simon, who was INSERT VERB in the INSERT NOUN in the dark. Hearing JJ's INSERT VERB Josh INSERT VERB and INSERT VERB downstairs, thinking the house was being burgled, only to find JJ and Simon INSERT VERB, INSERT ADVERB. INSERT VERB at the sight of them Josh INSERT VERB to INSERT VERB, just as Vikk INSERT VERB, complaining of a INSERT ADJECTIVE, INSERT NOUN, the result of a INSERT ADJECTIVE, INSERT NOUN.

With the boys in the INSERT NOUN, in nothing but their INSERT VERB, they decided to order a INSERT NOUN. While they waited they INSERT VERB around with their INSERT VERB before a INSERT NOUN, through the INSERT NOUN. Thinking it was INSERT NOUN, Simon INSERT VERB to the NOUN only to find it was Ethan, who had forgotten his INSERT NOUN from earlier in the day. INSERT VERB the INSERT ADJECTIVE Simon, Ethan INSERT VERB, INSERT ADVERB through his INSERT NOUN and saw the guys INSERT VERB around. Keen to INSERT VERB Ethan INSERT VERB JJ's INSERT NOUN, INSERT ADJECTIVE and VERB that he had a bigger one in his NOUN.

As the guys INSERT VERB, Josh saw that Tobi had INSERT VERB them a INSERT NOUN of them INSERT VERB earlier that night. Tobi was also doing a INSERT VERB of INSERT NOUN and then challenged the guys to INSERT VERB.

Just as JJ INSERT VERB Vikk had a skype call from Harry, who was INSERT VERB in the bath. Vikk INSERT VERB the guys just what Harry was doing. Ethan was impressed! Finally INSERT ADVERB of INSERT VERB the guys were relieved when the INSERT NOUN, INSERT ADJECTIVE. It was the INSERT NOUN! Excited to see him they INSERT VERB before INSERT VERB to join in the fun. INSERT VERB to hold his INSERT NOUN, JJ INSERT VERB into the kitchen, while INSERT VERB for his time.

After a long, hard, INSERT VERB the guys all went to INSERT NOUN, INSERT ADJECTIV :).

THE SIDEMEN'S DODGY CLOBBER

We hold our hands up. We've worn some right dodgy clobber in our time. Half the time we didn't even realise just how bad it was. In fact, some of us (JJ) still think that our worst crimes against fashion are cool. While we can't all be like Tobi, who looks fresh whatever he wears, there is really no excuse for some of the monstrosities in our closets. In an effort to help each other out, we've picked out each Sideman's worst item of clothing to ensure it never sees the light of day again! Please, forgive us…

JJ
SHOWER CURTAIN TROUSERS

JJ. I don't think I've got anything that bad?

S. Are you joking?

E. What about your Versace trainers?

V. Or your clothes with all the zips?

S. Or the shower curtain trousers?

T. YES! They're the worst!

JJ. I can't believe you're dissing those. Are they really that bad?

H. I genuinely thought they were actual shower curtains when I first saw them.

JJ. Brutal.

JOSH
ONE SLIPPER

E. It has to be one of his Millwall tops.

J. You're only saying that because you're a West Ham supporter!

S. What about his Minions socks?

H. I like them!

JJ. Hold up! It has to be his slipper.

S. It's sick. I bought it for him.

T. His slipper? Has he lost one?

J. No, it's just one big slipper which I can fit both feet in.

E. To be fair, that does sound worse than your Millwall top!

HARRY
BLUE JUMPER

H. Everyone's going to say my blue jumper aren't they?

JJ. Yes!

H. I've actually got five of them.

V. Why?

H. They were like my school jumper. I used to wear them in every video.

J. You haven't worn it in a while though.

H. It was becoming too much of a thing. I knew if I didn't stop wearing it I would be doomed to wear a blue jumper for ever. It had to stop.

S. That's a shame…

SIMON
CHRISTMAS JUMPER

т. Simon's clothes are actually pretty inoffensive.

JJ. His Xmas jumper wasn't the best.

s. Which Xmas jumper?

J. You own more than one?

s. Well the really bad one with the chain I only bought for a video.

E. Then what about the other one?

s. I bought it because I like it! There's nothing wrong with Xmas jumpers.

J. Yes Simon. Yes there is.

VIKK
'PRIMARK' JUMPER

v. Go on! Just say it!

т. Shitty Primark jumper.

J. Shitty Primark jumper.

s. Shitty Primark jumper.

E. Shitty Primark jumper.

н. Shitty Primark jumper.

JJ. Shitty Primark jumper.

v. It's not even Primark!

s. I can't believe you used to wear it in all your videos!

v. It's not actually a Primark Jumper and I like it.

TOBI
CHECK VEST FROM AYIA NAPA

J. This is actually going to be pretty hard.

s. Yeah, Tobi is usually cool in the wardrobe department.

т. Thanks Simon. That's probably the nicest thing you've ever said, to uh, anybody.

н. NO! Wait! What was that horrible check vest he wore in Ayia Napa?

v. Oh yeah! That was disgusting!

т. Wait a minute, I only wore it because Calfreezy brought it with him for someone to wear as a forfeit for losing a game.

E. So you lost the game?

т. No, but I thought it would be funny to wear it anyway.

JJ. But you've still got it in your wardrobe…

т. I'm waiting for the right occasion to wear it again.

s. Like the worst-dressed person in the world festival?

ETHAN
CUSTOM WHITE T-SHIRT WITH BAD PUNS ON THE FRONT

s. We could probably choose everything Ethan has ever worn here.

J. Apart from when he is in Sidemen clothing, obviously.

s. Obviously.

E. OI! I've got some well nice gear!

н. What about those polo shirts?

JJ. And those tight tops?

v. No! What about those custom white T-shirts he orders online?

J. With the 'funny' puns on them?

v. Yeah, they are pretty bad.

E. They're funny.

JJ. A T-shirt with a Phil Mitchell quote on it is not funny!

THE SIDEMEN'S FAVOURITE COMPUTER GAME CHARACTERS OF ALL TIME

We've all played our fair share of games over the years but some characters stand the test of time better than most. Over a cup of tea, a pack of chocolate digestives, and with JJ frantically trying to order a Domino's takeaway, we discussed who we think are the most iconic gaming characters of all time. Unsurprisingly, we couldn't agree on anything, but in the end we just about managed to put together our definitive list.

5

LARA CROFT

T. Lara Croft was pretty cool.

JJ. And she was really fit!

J. We can't pick someone just because you fancy them!

E. Yeah. You can't.

JJ. Sure you can!

V. She was probably the first video game character I ever fancied.

S. Wait a second! The first! Who was the second?

V. Wouldn't you like to know! ;)

H. To be fair *Tomb Raider* was actually a really good game.

4

SHADOW

H. If Mario is on this list then Sonic has to be on it.

JJ. I'd pick Shadow over Sonic.

H. No way! Why?

T. Shadow was the cooler version of Sonic.

S. All right, let's put it to a vote, Sonic or Shadow?

J. Sonic.

T. Shadow.

JJ. Shadow.

H. Sonic.

V. Shadow.

E. Sonic.

S. Oooooh, I've got the casting vote :)

H. You've got to pick Sonic over Shadow.

S. I'm gonna pick Shadow because he was so badass.

JJ. YES!

3

NIKO BELLIC (GTA 4)

JJ If it was up to me Niko Bellic would probably be at the top of the list.
J. I don't know. I think CJ from San Andreas is cooler.
T. No way. Niko Bellic is way more iconic.
JJ.The soundtrack to GTA 4 was so sick and he was so badass.
S. Remember the advert for GTA 4? I was so excited when I saw that. It was like a movie!
V. We really need to do some GTA 4 videos!

2

CAPTAIN PRICE (COD 4)

JJ.I'm gonna have to go with Captain Price from COD 4 for this.
V. He's such a legend.
T. Oh man, he was like my childhood hero.
E. The man is my father figure!
S. I actually need to play COD 4 when we arc done playing this.
J. Yes! Let's dig out the Xbox. I need to play it again.

1

MARIO

H. Mario has to be number one!
S. Yeah, I'd put Mario at the top as well.
J. The original Mario is still such a cool game.
V. And then you've got *Super Smash Bros* and *Mario Kart.*
JJ.Oh my God! *Mario Kart!*
E. He's probably the gaming character most people in the world recognise as well.
T. Yeah, I don't think many people would disagree with Mario being at the top of our list.

THE SIDEMEN'S TOP 10 GAMES OF ALL TIME

This list honestly took so long to come up with. A lot of hard compromises had to be made and a lot of voices were raised in the process. One of the group was even adamant that Nintendogs had to be in this list, which was frankly quite upsetting to hear. Anyway, in the end we are just about agreed that these are our top ten games of all time! Now we need to play them all again.

10 NEED FOR SPEED: UNDERGROUND (PS2)

YES! BAP! BAP! 'GET LOW, GET LOW...' The soundtrack to this game was insane. It had some real bangers on it while the game itself was just like Fast and Furious. Looking back this was the first underground, fully customisable, racing game, and it was total badness.

9 PRO EVOLUTION SOCCER 6 (XBOX 360)

We all love FIFA but we doff our caps in respect to this outstanding PES effort. Adriano was a world-beater in this. He was banging thumpers into the top bin from all over the place while the gameplay was slick. Sure FIFA has caught up in recent years, but at the time this was in a different league.

8 MINECRAFT (PC)

This was always going to appear in this list; the only question was where? This is one of the most creative games of all time and the fun never ends. As it's based on open-source software you can pretty much do what you like, and the community is always coming up with cool things that keep the game fresh.

7 POKEMON

There is really no need to explain why this is in the list. If you know then you know, and if you don't then call the NSPCC because you missed out on your childhood.

GOLDENEYE (N64)

Now this is old school but set a new benchmark for using split screen and for first person shoot-'em-ups. The graphics were incredible at the time and any game with James Bond and Oddjob is always going to be a classic. Although JJ says he always used to get stuck in the toilet cubicle, which isn't very Bond!

CRASH BANDICOOT (PS1)

A legendary childhood game. How many of us rushed home from school just to play this? There were so many cool mini-games it always seemed fresh. The amount of times we would be playing this and our mums would shout up, 'Dinner's ready!' and we'd shout down 'JUST ONE MINUTE!' just so we could squeeze in a few more games.

CALL OF DUTY 4: MODERN WARFARE

YES! This was truly groundbreaking and for us really started the whole gaming scene. It was only after this came out that gaming videos on YouTube really took off. This is actually the one game where we were all in agreement. This just had to be at the top of the list. They're actually remastering the game as we write this, which only goes to show what a classic it is.

MARIO KART (N64)

Just a stone cold classic! It's one of the best racing games of all time and one of the first games you could invite all your friends over to play against you. Sure, you'd throw your control pad (or your friend) against the wall when you lost, but the thrill of winning was unbeatable!

GTA: SAN ANDREAS (PS2)

There was a lot of debate over which GTA would make this list, with some of the group favouring *Vice*, but in the end the hot girls, mental soundtrack and legendary CJ saw this win the day. Sure we were too young to play it at the time but that definitely didn't stop us ;)

HALO 3 (XBOX 360)

What a game! This was the sole reason why so many of us bought an Xbox 360! The gameplay was sick and was so ahead of its time. You could create your own levels and mini-games, while the ranking system, and online play, was unreal. We didn't think it could be possible but this was somehow even better than Halo 2.

THE SIDEMEN DRAW EACH OTHER

They say that beauty is in the eye of the beholder. Well, if that's true then we are all screwed because there is nothing beautiful about these portraits!

We decided that each of us would pick a name out of Tobi's hat and that we would then have to draw a portrait of the person we had picked. It's safe to say that some portraits are better than others but Vikk definitely had an absolute result with Ethan picking him! When Ethan started drawing it was like watching that scene in *Titanic* when DiCaprio draws Kate Winslet, although thankfully Vikk wasn't naked.

Simon by Tobi

JOSH BY VIKK

GOLD TIER BEARD

SIDEMEN

JJ by Harry

BEAST

(All colored in by Tobi)

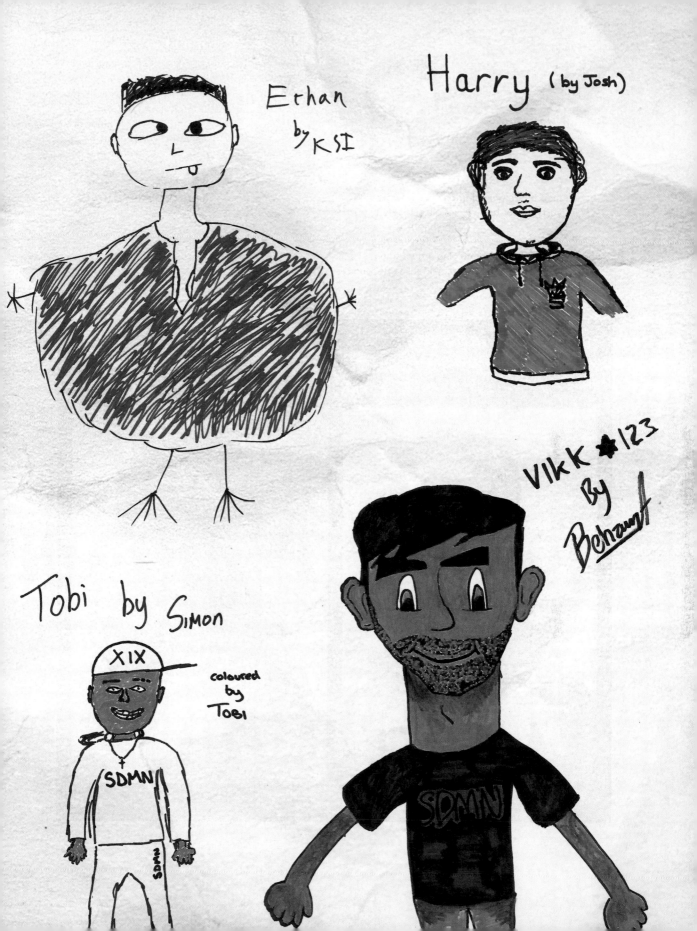

THE SIDEMEN FOOTBALL TEAM

FIFA CHALLENGES

When we play *FIFA* we usually pick our team based on players' stats, right?

т. Yeah, that's why everyone wants Ronaldo or Messi.

ı. But if we were picking our Sidemen football team what stats would we have?

е. Well if you compare us to Ronaldo or Messi not very good ones.

ı. Not compared to them but just our stats compared to our peers.

s. Do we get to rate ourselves?

т. No, the group should decide.

ıı. You're all going to stitch me up!

ı. If the group decides we can't stitch you up. It will be an honest appraisal of your football ability.

ıı. I can't wait…

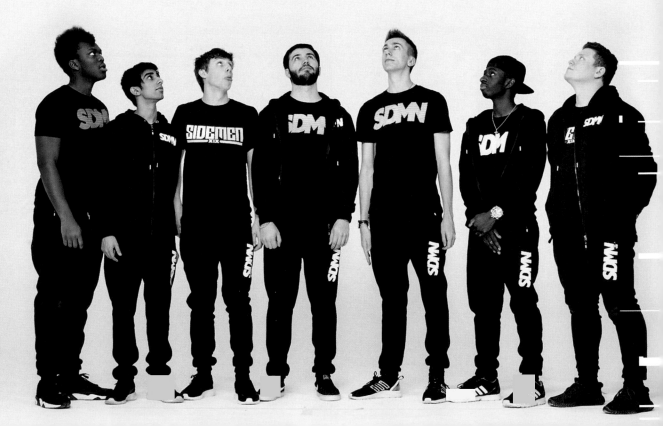

JJ

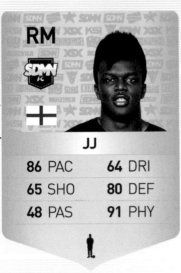

RM

JJ

86	PAC	64	DRI
65	SHO	80	DEF
48	PAS	91	PHY

PACE

s. This has to be a 4!

JJ.C'mon! If I'm a 4 then what it everyone else?

T. Seriously though, he's pretty quick so I'd give him an 88.

H. No way! You're the fastest here and he's never catching you!

J. I think 86 is fair.

JJ.Cool! I can deal with that.

SHOOTING

s. Oh God!

JJ.Hold up! Wait! I know that's not my best so I'll be willing to take a 65.

H. But that means two thirds of your shots go in and we know that's not true.

J. How many times did JJ kick it over the fence when we played the other day?

E. To be fair, his shooting is average.

V. Yeah, 65 is pretty middle of the road so I'm happy with that.

PASSING

J. His passing is much worse than his shooting.

JJ.No! I can do long balls!

s. Yeah, you can kick it in the air but the whole idea of passing is it has to go to a teammate.

JJ.All right, I know my passing isn't the best so I'll take a 50.

E. You're not that good mate.

s. Let's say 48.

JJ.For God's sake!

DRIBBLING

JJ.Every now and again I mess up but you have to admit I do have some skillz! Check out the video I did with the Freestylers!

s. This is actually really easy to rate. JJ, how did you injure yourself the other night when we played?

JJ.C'mon! That was an accident.

s. You twisted your ankle trying to do a stepover and had to go off.

H. Oh yeah! I was in goal. I laughed so much.

JJ.Ronaldo has done that!

E. But he's never injured himself doing it.

J. 62 is probably about right.

T. No, he's better than that.

JJ.Yes Tobi!

T. Give him a 64.

JJ.I swear I'm gonna walk out in a minute.

DEFENCE

J. All right, this is where JJ gets better.

V. Yeah, this is definitely one of his higher marks.

E. He does love flying into tackles but they are usually fouls.

JJ.That's all Ramos does and he plays for Real Madrid.

s. Let's give him an 80 before he hits one of us.

JJ.That's more like it!

PHYSICALITY

s. This is probably going to be his highest rating.

J. He might even sneak into the 90s with this.

V. I wouldn't go that far.

H. I just love how angry he gets when he plays.

E. I'd give him a 91 because he does love throwing himself around.

JJ.C'mon guys. I've got to have one rating in the 90s. I'm not that bad.

J. OK, let's give him a 91 so he shuts up for a bit.

SIMON

ST

SIMON

75	PAC	**84**	DRI
90	SHO	**76**	DEF
86	PAS	**72**	PHY

PACE

T. He's not the quickest but I wouldn't say he's slow either.

JJ. He's actually deceptive because you think he's quicker than he is because he's quite skilful.

H. If he didn't have long legs I don't think he would be that quick.

V. That's like saying if he didn't have any legs he wouldn't be quick!

E. He's quick enough to get past someone so I'd say 75 is fair.

S. Cool! That's one of my worst ones out of the way, so let's get on to the good stuff :)

SHOOTING

J. Oooooh, this could be his highest mark.

H. Yeah, he can hit the ball really hard and very accurately.

V. 86?

T. No. He's got to be higher than that because he's probably the best shooter out of all of us.

S. 99?

JJ. You're not that good!

E. 90 is fair. None of us are going to get any better than that!

PASSING

JJ. Simon is a good footballer so we're gonna have to pay him respect here.

S. Thanks man.

T. Again, he's probably the best passer out of all of us.

V. That's not hard.

J. Give him an 86. He's good but he's not in the 90s.

DRIBBLING

T. This is going to be in the 80s.

JJ. My boy can drop some skillz.

E. Mid 80s sound about right?

S. C'mon, if I'm the best dribbler here we've got to be looking at high 80s at least?

J. Who said you were the best dribbler?

S. Then who is?

J. You'll have to wait and see.

V. 84 is about right. He's mid 80s but nearer to 80 than 90.

DEFENCE

E. This isn't his strong point.

S. It's not yours either!

E. But we're marking you right now.

JJ. To be fair Simon does get back and defend.

H. Yeah, even though he's a forward he's still a team player, which I admire.

E. He only likes coming back if he can push you into the fence.

S. My bad.

J. He's not the best. He's not the worst. Let's give him a 76.

PHYSICALITY

V. Hmmmmm it's not that bad.

J. But it's not that good either.

S. C'mon, I've got to be in the 70s at least here.

T. Do you know what? I've don't think I've ever seen Simon be properly physical on a football pitch.

S. If you're good with the ball at your feet you don't need to be physical.

E. I was going to say 78 but after that comment you're definitely getting a 72.

VIKK

GK
VIKK

68 PAC	12 DRI
38 SHO	34 DEF
49 PAS	-4 PHY

PACE

H. I don't think I've ever seen Vikk run.

S. He doesn't run. He skips!

T. Vikk, how fast do you think you are?

V. No idea.

E. He might actually be really quick because he was a good swimmer.

J. We should have a race.

S. No way. I'd be sick. I haven't done any exercise in weeks!

J. I meant between Tobi and Vikk.

V. Actually, we did all have a race the first time we went to play football. I think I came around third or fourth.

JJ. All right, let's give him a 68 as like Ethan said, he was a good swimmer.

SHOOTING

JJ. Oh man, have you seen him shoot in our football videos? This should be around 20.

T. C'mon, he's not that bad.

V. I actually think shooting is one of my strong points.

S. Really? Have you watched those videos?

H. Let's bump him up to a 38 here as while he doesn't score many his shooting is reasonably accurate.

PASSING

S. Vikk's passing is better than his shooting.

J. Maybe a 65?

JJ. WOAH! Hold up! You're saying Vikk is better than me at passing? NO WAY!!!

J. But Vikk actually tries to pass the ball. You just run off and dribble.

S. To be fair, the only reason JJ doesn't pass is because he can't look up and dribble at the same time.

JJ. Yo, in eleven-a-side, where there's more time and space, I do pass.

S. No you don't!

H. What did we give JJ for his passing stat?

V. 48.

H. Then give Vikk a 49.

JJ. NO WAY! This is madness! People are gonna read this book and be like 'Damn, my boy JJ can't play!'

S. And they'd be right.

DRIBBLING

JJ. I swear if you give Vikk higher than me at dribbling I'm gonna bust a chair.

V. No, I'd give myself a 10 here.

J. As much as I would love to see JJ totally lose it I think we are going to struggle to offer you more than a 12 here. Sorry Vikk.

V. That's more than I was expecting so I'm happy.

DEFENCE

T. He's small but I reckon he could do some damage if he wanted to.

JJ. No!

T. You're just saying that because you don't want us to rank him higher than you.

V. I'm OK in goal.

S. But being a goalkeeper is different to being a defender.

H. Technically a goalkeeper defends the goal as the last resort of defence.

E. He's got a point. Plus Vikk is the only one of us who is happy to volunteer to go in goal so I think he deserves bonus points for that.

J. OK, just because he doesn't mind going in goal let's give him a 34.

PHYSICALITY

S. This could be our first minus rating…

H. Physicality shouldn't count for Vikk. He just avoids it at all costs, that's why he likes going in goal.

V. I'll happily take a minus four for physicality. There's no defending me here.

JOSH

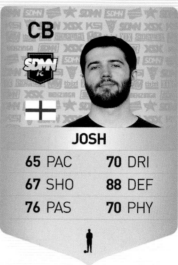

CB

JOSH

65	PAC	**70**	DRI
67	SHO	**88**	DEF
76	PAS	**70**	PHY

PACE

J. Oh great! This isn't going to be a strong start.

S. You're not renowned for your pace.

T. Sorry Josh but this is definitely going to be in the 60s.

JJ. 65 is about right.

SHOOTING

JJ. This could be 65 as well.

J. I've got no chance with you guys marking me.

H. That's not true. When we get to defence I'll be campaigning for you.

V. To be fair, I just don't think Josh gets in many shooting positions so it's hard to judge.

T. He does like to play at the back and most defenders aren't great at shooting.

E. We don't want two 65 stats so let's bump him up to 67.

J. You're too kind.

V. I'm glad to see this is such a scientific process.

PASSING

S. OK, this is a bit higher.

JJ. Yeah, but still only in the 70s.

H. I actually think Josh is good at passing.

JJ. No, he's a very average player.

J. Harsh!

JJ. You said Vikk was a better passer than me!

J. He is!

JJ. NO WAY! He

H. Uhhhh guys, we've gone over all that already. I say we give Josh a 76 for passing and move on.

DRIBBLING

T. He's a better passer than a dribbler.

J. That's probably true.

E. He knows his limitations so doesn't even try to dribble.

S. If we've given him a 76 for passing then he should be around 63 for dribbling.

H. He's better than that!

JJ. Yo! Why are you always sticking up for Josh?

H. I just think you guys are being harsh. He's a decent player.

JJ. All right, I'd give him 70 for dribbling. That OK with you?

H. That's acceptable :)

DEFENCE

S. All right, this is Josh's strong point.

J. At last!

E. Yeah, he does like hanging back.

JJ. That's only because he's unfit!

H. No, I think he's good in defence because he can read the game.

JJ. Harry, if you like Josh so much maybe you should marry him?

S. Imagine what their kids would look like?

V. Let's do a FaceMerge later and have a look!

J. I can't wait for that!

H. If his defence is his best stat, and he's one of the best defenders out of all of us, we should probably give him an 88.

JJ. Why don't you give him a kiss as well!?

PHYSICALITY

JJ. It's weird because while Josh is a good defender he doesn't seem to get physical.

J. That's because I can read the game.

E. You definitely didn't pick that up watching Millwall!

J. That's rich coming from a West Ham supporter!

E. We've produced two of the greatest English centre halfs of all time, Bobby Moore and Rio Ferdinand.

S. You're going to bang on about West Ham winning the '66 World Cup next aren't you?

E. We did!

S. No Ethan! You didn't! You weren't even born at the time anyway!

T. Anyway, let's get back to Josh's physicality stat. To be honest, I don't think he likes the dark side of the game.

J. I'm a purist.

S. Give him a 70 just because he can apparently 'read the game', whatever that means.

HARRY

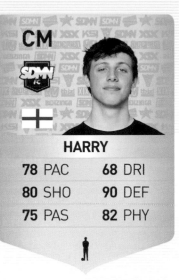

CM

HARRY

78	PAC	**68**	DRI
80	SHO	**90**	DEF
75	PAS	**82**	PHY

PACE

s. Are you faster than me?

н. I'm not sure.

т. I don't think he is.

j. But Harry is pretty quick.

s. If I'm 75 I would put Harry 78.

н. I don't know if I'm quicker than you but I'll take a 78!

SHOOTING

т. Harry actually pulled off an amazing shot the other night.

е. Oh yeah, it went top bins!

s. But Vikk was in goal!

v. If we had all been in goal we still wouldn't have stopped it.

jj. No, Harry is surprisingly good at shooting.

s. To be fair he is always pretty good in our football videos.

е. Could he be as high as 80?

j. After his shot the other night he deserves it.

PASSING

s. He's pretty average here so I'd give him a 75.

jj. I still don't get why my passing is so low!

е. BECAUSE YOU DON'T PASS!

s. And when you do try you're really really bad.

j. The only time I remember JJ passing accurately to someone on his team it was actually a miss-hit shot.

jj. That's not true! This book is full of lies!

DRIBBLING

т. I've seen Harry bust out some nice skills.

jj. He's not really a dribbler though. What did you guys give me?

v. 64.

s. Then give Harry 68.

jj. For real? I can't believe I'm gonna be one of the worst dribblers here! I swear to God! You guys are sick.

DEFENCE

s. We gave Josh 88 here but I think Harry might be a slightly better defender.

н. Ooooh, do I get a 90?

jj. Positioning wise he is good. He always seems to come out of nowhere and nick the ball away. It makes me so mad.

s. When we played at Wembley Harry was immense. If Roy Hodgson was watching that day he would have made the England squad.

j. Give Harry a 90 for defence because he was sticking up for me.

v. I wonder if the guys who do the ratings at FIFA do their ratings based on things like that?

jj. I don't think the guys at FIFA base their ratings on anything. I swear half of them have never even seen a football match.

PHYSICALITY

т. Harry doesn't really get stuck in.

v. But when he does put in a tackle it is usually a big one.

е. Yeah, I've seen Harry put some massive tackles in.

jj. I'd say he's about an 82.

н. Wow! I actually look like a decent player according to this!

TOBI

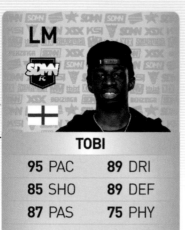

TOBI

95	PAC	**89**	DRI
85	SHO	**89**	DEF
87	PAS	**75**	PHY

PACE

s. This is going to be the highest rating we've given to any of us.

J. Definitely in the 90s.

T. I don't think I'm as quick as I look.

JJ. How can you look quick? You either are or you're not!

H. Tobi is so quick sometimes he outruns the ball.

E. He's easily a 95 for pace.

SHOOTING

s. Tobi's shooting is decent.

JJ. When he gets in good positions he does usually finish.

J. I'd say 81.

H. I think he's better than that.

E. 85?

s. Done! Next!

PASSING

s. Would you say his passing his better than his shooting?

V. Definitely. You rarely see Tobi give the ball away.

J. I don't think it's quite good enough for the 90s though.

JJ. 87 is about right.

DRIBBLING

T. I have to admit, I do like dribbling.

JJ. To be fair, my boy Tobi has got some skillz.

H. He sent me so many ways when I went to tackle him the other day I fell over!

E. I'd go with high 80s for this.

J. Well we can't go any higher than 89 so let's give him that.

DEFENCE

T. I know you might not think it but I'm not a bad defender you know.

JJ. I don't think I've ever seen you play defence.

T. I played four games at right back in Sunday League and we didn't concede in three of the games.

H. That's good enough for another 89 for me.

PHYSICALITY

JJ. Tobi does actually get stuck in but because he's not the biggest, when he gets nudged he goes flying.

T. I know! I always end up getting really bad astro burns.

V. I actually think he should be marked up because of that. Even though he's small he's not afraid to put himself about.

s. True. I was going to say 68 but now you've said that I think 75 is fair.

ETHAN

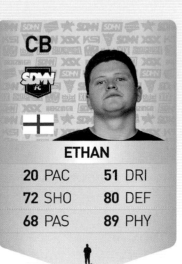

CB

ETHAN

20	PAC	51	DRI
72	SHO	80	DEF
68	PAS	89	PHY

PACE

т. 20?

E. C'mon! I know I'm slow but I'm not that slow.

J. I think you actually are.

JJ. There's no way Ethan is higher than 20.

SHOOTING

H. He does have a thumper on him.

S. All right Harry, steady on.

H. No! Not like that! He's just got a really hard shot.

J. Yeah, every now and again he does catch one sweetly.

E. That's when I wind up the long-range beast.

JJ. But how many actually go in?

J. That's true. Not many but when they do go in they are usually spectacular. I'd say 72.

E. I can live with that.

PASSING

E. I can definitely pick a pass.

S. You're better at picking your nose!

JJ. Yeah, I'd say 68.

E. Can we say 69 for bants?

JJ. No.

DRIBBLING

S. Ethan is definitely not a dribbler.

E. All right, I hold my hands up, but I can drop a sick body feint.

J. Not that sick.

H. Is he better at dribbling than JJ?

S. Definitely.

JJ. WHAT!!!? Nah, I've had enough of this man. How can you even say that with a straight face?

S. Because when Ethan tries a stepover he doesn't fall over and injure himself.

JJ. That happened one time. I'm outta here man. This is so messed up.

S. Chill JJ. I'm joking. Ethan is never better than a 51 for dribbling.

DEFENCE

т. Ethan isn't actually too bad at tackling.

JJ. I swear he injures me every time we play.

S. That's just you trying stepovers ;)

JJ. Why do you want to make me mad? Serious! You know what I get like when I get mad!

J. Shall we say 79?

S. Give him 80 because I'm in a good mood.

JJ. This is you in a good mood!?

PHYSICALITY

E. All right guys, you've got to give me a decent score here?

V. Who's had the highest physicality score so far?

H. We gave JJ 90.

J. Ethan does like to throw himself about but I don't think he should get more than JJ.

S. Yeah, I think he just misses out so 89 is fair.

JJ. At last common sense prevails!

THE SIDEMEN
SEVEN-A-SIDE TEAM

Going through our strengths and weaknesses has made us realise what position some of us should play rather than what position some of us want to play.

We now know for sure that with his dubious passing ability JJ should never play centre midfield, while a sweet right foot like Simon's needs to be up front where he can do the most damage. On the other hand Vikk has to go in goal where he can do the least damage.

The self-proclaimed 'readers of the game' Josh and Ethan can use their silk and grit at the back, with Harry's eager energy, and diligent passing, in defensive midfield keeping the team ticking over.

Our secret weapon however has to be Tobi's pace out wide. Not only is Tobi a threat to the opposition but he can also keep the ball away from Josh and Ethan long enough for them to catch their breath. This football malarky is hard work you know!

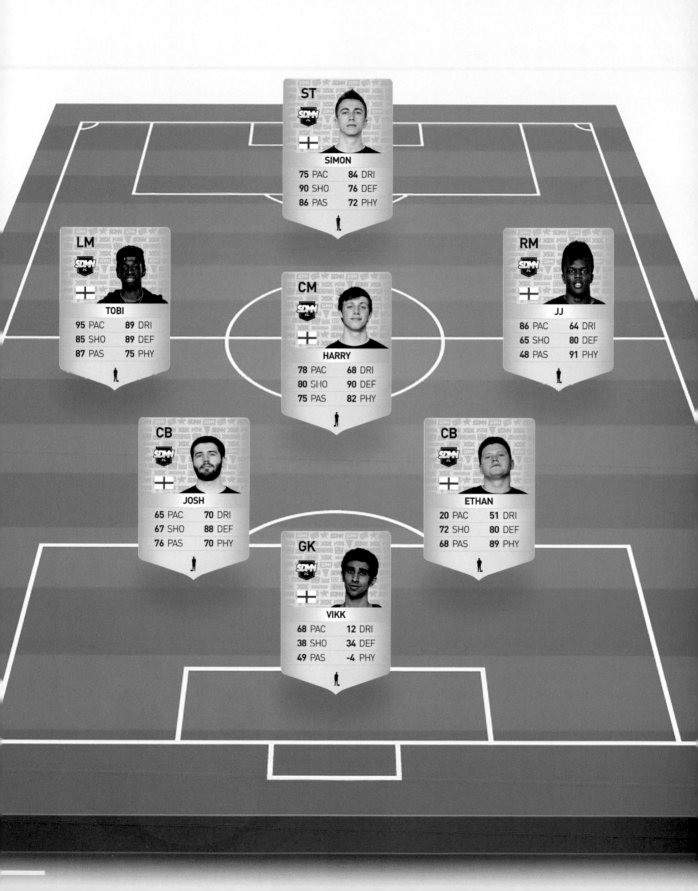

ST
SIMON
75 PAC 84 DRI
90 SHO 76 DEF
86 PAS 72 PHY

LM
TOBI
95 PAC 89 DRI
85 SHO 89 DEF
87 PAS 75 PHY

CM
HARRY
78 PAC 68 DRI
80 SHO 90 DEF
75 PAS 82 PHY

RM
JJ
86 PAC 64 DRI
65 SHO 80 DEF
48 PAS 91 PHY

CB
JOSH
65 PAC 70 DRI
67 SHO 88 DEF
76 PAS 70 PHY

CB
ETHAN
20 PAC 51 DRI
72 SHO 80 DEF
68 PAS 89 PHY

GK
VIKK
68 PAC 12 DRI
38 SHO 34 DEF
49 PAS -4 PHY

THE SIDEMEN'S GUIDE TO SEVEN A SIDE

As we write this we are gearing ourselves up for our big match at Southampton's St Mary's Stadium. We can't wait, but at the same time we are also a little nervous.

While we are happy to look stupid in front of millions of people in our videos, no one wants to fall over the ball in front of a big football crowd. In order to help us get sharp, and avoid this fate, we have been organising a lot of seven-a-side matches. However, these matches have emphasised a few things, mainly that we are really unfit!

Anyway, as we tweak our tactics for the big game we thought we would share some very valuable seven-a-side lessons that we think are going to be the key to our victory, or at the very least make any defeat as painless as possible...

1

If you are near any member of the opposition JJ recommends diving to the floor and screaming like you've just been shot. For inspiration watch Real Madrid's Pepe in action.

2

Don't go near the fences. Someone will always body-slam you into them, and their name usually begins with an E...

3

Nutmegs are as good as goals, especially if you shout 'PANNA' just after you slip it through your opponent's legs. Simon loves this. It's really annoying.

4

Do your boots up tight and avoid rolling around on the artificial turf. Those black bits are a nightmare once they get in your car, or on the carpet, or, as Vikk found out, finding them lodged in some unusual places when you have a shower afterwards...

5

Place your bag as near to the goal as possible, but not too near. This is a very specific science. You need it to be far enough away so people don't trample all over it but also not too close, so the ball doesn't hit it. Vikk recommends bringing a tape measure to get the perfect distance.

6

Don't get hit by the ball when it's cold. In fact, when it's cold Harry thinks you're better off staying indoors and having a lovely cup of tea.

9

Always be prepared to take one for the team. However, luxury players like Tobi are excused, as he's one of our best players, and we can't afford for him to be injured.

12

Save energy tracking back by just calling for the ball as if you're on the other team. It's amazing how often they will pass you the ball if you just call for it. However, if they do pass you the ball don't just stand there and laugh like Ethan.

8

If you are prone to kicking the ball over the fence Josh recommends making friends with the people on the pitch next to you. At least then you stand a good chance of them kicking it back.

11

Everyone should bring a football just in case the one person you're relying on to bring one forgets or doesn't turn up. Ahem JJ….

14

If you lose, go home, play *FIFA* and take out your frustration on the worst team in the game.

7

Avoid kicking the ball over the fence. However, the rule is that whoever kicked the ball over has to go and get it. No excuses! We are looking at you JJ!

10

Bring bananas and Luccozade with you to share. Vikk thinks this is especially important if you're not very good at football, as if you mess up during the game people are less likely to shout at you.

13

Bring goalkeeper gloves. If it's your turn in goal you don't want to be saving shots without any protection, especially on a cold night. Harry also has another solution. Just jump out of the way of the ball. We don't recommend this.

THE BEST FIVE-A-SIDE FOOTBALL TEAM NAMES EVER

Since we've all started playing a bit of five-a-side we couldn't help but have a good old chuckle at some of the team names we've come across. Sometimes we look at the leagues on the board just to amuse ourselves.

So, if you are ever struggling to come up with a name for your five-a-side team then we can definitely recommend some of these for the pure bants:

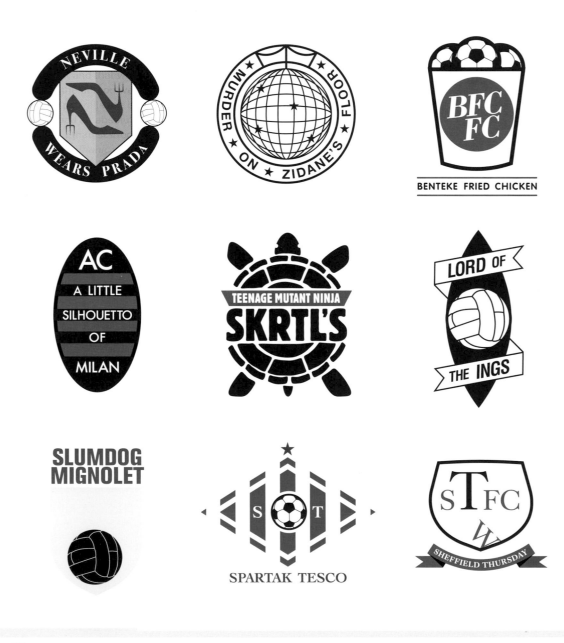

YOU CAN'T HANDLE THE HUTH

TAKE ZLAT AND PARTY

CESC AND THE CITY

ABCDEFC

REAL SOCIOPATH

THE BIG LEWANDOWSKI

LADS ON TOURE

If you've got any other funny five-a-side team names tweet them to us with the hashtag #sidemen5asidenames. We will retweet the ones that make us snort with laughter.

FIFA CHALLENGES

Sometimes a regular game of FIFA just doesn't cut it. Don't get us wrong, we love FIFA just as it is, but every now and again it's good practice to really put your skills to the ultimate test. It's amazing how even the most skilled players can crack when something more than just the game is riding on it. In fact, we think the Premier League should seriously consider bringing some of these challenges in just for the bants!

PLAYERS PLAY EACH OTHER BLINDFOLDED.

PLAYERS CAN ONLY USE THEIR FEET TO CONTROL THE CONTROL PAD.

PLAYERS MUST PLAY THE GAME WITH THEIR BACKS TO THE SCREEN WHILE FACING A MIRROR.

BEFORE THE GAME EACH PLAYER MUST GIVE THEIR CONTROL PAD TO THEIR OPPONENT, WHO IS THEN ALLOWED TO CHANGE THE CONTROL OPTIONS.

EVERY TIME A PLAYER MISSES A SHOT THEY HAVE TO PICK, AND EAT, A JELLY BEAN FROM A PACKET OF BEANBOOZLED. WHO KNOWS WHETHER THE GREEN JELLY BEAN IS LIME OR LAWN FLAVOURED?

EVERY TIME ANYONE SCORES A GOAL THEY HAVE TO POUR SOMETHING INTO A GLASS. THE EVENTUAL LOSER OF THE GAME HAS TO DRINK WHATEVER IS IN IT.

PLAYERS HAVE TO PLAY THE ENTIRE GAME WITH THEIR CONTROLLERS UPSIDE DOWN.

EACH PLAYER HAS TO PLAY USING TWO CONTROLLERS.

THE STRONGEST PLAYERS IN THE GAME PLAY AGAINST THE WEAKEST PLAYERS IN THE GAME.

THE MOST EXPENSIVE PLAYERS IN THE GAME PLAY AGAINST THE LEAST EXPENSIVE.

FIFA FORFEITS

Oh man, sometimes the simple joy of absolutely battering your mate at FIFA just isn't enough. They've been giving it the big one all day, and ~~you really want to yell in their face and let them~~ know who's boss. Sure, you'll sleep well at night thinking of that sweet Neymar goal that clinched the win, but what you really want is to laugh your tits off as your mate suffers the ultimate humiliation of a crushing FIFA defeat... a forfeit. As you can imagine, in the Sidemen house we've had to enforce a few forfeits from time to time. It's not big, and it's not clever, but sometimes it has been very necessary to put people in their place. Here are just a few of the forfeits we've had riding on our games:

THE LOSER MUST SIT IN AN ICE BATH FOR ONE MINUTE IN JUST THEIR UNDERWEAR.

THE WINNER IS ALLOWED TO USE WAX STRIPS ON THE LOSER'S LEGS (ASK YOUR MUM OR SISTER'S PERMISSION BEFORE YOU GO AND STEAL THEM!).

IF HESKEY SCORES AGAINST YOU, YOU HAVE TO CHANGE YOUR PROFILE PICTURE ON SOCIAL MEDIA TO ONE OF HIM, AND ~~CHANGE YOUR NAME TO~~ **'I'VE BEEN BEASTED!'**

THE WINNER IS ALLOWED TO SLAP THE LOSER ACROSS THE FACE WITH A FISH. PRO TIP: THE SMELLIER THE BETTER.

3

THE WINNER IS ALLOWED TO BREAK AN EGG ON THE LOSER'S HEAD. WE FIND BREAKING THE EGG VERY SLOWLY INCREASES THE LOSER'S PAIN. JUST THE ANTICIPATION OF IT BREAKING ON THEIR HEAD IS ENOUGH TO HAVE THEM SHRIEK LIKE A BABY.

4

THE LOSER MUST HAND OVER THEIR SOCIAL MEDIA ACCOUNTS TO THE WINNER FOR FIVE WHOLE MINUTES. DURING THAT TIME THE WINNER IS ALLOWED TO POST WHATEVER THEY PLEASE.

5

IF THE LOSER HAS LOST BY FIVE GOALS OR MORE THEY MUST WRITE, OR FILM, A PUBLIC LETTER OF APOLOGY AND POST IT ON SOCIAL MEDIA.

8

THE WINNER IS ALLOWED TO PELT THE LOSER WITH WATER BALLOONS.

9

THE LOSER MUST EAT A CHILLI PEPPER. MAKE SURE YOU HAVE MILK ON STANDBY.

10

THE LOSER MUST DYE THEIR HAIR A COLOUR OF THE WINNER'S CHOICE AND KEEP IT FOR TWENTY-FOUR HOURS. AMAZINGLY, WHEN JJ BLEACHED HIS HAIR BLONDE THAT WASN'T FOR A FORFEIT...

THE SIDEMEN TEENAGE YEARS

Here we go, now we are starting to resemble the Sidemen you all know. The haircuts are getting worse, and so is the dress sense and acne, but can you still guess who is who? It's a miracle any of us have ever had girlfriends looking like this!

a)

b)

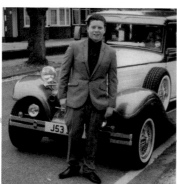

c)

d)

e)

f)

g)

Answers: a) Simon; b) Ethan; c) Tobi; d) Vikk; e) Josh; f) Harry; g) JJ

THE SIDEMEN RANDOM TRIVIA PAGE

I bet you think you know all there is to know about us? Yeah we spend a lot of our time making videos, telling you guys all about our lives, but here's some stuff we've never revealed before, until now...

1.
JJ can't straighten his little finger after his grandmother slammed a door on his hand as a child.

2.
Tobi has a silver tooth.

3.
Simon has OCD. Everything always has to be at an even number but even though it's odd, he can handle the number 5.

4.
Vikk used to have a pet duck called Chocolate and a pet chicken called Speedy.

5.
Josh is ambidextrous.

6.
Ethan is claustrophobic. He freaks out whenever he is in an enclosed space.

7.
Tobi owns over fifty hats.

8.
Simon is a shareholder in Domino's Pizza! He gets a cheque for 11p every month.

9.
Harry has at least four showers every day.

10.
Josh used to have two pet rats, George and Stuart (after Stuart Little).

11.
JJ has a scar on his right elbow after he ran into a tree.

12.
Vikk has a star named after him (The Vikkstar).

13.
Ethan had a skin graft on his arm after he accidentally tipped hot water from a kettle on himself as a child.

14.
Tobi can play the drums and the piano.

15.
Neither Josh nor Ethan has ever drunk tea in their life.

16.
Harry has had an enema, and he kinda enjoyed it...

17.
Simon has the title of 'Laird' after someone bought him a tiny plot of land in Scotland but he doesn't like to talk about it...

THE SIDEMEN TAKE OVER THE WORLD

Over the last few years we've done quite a bit of travelling individually as well as together. It's gone so fast that it's hard to remember all the places we've actually been, so we thought it would be cool to show it on a world map, using our GTA colours. It turns out the Sidemen really are taking over the world ;)

JJ
India, Germany, Guernsey, Cyprus, Netherlands, USA, France, Italy, Spain, Portugal, Wales, England, Scotland, Switzerland, Iceland.

HARRY
England, Guernsey, Alderney, Jersey, France, Switzerland, USA, Hawaii, Germany, Portugal, Gibraltar, Netherlands, Cyprus, Italy.

SIMON
England, Wales, Scotland, Ireland, France, Spain, Portugal, Italy, Greece, Sweden, Luxembourg, Mauritius, Netherlands, Ghana, Burkina Faso, USA, Mexico, Canada, Switzerland, Cyprus.

VIKK
France, Switzerland, UAE, England, Wales, Ireland, USA, Canada, Australia, Germany, India, Spain, Hungary, Sweden, Cyprus, Netherlands, Austria.

TOBI
England, France, Belgium, Spain, Italy, Cyprus, Iceland, Nigeria, Germany, Sweden, USA.

ETHAN
England, Germany, USA, Ibiza.

JOSH
England, all of the Caribbean, Mexico, USA, France, Spain, Portugal, Turkey, Italy, all Greek islands, Germany, Switzerland, Luxembourg, Wales, Greece, Cyprus, Belgium, Austria, Malta, Egypt, all of the Canary Islands, Madeira.

THE SIDEMEN ON TOUR

Yeah boi! We love it when we get to go away together. Mad stuff always seems to go down and thankfully we usually manage to capture most of it on camera for your viewing pleasure.

But sometimes the funniest stuff happens when we least expect it. So kick back, relax and let us regale you with tales of 'The Money King' and how Harry almost drowned in a hotel room!

GAMESCOM 2014 – GERMANY

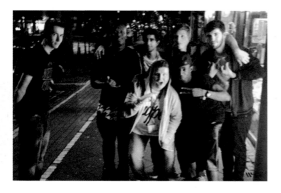

This was the first time we attended anything outside the UK as the Sidemen. Gamescom is in Cologne and is the biggest gaming convention in the world, so it was a big deal and really cool to meet fans from around the world. We remember we were so excited when we landed we went straight from the airport to Phantasialand but Ethan had to leave early as he had a toilet emergency…

The photo of us all was taken outside a bar in Cologne where we had a few wild nights out with some really funny stories. One night a group of girls were quite impressed by Ethan buying everyone drinks, and christened him 'The Money King', which he thought was sick. Sadly 'The Money King' puked in his bed later that night and instantly lost all credibility.

One night Harry almost managed to flood the room! He fell asleep in the shower but blocked the plughole. Simon noticed water was seeping under the bathroom door but couldn't get in because Harry had locked it. It was only after Simon almost banged the door down that Harry woke up and realised what he had done. This picture captures the moment perfectly.

It was a great few days though and really marked the start of the Sidemen on the world stage.

COMEDY CENTRAL – LONDON

We were so excited when Comedy Central invited us to take part in a series of challenges that would determine who was the ultimate Sideman! Deji and Lucy Vixen hosted the show (as you can see in the picture we were all keen to get close to Lucy), and it was basically just a load of crazy challenges, like eating chillies and making prank calls on helium. In the end Josh emerged victorious and a day has never passed since when he doesn't remind us that he is 'The Ultimate Sideman'!

Still, it was a real honour to work with Comedy Central and we laughed our asses off the entire time we were there.

INSOMNIA 53 – COVENTRY

This is the first UK gaming event we all did together and it was the first time it really hit home to us just how mad things had become. As soon as the doors opened our stand was swarmed by fans. It actually got so out of control we had to hide behind the table, but fans were still sticking their hands between the gap and pulling our hair and stuff. It was so overwhelming. None of us had experienced anything like it before but it was amazing to actually get to meet our fans in such large numbers.

We remember that JJ was so exhausted by it all that when he fell asleep Lucy Vixen covered his face in Smarties. He was asleep for so long they melted into his face so he had blue marks all over him. He didn't even realise, so we didn't tell him. He ended up spending the whole day with his face covered in chocolate!

PAX EAST – BOSTON

This was pretty major as it was the first time we had all gone to an event in the USA together, so we were all gassed, especially when the event paid for us all to travel in Premium Economy, which we thought was pretty sweet. However, for some reason JJ ended up having to pay for his own flight so he sat in Business! We were all so jealous, as it was complete luxury, but we were getting a free trip to the USA so couldn't complain.

The event itself was major as we got to meet our US fans, but sadly we didn't see as much as the city as we would have liked because there was a snowstorm and it was so cold. However, we can testify that Boston does bad boy steaks and fat burgers, while Ethan bought eleven pairs of trainers in the mall, which meant he had to buy a new suitcase so he could bring them all home. We also repped the UK by making all our cab drivers play UK grime music. We think they liked it…

INSOMNIA 55 – COVENTRY

That's Harry with his pants down in the picture! When we uploaded the video to YouTube they made it age-restricted just because of that!

Anyway, if we thought Insomnia 53 got out of hand then this was another level again. We had planned to do loads of cool stuff but so many people came to see us that our stand broke and we were warned we would have to cut our show down for health and safety reasons. We were also told we couldn't ride our Swegways (hoverboards) because of health and safety, which we ignored of course being as we are total badasses…

It was a shame we couldn't do as much as we had planned but we spent hours signing autographs for fans and had a really good time meeting everyone. While Ethan's day started on a bad note, him having left his wallet in a taxi, he ended up getting emergency cash from the bank and turning £250 into £2000 in the casino later that night. All in all it was an amazing few days.

AYIA NAPA

Only six of us could go on this trip because Josh was man down. We tried to think how we could put this diplomatically but all we can say is that he was whipped!

Anyway, as you might be able to see in the picture, we were joined by some of our YouTube bros, and had a mental ten days! JJ was performing with Chris Brown at Napa Rocks where he played Lamborghini, which was something we will never forget, and then we just spent the rest of our time soaking up the sun and hitting the bars. A few of us had to spend a month in bed afterwards to recuperate but it was a great way to blow off some steam after lots of hard work.

THE SIDEMEN TWO-YEAR ANNIVERSARY PARTY

It's hard to believe that just two years after we kicked everything off as the Sidemen we were celebrating at the Emirates Stadium. During the day we hung out with around 150 of our fans, playing games against them, and doing a stadium tour, and then at night we had a huge party with friends and fellow YouTubers. There was a free bar and camera booth as well so things got pretty cray. In fact, the picture we've used is just about the only one we could find of us all in the camera booth that was appropriate.

By the time this book comes out we will have been doing this together for three years. Hopefully we will have some sort of party to mark the occasion and we hope there will be plenty more to come!

HARRY'S GUIDE TO

Guernsey

HARRY'S GUIDE TO GUERNSEY

H. **Welcome to Guernsey, which is a wicked place for a holiday if you've never been. The flight is short, the beaches are sandy and you don't have to worry about changing currency, although we also have our own. Check out this bad boy Guernsey pound!**

So roll up, roll up, and have a gander at what Guernsey might have in store for you.

PETIT BOT BEACH

What an absolute stunner this place is. It's probably my favourite beach on the island; although there are quite a few I love. Petit Bot is surrounded by high cliffs and is a real suntrap, so you're guaranteed to get a good tan.

There is a waterfall as you approach the beach as well as an old German watchtower from the Second World War to explore. If you're into your surfing then Guernsey is also a great place to catch some waves.

PEA STACKS

Rock jumping from Pea Stacks is an absolute must if you're in Guernsey. This might sound suicidal but trust me, it's not. I've been doing it since I was a kid and I turned out all right… didn't I?

As you can see in the picture, there are three levels you can jump from. I've done the first two but I've always bottled the big one at the end. I'll do it one day! Maybe for a video…

ST PIERRE PARK HOTEL

This is one of the nicest hotels on the island and is where JJ stayed when he came to visit. The suites have huge beds to bounce around on, while you can also attempt to play golf and hit up the indoor health spa. I recommend bombarding room service and watching a good film while also raiding the minibar!

LIHOU ISLAND

Guernsey is surrounded by small islands, such as Herne and Sark. All of them are worth checking out but I would say the best way to do it is to hire a jet ski and go from island to island.

For me the best island to go to is Lihou Island. When the tide is out you can actually walk there, which is really cool. Once you're there you can explore the old priory ruins and go for a dip in the natural Venus Pool, which forms at low tide. And if you really want to get away from it all you can stay the night at the only house on the island! A word of warning though – there is nowhere to eat so make sure you take your own food, unless you like eating seaweed, which doesn't taste as nice as the kind you get in your local Chinese takeaway!

THE HOOK

I like to think I know my sushi and this place is out of this world. Sure, Guernsey has loads of top-class restaurants but if I had to pick just the one this would be it. You definitely need to reserve a table though, as this place books up fast, especially in the summer. And who knows, you might even see me in there stuffing my face!

A: Petit Bot Beach

B: St Pierre Park Hotel

C: Pea Stacks

D: Lihou Island

E: The Hook Restaurant

TOBI & JJ'S GUIDE TO

Nigeria

JJ & TOBI'S GUIDE TO NIGERIA

JJ. Yo, I told you all I was gonna drop some sick facts about my motherland, Nigeria, so here it is! And seeing as Tobi has been as well he's coming along for the ride.

T. I've visited Nigeria a few times because I've got a lot of relatives over there, so let's do this!

FACTS ABOUT NIGERIA

JJ. All right, the capital of Nigeria is Lagos and —

T. Actually, it's Abuja, which replaced Lagos as the capital in 1991.

CLIMATE

JJ. So it's like really really hot in Nigeria so you're guaranteed to get a good tan. That's why everyone is black!

T. Y'know, it is really hot in Nigeria. In its hottest month, February, the average temperature is 30°C but even in its coldest month, July, the temperature is still 25°C. But that's not why everyone is black!

SIGHTSEEING

JJ. First of all, you gotta know that there are lions everywhere in Nigeria. People even ride lions to work. If you're rich you get a gold-plated one.

T. It's true! You can see lions in Nigeria but they are not on the street, and people don't ride them to work. You have to go to a national park if you want to see them. Nigeria has seven national parks but Yankari, near the village of Mainamaji, is regarded as the best. There you can see lions and also elephants, hippos and baboons. One of the other recommended spots to visit in Nigeria is the Nike Art Gallery…

JJ. Bro, that place is sick. When I went they had an amazing Nike Air Jordan collection.

T. It's actually an art gallery with some of the best artwork in Africa.

JJ. Oh yeah, I knew that, but if you're hitting up Lagos then you gotta make your way to the Lekki Market. That's where you can get all the loud, oversized African clothes, bones to go through your nose and big hats.

T. You can get a lot of cool things in Lekki Market but I don't think they sell bones to go through your nose…

FOOD

JJ. YO! The food in Nigeria is the best! I always hit up Kentucky Fried Lion and have the Sizzling Tower Lion wrap! But most people in Nigeria hunt for their food with spears.

T. JJ! Are you for real? There is no such thing as Kentucky Fried Lion and people definitely don't eat them or hunt for food with spears. The delicacy in Nigeria is stuff like jollof rice, fufu, moi moi, goat and okra.

MAJOR INDUSTRY

JJ. It's all about the booty dance in Nigeria. That's how they make all their energy. If you want to charge your phone you've got to shake your ass. For real! They've got whole factories of people just dancing all day.

T. Actually the major industry in Nigeria is oil! The country has proven oil reserves of 35 billion barrels and is one of the world's major exporters.

ACCOMMODATION

JJ. The last time I went to visit my fam I stayed in this proper mud hut where they made me the leader of the tribe. It was so badass. They carried me around on their shoulders and made me wear a lion skull crown.

T. Uhhhhh OK, but most people who visit Nigeria tend to stay in hotels, which are really nice. When I went I just stayed with my family in their house, which was pretty normal. You make Nigeria sound like the ghetto but so much of it is really nice. I went to Victoria Island, which had loads of cool malls, restaurants, cinemas and shops. They had all the Western chains as well.

HEALTH WARNINGS

JJ. So yeah, we all know that Ebola was in Nigeria so these days everyone has to walk around in giant condoms to stop them getting infected.

T. All right, there was an Ebola outbreak in Nigeria in 2014 but the country has since been declared Ebola-free.

JJ. Those massive condoms worked then!

T. You've never been to Nigeria have you?

JJ. No : /

A

B

C

A: Lekki Market

C: Healthy locals

B: Kentucky Fried Lion

ZERKAA

JOSH'S
**Perfect London
Day Out**
GUIDE

JOSH'S PERFECT LONDON DAY OUT

J. **London is one of the best cities in the world and having grown up there I like to think I know some of the top places to go. If you're thinking of having a day out there then why not follow my guide to the perfect day, which should have something for everyone!**

SELFRIDGES – OXFORD STREET

I love going into Selfridges just to check out all the cool gadgets downstairs. They've got everything you can think of from computers, phones and headsets to the biggest TVs you've ever seen! Even if you're not buying anything it's fun just to check out all the latest stuff. And there is nothing to stop you adding it to your Christmas list ;)

HAMLEYS TOY SHOP – REGENT STREET

This is seven floors of kids' paradise, and while it is meant for kids it's still a good laugh to go even if you're a little older. Hamleys is the world's oldest toyshop, and one of the biggest, so they have just about everything you can think of. And you don't need to buy anything to have fun, because they've got things like a huge Scalextric you can play with, and you can even jump around on a massive piano!

THE THEATRE

If you're in the West End you have to go to the theatre! There are so many cool shows out at the moment, like *The Lion King* and *Charlie and the Chocolate Factory*. I remember going to see Chitty *Chitty Bang Bang* when I was in school and I loved it!

THE DEN – MILLWALL

You didn't think my perfect London day out would miss out football did you? As you probably know, I'm a huge Millwall fan and nothing gets me more excited than a big game under the floodlights at The Den. The football might not always be the best but the atmosphere is amazing. Before the game you should pop into the Millwall Café and grab yourself a battered sausage and chips!

THE RAINFOREST CAFÉ – PICCADILLY CIRCUS

Just a short walk from Hamleys is the incredible Rainforest Café, where my parents used to take me for my birthday when I was a kid. It's literally like being in the middle of a rainforest, as they've not only got loads of cool robot animals, like elephants and monkeys, but they also do a fake storm that can actually be really scary. The food is great as well, especially if you go for my personal favourite, the Rainforest Classic Steak Burger!

HELIOT COCKTAIL BAR – HIPPODROME CASINO

After the madness of the West End you'll probably want to take a moment to chill, and this is my favourite place to do just that. It's situated in the Hippodrome Casino, but that doesn't mean you have to gamble. It's just got a really chilled-out vibe, refreshing drinks and lots of big screens, so there is always something decent to watch.

A: Hamleys Toy Shop

B: The Rainforest Café

C: Chitty Chitty Bang Bang

D: The Rainforest Café

E: The Den, home of Millwall FC

F: Heliot Cocktail Bar

MINTER
MM
MINI

SIMON'S
Gap year
GUIDE

SIMON'S GAP YEAR GUIDE

s. **Some of you reading this might be thinking of taking a gap year after school, and seeing as I did just that myself, I thought I'd share my experience so you can see if it's for you!**

I had always been tempted to do a gap year, because my two older brothers had done it and really enjoyed it. When I didn't get into my first-choice universities I thought it was the perfect opportunity.

A group of my friends were planning to go backpacking in Thailand later in the year so I agreed to go with them, but before that I really wanted to coach football somewhere.

Someone recommended I check out www.studentsabroad.com for a list of countries where I could go, and for some reason Ghana immediately jumped out at me. I don't really know why but it looked a nice place and would definitely take me out of my comfort zone. However, before I could jet off I first had to spend six months packing boxes in the Temptations factory so that I could afford to go!

GHANA

I stayed in a place called La Badi, south of the capital, Accra. An elderly couple put me up, as well as other travellers from all over the world, including people from America, Denmark and Holland.

A typical weekday usually went something like this:
1. Up at 8.30 a.m. to walk into the town centre to catch a tuk-tuk to the football pitches.
2. Coach the under-tens, elevens and twelves for three hours.
3. Head back to the elderly couple's house to eat.
4. Be back at the football pitches for 2 p.m. to coach the under-fourteens, fifteens and sixteens.

5. Go to the internet café to read and respond to emails and check in on social media.
6. Have a shower from a bucket because there was no running water.
7. Head into Akra and check out a few bars.

Coaching football was such an incredible experience. The kids knew all about English football and were so keen to learn, and some of them were really good!

I coached football all week, but the weekends allowed me and my friends to explore Ghana, and we had some incredible experiences.

PAGA CROCODILE POND

Oh my God! This was just insane. In this town near the Burkina Faso border there is a place where they worship crocodiles. There is a pond where people just rock up and hug them. As you can see in my picture, I am absolutely bricking it. It took a few attempts to get that picture, as I was convinced he was going to eat me, but he was actually quite chilled.

SAFARI PARK

Ghana is renowned for its wildlife. Even at some of the hotels we stayed in, wild warthogs were just roaming around outside. However, if you really want a true Ghanaian experience you need to check out a safari park, where there are lions, tigers, monkeys, elephants and a whole lot more.

WLI WATERFALLS

The Wli Waterfalls are the highest waterfalls in West Africa and are situated twenty kilometres from Hohoe in the Volta Region of Ghana. You have to hike to get there but it's well worth the effort as there is nothing more refreshing than dunking your head under a waterfall on a hot day!

USA

After two incredible months in Ghana I returned home to prepare to join my friends on a backpacking trip around Thailand. The only problem was, I didn't want to go! I was tired after two months in Ghana and really fancied going to visit my brother instead, who was studying in Texas, so the night before I changed my flights and made my way to the USA!

My bro was studying at Texas A&M, which is in a town called College Station. I had to catch a flight to Dallas and then on another flight, which would take me there. However, when I arrived in Dallas I learnt that my connecting flight had been cancelled and there wouldn't be another flight until the following day. As I had nowhere to stay I started to panic.

Thankfully, an older lady mentioned she had hired a car and was driving right there, so she said I could tag along with her. It was totally random. I didn't know her at all. She could have been a serial killer for all I knew but I wanted to get to College Town and had nowhere to stay, so I didn't have a lot of choice. She was actually pretty cool, although she played death metal music at full blast for the entire trip…

My time in the US was only six weeks but I had such a good time. I did all the sights in New York, Philadelphia and Washington before soaking up the sun, and theme parks, in Orlando and Miami.

Looking back I wouldn't change a thing about my gap year. It was such a great experience and I learnt so much. If you do get the chance to do it then I can highly recommend it!

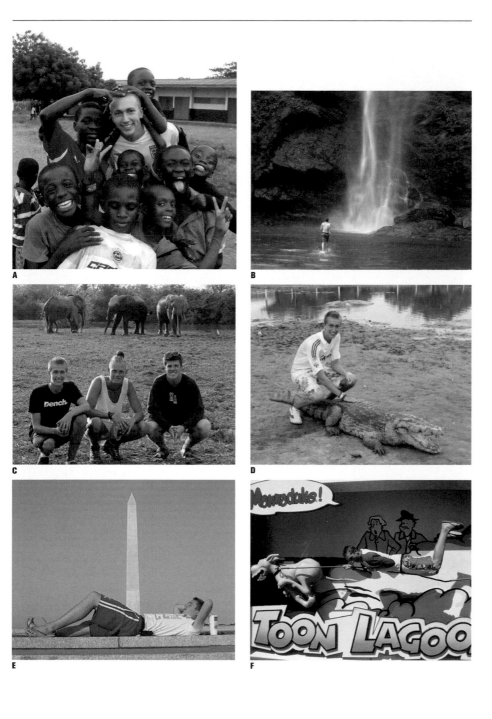

A: Ghana, La Badi

B: WLI Waterfalls

C: Chitty Chitty Bang Bang

D: Paga Crocodile Pond

E: USA

F: USA

VIKK'S GUIDE TO

Sheffield

VIKK'S GUIDE TO SHEFFIELD

v. At the start of the book I mentioned that when I was young I moved from the south to Sheffield, which was a bit of a culture shock. So, if you ever find yourself moving up north, or visiting Sheffield, hopefully this guide will help you out.

LEARNING THE LINGO

As you can probably tell, Sheffield is a pretty normal city. However, one thing that I did find difficult when I moved up north was getting to grips with the language. Sure, everyone speaks English but they say some things differently – like did you know that in Sheffield a 'genal' is an alleyway? So, if you do ever go up north bear some of these phrases in mind:

Aye	Yes
Bairn	Child
Chelpin'	Talking
Dursn't	Daren't
Flittin'	Moving house
Gaffer	Boss
Jiggered	Tired
Kegs	Trousers
Lavvy	Toilet
Maffin'	Hot weather
Neb	Nose
Owt	Anything
Plother	Mud
Radged	Angry
Spoggs	Sweets
Ta	Thanks
Yam	Home

THE PEAK DISTRICT

I always love visiting the Peak District for walks with my family. I've been going since I was young, and it's not far from my house so I try and go whenever I'm home. It's really relaxing to go for a walk, and get some fresh air, with some of the most incredible scenery.

If you're not one for walking then the Peacock Inn is one of the most famous pubs in the Peak District and I love going there. Not only does it have amazing food but the views are something else.

WINTER GARDEN

The Winter Garden is right in the middle of Sheffield and is like a giant greenhouse, with over 2,500 plants.

The building looks really cool and the café does nice cake, plus it's so warm you feel like you're abroad, which is never a bad thing in Sheffield because it can get quite cold.

PONDS FORGE INTERNATIONAL SPORTS CENTRE

Ponds Forge has an Olympic-sized swimming pool and is where I pretty much spent most of my time growing up, as I would train there most days. If you're feeling brave it also has Europe's deepest diving pool, which was home to the USA's diving squad for the London 2012 Olympic and Paralympic Games.

However, most people love Ponds Forge because of Surf City, which has a lazy river and some really cool slides.

THEATRES

Sheffield has two really cool theatres, the Crucible and the Lyceum. I always used to watch the Lyceum's pantomime at Christmas, and I loved *Oliver!* at the Crucible. Most people have heard of the Crucible, as it's where they host the snooker world championship. I've never actually been to watch it but everyone gets really excited when it's in town.

DRY SKI SLOPE

This is actually really sad as I learnt to ski here when I was a kid, but it's been closed for over a year now due to a fire and doesn't look like it is going to reopen. A lot of the Team GB Olympic athletes trained here as well, so I hope someone steps in to save it soon.

A: The Peacock Inn, Peak District C: Ponds Forge Sports Centre E: The Crucible, Sheffield
B: Peak District D: Winter Garden, Sheffield F: The dry ski slope.

THE ONLY WAY IS ETHAN

Oi Oi, welcome to my manor, the home of TOWIE, the mighty Hammers, Bas Vegas and yours truly. So slap on your fake tan and get yourself set for a whirlwind tour of my favourite places.

BEHZINGA

ETHAN'S GUIDE TO

Essex

ROMFORD

Romford is my old stomping ground but I ain't gonna lie to you, there isn't a lot to do. You've pretty much got your standard cinema, bowling alley and games arcade, which suits me down to the ground as I love all that stuff. Growing up I used to love a trip to the cinema. My mates would usually take girls with them, and sit in the back row, but I could never get anyone to go with me : (I still tagged along though as I couldn't resist a bucket of popcorn and *Nanny McPhee!* And I used to tear it up on the dance machine afterwards.

SUGAR HUT

Most people know of Sugar Hut through *TOWIE* but it's been an Essex institution for years and is such a banging club. It's got quality tunes, great drinks and good-looking girls. It's a bit posey though so it's not for me. Word of warning, get there early if you want to avoid queuing around the block.

LAKESIDE

Lakeside is an enormous shopping mall in Thurrock that has just about anything you can think of. To be honest shopping isn't really my thing, but I go there for two reasons, JD Sports for the trainers and Nando's for the nourishment. My perfect day is picking up a pair of fresh trainers and then treating myself to medium spice butterfly chicken, peri peri chips, halloumi cheese and then washing it all down with a soft drink.

SOUTHEND

If you get the weather right then a day out at Southend can be absolutely legendary. You've got a funfair where you can hit up rollercoasters, a promenade with games arcades, a sandy beach, the longest pleasure pier in the world and plenty of places to gorge on ice cream and a bag of chips covered in salt and vinegar. This is truly the crème de la crème of Essex and I've had some right good laughs there in my time.

THE SIDEMEN HALL OF FAME

We've all done a few things in our lives that we're proud of, and not so proud of (more on that in a bit). Anyway, we thought we'd all share with you the one thing in our lives that, if we kicked the bucket tomorrow, would allow us to die with smiles on our faces.

E. No contest. Mine would definitely be buying my mum a Mercedes convertible. I was so proud to give that to her.

JJ. Kicking my parents out of their house was pretty funny... and then buying them a new place!

S. OK, you'll think this is just for jokes but it's honestly completing my 2003 Premier League sticker album. I spent all my pocket money buying the stickers and it took me ages. When I finished it I even got a certificate, which I've still got to this day.

H. When I was thirteen I won a bronze medal in a UK singles table tennis competition. I don't think it was a national championship, or anything like that, but it was still awesome!

V. People will laugh at this or probably think I'm a super-geek but I would definitely say the 12 A stars I got for my GCSEs. I worked really hard so it was so satisfying to see it pay off.

J. Finishing university and getting a 2:1 whilst also doing YouTube full time has to be my greatest achievement. Trying to balance the two at the same time was extremely difficult.

T. Man this is tough, but I suppose reaching two million subs just the other day has been the highlight for me. I still can't believe all this has happened so quickly.

THE SIDEMEN HALL OF SHAME

Now we've basked in the glory of our greatest achievements it's time to take a long hard look at ourselves, as we finally reveal the thing we are most ashamed of…

E. Definitely my GCSE results. The best grade I got was a C, all the rest were Ds, Es and Fs. Although I didn't get a U, which I suppose I'm pretty proud of.

J. I'm still upset I've never released my 'Illuminate' video because it is amazing. I've been saying I'm gonna do it for a few years now so maybe I'll give the fans a treat soon ;)

JJ. Where do I begin? Getting rejected by my ex in front of everyone during a Duke of Edinburgh expedition wasn't that fun but I suppose getting kicked out of school wasn't my finest moment.

H. Uhhhhh this would have to be getting seven majors and sixteen minors on my driving test. I went through two red lights : /

V. This is really hard as I don't think I've done anything that bad. I suppose the one thing that does stand out is falling in a fountain when I was five but that was actually funny.

S. I got a U for my sociology AS level. I actually got 16 out of 120 but when I asked for it to be remarked they bumped it up to 21. Result!

T. No question, losing the Wembley Cup still hurts.

THE SIDEMEN AND FAMOUS PEOPLE

You've guessed which pictures have been us right the way to us becoming YouTubers. Seeing as it's too easy for you to guess who we are now we've mixed it up. Along the way we've had the privilege of meeting some pretty cool people. Why don't you try and guess who we are with in each picture?

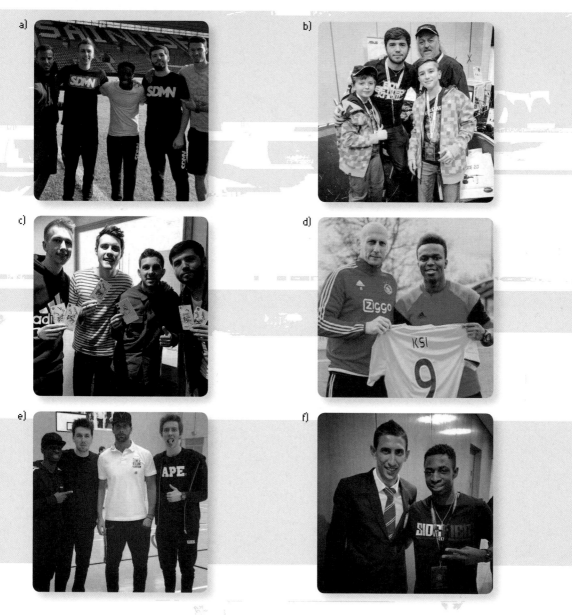

a)

b)

c)

d)

e)

f)

THE SIDEMEN ON THE SIDEMEN

We've all known each other for quite a while now, and document a lot of our lives in our videos and across social media. You'd think because of that we would know each other back to front. However, when we put each other to the test it turned out that maybe we don't know each other that well at all...

1. WHICH OF THE SIDEMEN GOT A C IN THEIR LATIN GCSE?

s. Well I got a B in Latin!

h. Well it's definitely not Simon.

j. Hang on, we can't say if we took Latin, or what our grades are, otherwise we can just work it out.

t. Vikk never got a C in his life. He always got straight As so it's definitely not him.

s. And Ethan never got a C in his life either. He always's got straight Ds!

e. Hey! I went to college!

v. It can't be JJ as he can't pronounce English words half the time, let alone Latin.

h. Yeah but he went to the same school as Simon so he might have taken Latin.

t. I actually think it might be Josh.

j. Why would it be me?

e. Because you look like the kind of guy who would actually pick Latin as a subject.

v. I'm going to say Josh as well.

jj. Josh.

h. Josh.

e. Josh.

s. Josh.

j. Tobi.

h. So who was it?

ANSWER: TOBI
RESULT: 0/6

2. WHICH OF THE SIDEMEN GOT AN X IN THEIR ADDITIONAL MATHS GCSE?

s. Ethan!

e. Hey! We haven't even discussed it yet.

jj. Woah, hold up. What is an X?

v. Isn't a U the lowest you can get?

jj. Yeah! There's nothing lower than a U. I swear. I know!

h. Maybe the X stands for excellent?

s. How would you even get an X? The examiner would just have to come in and tear up your paper.

t. Maybe you get an X for cheating? So it could be JJ?

jj. Hey! I don't cheat!

s. Maybe you should have?

e. Hang on a minute. Don't you have to be really clever to do additional maths? You need to get an A in the first place, so it can't be JJ.

jj. Thanks bro, I think...

j. Do you know what, I don't think we get Xs in this country so it has to be someone who isn't from England! I'm gonna say Harry.

v. Good point. I'm saying Harry as well.

jj. Nah, it has to be Ethan.

e. I'm going for Vikk.

v. Why me?

e. Because you're clever.

v. So why would I get an X?

t. Harry.

s. Yeah, I reckon Harry might have got an A in normal maths but not sure how he could have got an X. Harry?

h. Yeah it was me. I dropped out of the course but they still registered me for the exam. I didn't know, so I didn't turn up, and they gave me an X!

ANSWER: HARRY
RESULT: 4/6

3. WHICH OF THE SIDEMEN COUNTS COMPLETING A FOOTBALL STICKER ALBUM AS THEIR GREATEST ACCOMPLISHMENT?

JJ. Simon.

E. Simon.

J. Simon.

V. Simon.

H. Simon.

T. Simon.

S. Hey! I've never told any of you that so what made you so sure it was me?

T. Because that is just the kind of thing you would say.

S. I just think you all knew no one else in the group would have the discipline to complete an album.

ANSWER: SIMON
RESULT: 6/6

4. WHICH OF THE SIDEMEN WAS OBSESSED WITH ONE OF THE CAST OF TRACY BEAKER?

S. I think that has to be one of the younger Sidemen as we are too old to have watched it. I'll say Harry.

T. I watched *Tracy Beaker* but I wasn't obsessed with anyone. How can you be obsessed with someone from *Tracy Beaker*?

V. It's the type of thing Ethan would do.

E. I've never even watched it!

JJ. That's because you didn't own a TV! I think it's Harry.

E. Harry.

J. Harry

T. Harry.

H. Ethan.

JJ. HA HA it was me! I punked you all!

V. Who were you obsessed with? That's really weird!

JJ. All right, I wasn't 'obsessed' but I just thought the girl who played Justine was really really fit.

T. Montanna Thompson!

JJ. Yeah, that's her! You sure you didn't have a thing for her as well?

T. I actually met her at Soccer Six. She was cool.

S. You know she follows you on Twitter?

JJ. NO WAY!!!!

S. Jokes ;)

ANSWER: JJ
RESULT: 0/6

5. WHICH OF THE SIDEMEN WANTED TO BE A PILOT WHEN THEY GREW UP?

S. That has to be Ethan!

E. I've hardly flown in a plane!

J. Maybe that's why you wanted to be a pilot.

V. Harry has flown a lot.

H. Only as a passenger though.

S. I actually applied to be a pilot but I didn't get in.

JJ. What!!?

S. Yeah, I applied and everything but they turned me down.

H. So it's you?

S. No. I don't think so. I wouldn't say I really wanted to be one. I reckon it has to be Ethan.

J. Ethan.

JJ. Ethan.

V. Ethan.

H. Ethan.

E. I've already told you it's not me!

T. It was me! I used to love playing Flight Simulator as a kid.

JJ. What? You know there are no black pilots!!?

J. Yeah there are. Denzel Washington played one in that film *Flight*.

JJ. Yeah, and he crashed the plane!

J. Good point.

ANSWER: TOBI
RESULT: 0/6

6. WHICH OF THE SIDEMEN ONCE PLAYED FOR A JUNIOR FOOTBALL TEAM THAT LOST 32–0?

E. Harry.

JJ. Harry.

V. Harry.

J. Harry.

T. Harry.

S. Harry.

H. Yeah, it was me! And I was sub. Ha ha!

JJ. How can you be sub for a team that loses 32–0? How bad were you?

H. We were so bad that the league considered kicking us out. It was brutal.

ANSWER: HARRY
RESULT: 6/6

7. WHICH OF THE SIDEMEN HAD A HOBBY OF COUNTING CAR NUMBER PLATES GROWING UP?

S. I know this! It's Josh!

E. Really?

V. How do you even count that as a hobby?

J. When I was in the car I used to make a tally of all the number plates I had seen so at the end I could see how many cars with the letter M I had seen.

JJ. All right, that's really weird…

H. How old were you at the time?

J. About eight.

T. Wow! We grew up together but I don't remember you being that weird.

ANSWER: JOSH
RESULT: 6/6

8. WHICH OF THE SIDEMEN HAD A CRUSH ON THE SINGER JOJO?

T. Everyone!

JJ. I don't even know who she is!

J. You're missing out.

V. I think it's Simon actually.

H. Yeah, I think it's Simon.

S. Yeah, it is me, but it could have been all of us.

E. I actually thought it was me but I have never told anyone so I was wondering how anyone knew ha ha.

ANSWER: SIMON
RESULT: 5/6

9. WHICH OF THE SIDEMEN WAS A BENDY-RULER ENTREPRENEUR IN PRIMARY SCHOOL?

H. What's a bendy ruler?

E. A ruler that bends!

H. HA HA oh yeah.

S. Josh is always really business-orientated so it must be him.

T. I don't know. Vikk has gone really quiet all of a sudden.

JJ. Yeah, it's definitely Vikk.

V. Yeah, it was me. I thought I was going to be rich but there was no one left to sell them to after everyone in my year bought them.

ANSWER: VIKK
RESULT: 5/6

10. WHICH OF THE SIDEMEN HAD AN OBSESSION WITH CHEWING STRING AS A KID?

H. Why is everyone looking at me?

JJ. No, it's not Harry! It's definitely a thing Ethan would do. He's always hungry.

V. I actually think it's something you would do.

JJ. Why would I chew string when I could just go to KFC?

S. I actually think it might be Josh. When we first moved in he used to eat pen lids! I don't mean chewing them either. He used to devour them.

J. Pen lids are a fine delicacy.

T. No, I think it's Ethan as well. He always chews the string on hoodies come to think of it.

H. Yeah, it's definitely Ethan.

E. HA HA yeah, it was me. I loved the stuff!

ANSWER: ETHAN
RESULT: 2/6

11. WHICH OF THE SIDEMEN WANTED TO BE AN ARCHITECT GROWING UP?

H. I actually did but I'm not the answer you're looking for.

JJ. It's probably Ethan.

E. I swear you've said me for every question.

V. Well even a broken clock is right twice a day.

H. Is it? How does it tell the time if it's broken?

V. Are you being serious?… Don't worry. I'm going to say Josh.

T. Simon's gone really quiet though.

JJ. Yeah, but so has Josh…

S. Maybe it's both of us?

J. I think it actually is.

S. Yeah, I wanted to be an architect and I know you did as well so this question doesn't really work.

JJ. I suppose we should just give ourselves full marks!

ANSWER: JOSH AND SIMON
RESULT: 6/6

THE SIDEMEN SECRET SANTA

When we sat down to write this book Christmas was still a long way off. However, now it's fast approaching we're glad we did this exercise, as we know just what to get each other.

We all picked a name out of Tobi's hat and then had to think of what we would buy that person for no more than £10. It's safe to say that some of these presents will be going straight into the bin!

VIKK

E. Vikk is really clever, and loves science, so he could put this periodic table on his wall. I don't know what he would do with it but I suppose it would make him look clever.

SIMON

T. Simon seems to stress a lot so a stress ball might give him some relief.

JJ

S. I thought I would get JJ a sports bra for his man boobs. He needs all the support he can get!

JOSH

JJ.Josh is twenty-three going on fifty so some anti-aging cream should help keep my boy looking fresh.

HARRY

V. Harry seems to really like throwing chairs, so he can keep throwing an inflatable around to his heart's content.

TOBI

J. Tobi always seems to go missing – even he doesn't know where he goes sometimes – so this GPS tracker will help us find him.

ETHAN

H. Ethan gets really claustrophobic so he would probably really like some space. The picture shows actual space but I couldn't get him there for a tenner so I'd probably take him to a big open field and just leave him there. He'd love it!

LAST PHOTO ON CAMERA ROLL...

Absolutely no cheating was allowed for this. Everyone had to put their phone on the table and let the others see the last picture they had on their camera roll, which we were then going to share with you...

Everything was going well until we got to JJ's phone. That's when we had to change the rules. Instead of sharing the last photo we had on our camera rolls we suddenly had to change it to the last 'appropriate' photo. To be honest, it took us quite some time to find one on JJ's phone, and I'm pretty sure we are all scarred for life by what we've seen, but we got there in the end. Anyway, here is the last photo on all of our camera rolls...

TOBI

JOSH

JJ

SIMON

ETHAN

HARRY

VIKK

THE SIDEMEN TRY TO MAKE EACH OTHER LAUGH

OK, so we were all put on the spot and forced to tell the cheesiest joke we could think of in an attempt to make the others laugh. This is what we came up with…

JJ. Two cannibals are eating a clown. One turns to the other and says 'Does this taste funny to you?'

V. I went to buy some camouflage trousers the other day but I couldn't find any.

T. An invisible man marries an invisible woman. The kids were nothing to look at either.

S. What's the fastest biscuit? S'cone.

E. What do you call a fish with no eyes? A fsh.

J. What did the policeman say to his belly button? You're under a vest.

H. I went to a seafood disco last week… and pulled a mussel.

After we survived the tumbleweeds that went rushing past we realised that no one really tells jokes any more. It's all about memes! So, still in search of a good laugh we decided to share with you some of our favourites!

BROTHER WAS EATEN BY A LION

MORE RICE FOR ME

memegenerator.ne

BRUV DAT IS

VIKK

YOU MUST BE NEW HERE.

YOU DON'T SAY?

THAT POST WAS HILARIOUS!

I'LL COMMENT "LOL" SO THEY KNOW I LAUGHED

I DIDN'T CHOOSE THE THUG LIFE

THE THUG LIFE CHOSE ME.

IF THE SIDEMEN WERE EMOJI'S...

VIKK

This is literally amazing! Vikk likes to take his time to think and pulls this exact face when he does. It's like this emoji is an exact replica of Vikk's face.

ETHAN

Ethan is a very angry man. He's only one bit of 'bants' away from blowing his top and this emoji captures his expression perfectly when JJ is getting up in his grill.

JJ

You could probably use every emoji to describe JJ, but in the end we settled for this as we are pretty sure this was his exact face the day he bought his Lamborghini.

TOBI

Always calm, cool and collected. There was only ever going to be one emoji for Tobi and this is it.

HARRY

Harry worries about everything! He even used to think that we didn't like him, and sometimes he still thinks that we don't, which is mad.

JOSH

We joke that Josh always likes to stay neutral, and doesn't like to upset anyone, so this emoji with no mouth pretty much sums him up.

SIMON

Possibly the most sarcastic man on YouTube. If you've got a great idea, and want your dreams shattered, Simon is your man as this is the face he would pull!

SIDEMEN CHARITY FOOTBALL MATCH

If we had to pick a highlight from our time as Sidemen then this would be right up there. Playing against a YouTube Allstars team, at Southampton's St Mary's stadium, we always knew it was going to be a special day but in the end it surpassed all our expectations.

We not only got to have the time of our lives, and won the game 7-2, but we also had over 14,000 of you turn up to cheer us on in the stands and over 7 million watching on YouTube, which was a bigger audience than the Champion's League Final! You don't know how much that means to us and we can't thank you all enough for coming from all over the UK to support us. To top off a perfect day we raised over £100,000 for charity, which is truly incredible, and goes to show just how generous our fans really are.

As for the game itself we put all of our hard training to good use and put on a masterclass. Tobi and Manny were electric up front but the highlight for many was Simon's outrageous goal from the half-way line, which is probably the best goal any of us have ever seen. However, we also particularly enjoyed the fact that JJ didn't score as we would never have heard the end of it.

You might remember that we asked those of you who were at the game to tweet us pictures of you cheering us on? Well, the response blew us away, and I think we could have filled a few books with just pictures of our fans at the game and nothing more. Unfortunately we can't do that but we've picked out just a few here.

We hope to see you all again at our next Sidemen football match...

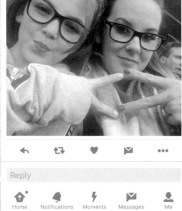

FAN Q&A

Alright, you guys know the drill. You ask us a series of serious and messed up questions and we give the same straight back at you. It's not complicated so let's just roll on into this and let the fun and games begin!

@kappalia
WHICH OF THE SIDEMEN WOULD YOU TELL YOUR DEEPEST, DARKEST SECRET TO?

V. I'd tell Tobi, he's super considerate!

JJ. Yeah, definitely Tobi.

E. Erm most likely Josh... I feel like he can be handy!

S. Tobi.

J. Tobi, 11 years gang.

T. Josh for the same reason!

H. Hmmmm, Tobi or Ethan probably.

@MrsLerone
SIDEMEN MOVIE NEXT LADS?

V. We'd all love to do a movie, but with all of our YouTube schedules, it's doubtful there would be time any time soon. It's hard enough to get us all in the same place once, let alone several times to shoot a movie!

E. Hmm.. we'll see. It could be pretty cool.

H. You never know! But at the moment all it would be is footage of us sat at our computers so we'd have to come up with a cool story.

S. Yeah, if we had an idea that felt natural then anything is possible.

J. A movie would be awesome, but I think our schedules are all a little too busy for that to be a possibility right now. The amount of videos we'd have to make in advance would be insane.

JJ. The only movie we would make would be a porno... Uhhh not together though...There would be girls there too...Loads of them! Ah man...

T. This isn't a movie???

@KILLERSHORAN
WHAT WAS YOUR FIRST IMPRESSION OF EACH OTHER WHEN YOU MET EACH OTHER?

v. I had a positive impression of anyone when I met them. YouTubers tend to have an ingrained respect for each other unless there's any distinct reason not to. We've all gone outside our comfort zones, worked hard, and taken risks to be able to do what we do to the level that we do.

JJ. I hope these aren't my friends for life.

E. Erm... JJ was quite loud and out there but everyone else was just like meeting a new mate for the first time!

s. Oh God, what have I got myself into...and Tobi seems cool.

T. Ethan – 'This guy has an incredibly contagious laugh?!'
Harry – 'So much quieter than in videos.'
Josh – 'It's so long ago that I actually can't remember.'
JJ – 'WTF?! This guy is too nice to have that many subs.'
Simon – 'JJ's friend seems cool!'
Vikk – 'Same in person as he is on Twitter.'

H. I'd spoken to all the guys in Skype calls nearly every night before I even met them so I kind of knew what to expect. However, I was taken back by how jokes everyone was in person! They were all so fun to be around!

J. Tobi - I've known him too long to even remember what my first impression of him was. It must have been a good impression as we're still friends 11 years later.
Ethan – I spoke to him for a long time before actually meeting him, but he was exactly the same in person, infectious laugh, and fun to be around.
JJ - When first meeting JJ, you realise he's a lot calmer than what he is like in his videos. He's actually very chilled and relaxed, but has the ability to go crazy at any point.
Harry – I first met Harry in New York when he was still rather young and rather shy. He's grown a lot as a person since then, although he still has the tendency to be shy with new people.
Vik - I remember meeting Vikk and him also being young and shy, but it was clear that he was smart, very driven and wanted to achieve.
Simon - I remember meeting him back when he was referred to as JJ's cameraman. Me and Tobi got along well with him, as he was cool, and could bust a few dance moves. Me and Tobi get along with anyone who can dance!

@SidemenMD

WHAT IS THE BEST THING ABOUT BEING IN THE GROUP?

V. The best part of being part of the group is the lifestyle, to be able to live YouTube day in day out, seek assistance, and advice, rather than just do YouTube as a 'job'.

JJ. The chicken!

E. Having mates around 24/7, no matter what time of day, there's always someone around!

S. Getting to do what I love with my best mates, and someone is always about if the others are busy.

T. I get free clothes from SDMN.

H. It makes YouTube a lot more fun! Trying to grow your channel is always way more entertaining when you're doing it with like-minded people. It's also good because you have people to back you if Twitter beef goes down! I think the main thing I like though is the opportunities to go on cool trips together such as PAX East and Gamescom, as well as do things like the charity football match.

J. Being surrounded by like-minded people who all have similar goals/ambitions and with good work rates. I think we all push each other to continue to do better and strive for more.

@A_H_opkins

WHERE WOULD YOU BE IF YOUTUBE WASN'T A THING?

V. I would have most likely just graduated from studying Natural Sciences at UCL and be looking for a job.

JJ. Homeless…

E. I'm still only 21 years old, so would most likely be working on a degree to do with game development or something creative.

S. On the toilet.

T. Probably in the graduate unemployment statistics to be honest.

H. I don't even wanna know. I always knew for a fact I'd hate an office job, but I didn't really have a plan for what else to do. I'd probably be at uni at the moment but I don't think I'd be enjoying myself all that much. I like to think I'd be able to find myself a different, cool, job but I don't think anything could compete with YouTube.

J. I studied Digital Film Production at university and was on the road to becoming a music video director, so I would probably be doing something along those lines. If not I probably would have caved in and worked in London with my dad.

@polarizemcvey

WHO WAS THE FIRST YOUTUBER YOU ALL WATCHED?

V. The first YouTuber I watched was Ray William Johnson.

JJ. Same!

T. Ray William Johnson was definitely the first YouTuber I actively subscribed to.

E. Yeah, Ray William Johnson = 3 series was great but the first YouTuber's I watched might have actually been Josh and JJ HAHA!

S. KSI, the Beast!

H. A vlogger called TristopiaTV. I used to send him clips of me in hopes of getting in his videos HA HA!

J. The first YouTuber I probably watched was a guy called iBLaCKOuTz.

WHOSE FART SMELLS THE MOST?

J. I'm not entirely sure, but I'm gonna go with Ethan. He has complained of his own farts smelling before so I'm gonna believe him.

V. I'd go with Harry.

JJ.Harry.

E. Harry without a shadow of a doubt.

S. Harry, even when he doesn't fart.

T. Harry's. 100%

H. Uh thanks guys : / I'll go Vikk.

WHO'S THE LOUDEST IN BED?

V. Don't know the answer to this question, but would go with JJ at a guess.

JJ.Probably me because she screams too much.

E. JJ, the beast from within.

S. KSI the beast.

T. JJ...have you heard that guy snore?

H. Probably JJ, in fact definitely JJ. I feel like Josh might be a dark horse though.

J. Vikk, he's always at it, his bedroom is the closest to mine. I have to turn up my Netflix just to drown out the noises.

WHEN IS KSI GONNA BE BALD?

V. I'd give him a year or two and I'm sure it'll seem like a good idea to him.

J. Once everyone has tweeted him #BALDSKI

T. #BaldSKI...tweet him!

E. 10,000 RT's?

S. When the book is released.

H. Hopefully never, I don't think he has the right head shape for it, and it could go horribly wrong.

JJ.F*** OFF!

HOW LONG ARE YOU GUYS PLANNING TO REMAIN AS A GROUP?

V. For as long as it makes sense, or until we have reason not to.

JJ.Until 7 o'clock, so make the most of us.

E. Not too sure on the expiry date HA HA!

S. Until last Monday…

T. 'What's the meaning of life?'

H. Until a meteorite hits the earth and wipes everyone out

J. For as long as YouTube exists and for as long as we're relevant. That's the thing with YouTube, everyone is replaceable.

FAN ART

When we asked you to send us your fan art we really should have known what we were getting ourselves into. As always, most of you excelled, and your pictures deserve to be hung in museums and admired for centuries, let alone displayed in this book. However some of you are either really, really bad at art or we are just that ugly. Either way, some of these are very cool! Thanks for sending them in :)

IG: @_para.noia_

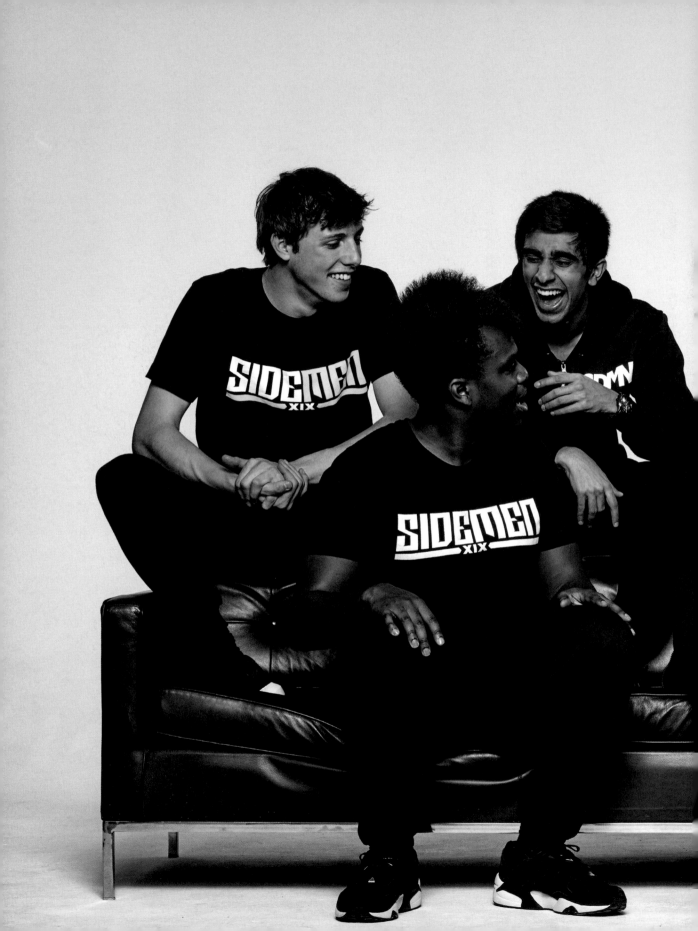

THINGS WE WANTED TO PUT IN THE BOOK BUT WEREN'T ALLOWED...

When we first started talking about doing a book we had so many crazy ideas. Thankfully we were allowed to put 99% of them in. However, when we mentioned a few things we wanted to do we were met with stony faces. It seemed that some of our ideas just weren't book-friendly or, to put it another way, humanity just wasn't ready for them.

But you know us, we never take no for an answer. So, in the end we just about got our own way. Here are the things we wanted to put in the book but were told we weren't allowed...

BOOBS/SWEAR WORDS/HESKEY NAKED/ JOSH'S 'ILLUMINATE' VIDEO/GUNS/ FAKE MONEY/BLOOD/ETHAN'S SECRET/

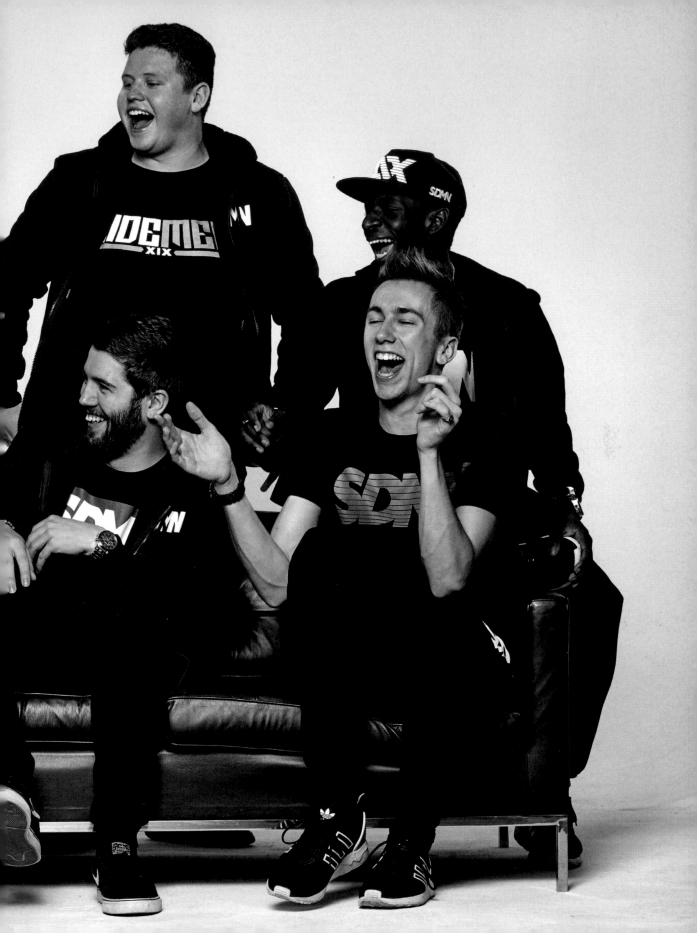

THE END

Round of applause all round! We've actually written a book, and you've read one! The odds of that happening are probably the same as Leicester winning the Premier League, and… Well, we guess that example doesn't work any more.

As you've seen, it's been one hell of a crazy ride to get to this point. None of this was planned. We are just seven guys, with a goofy sense of humour, who like playing games. Thanks to you, our paths have crossed, and now we are not only the Sidemen but also the best of friends. Awwwwww sweet.

Anyway, there's still so much we want to achieve in the coming years and we hope that as long as we keep making videos you'll keep joining us for the ride. How else is JJ going to afford the petrol for his Lambo? And Harry doesn't want to have to go back to singing Justin Bieber song parodies!

All jokes aside, thanks guys. You make all of this worthwhile. You've shared our tantrums, tears and laughs, and if your parents complain you're spending too much time on YouTube just tell them that we are the guys that got you to read a book. Eat that Shakespeare! Peace!

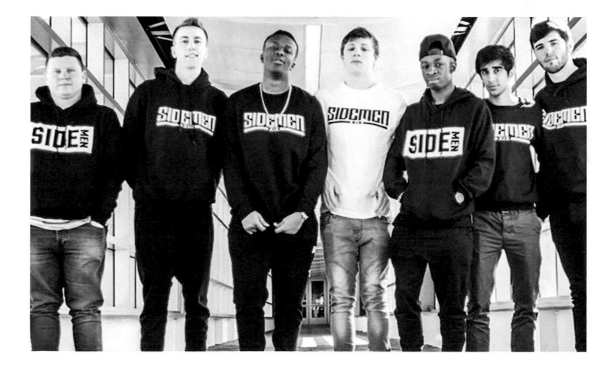

PICTURE CREDITS

ACKNOWLEDGEMENTS

Where do we even begin? There are so many people who have made this book possible, whether they worked on this with us directly, or have provided us with support along the way. So, in no particular order, we would like to thank…

Our families, our fellow YouTubers, Lewis Redman, Freya Nightingale, Charlotte Hardman and everyone at Hodder, Liam Chivers, Gordon Wise, James Leighton, Tice, Jme (8th Sideman), James Edgar and last but not least our incredible fans!

Get the audiobook, narrated by the Sidemen, with exclusive behind-the-scenes commentary, at Audible.

an **amazon** company

ALTERNATIVE WAYS YOU CAN USE THIS BOOK

**Now you've finished reading the book
I bet you're thinking; what the hell do
I do now? Unlike school there are no
tests, so chill. It's all good. You can read
a book just for fun y'know!**

You could just read this book all over again, but if this
has been enough reading to last you a lifetime then
here are some alternative ways you can use the weird
thing in your hand for.

A MOUSE MAT/A DOORSTOP/ A WINDOW OPENER/A MAT/ A WEAPON/WEIGHTS/A FRISBEE/ A POSTER/A SNOWBOARD/ TOILET PAPER/A PET/A BLINDFOLD/ A HAT/A SEAT/